Circulation

Edited by François Brunet

With essays by
Thierry Gervais, Tom Gunning, J. M. Mancini,
Frank Mehring, and Hélène Valance

**Terra Foundation Essays
Volume 3**

Terra Foundation for American Art
Chicago | Paris

Distributed by
University of Chicago Press

Terra Foundation Essays

The history of American art is a history of objects, but it is also a history of ideas. The Terra Foundation Essays illuminate and explore a selection of ideas that have been particularly salient within the production and consumption of art in the United States over three centuries. They present original research by an international roster of established and emerging scholars who consider American art in its multiple, trans-geographic contexts. The essays in each volume expand the conceptual and methodological terrain of scholarship on American art by offering comparative models and conceptual tools relevant to all scholars of art history and visual culture, as well as other disciplines within the humanities.

Circulation

Edited by François Brunet

Francesca Rose, *Program Director, Publications*

Rebecca Park, *Publications Assistant*

James Goggin & Shan James, Practise,
Series Design Direction & Volume Design

Kelly Finefrock-Creed, *Copy Editor*

© 2017, Terra Foundation for American Art

Published by the
Terra Foundation for American Art
120 East Erie Street, Chicago, Illinois, 60611, USA
terraamericanart.org

Printed by Die Keure, Bruges, Belgium

Separations by Colour & Books, Apeldoorn,
The Netherlands

Distributed by The University of Chicago Press
press.uchicago.edu

Library of Congress Cataloging-in-Publication Data

Names: Brunet, François, 1960- editor. |
 Terra Foundation for American Art, issuing body.

Title: Circulation / edited by François Brunet ; with
 essays by Thierry Gervais, Tom Gunning,
 J.M. Mancini, Frank Mehring, and Hélène Valance.

Other titles: Circulation (Terra Foundation for
 American Art)

Description: Chicago : Terra Foundation for American
 Art, 2017. | Series: Terra Foundation essays ; Volume
 3 | Includes bibliographical references.

Identifiers: LCCN 2017002585 (print) | LCCN
 2017003689 (ebook) | ISBN 9780932171610
 (paperback) | ISBN 9780932171627 (E-book)

Subjects: LCSH: Art and society--United States. | Art,
 American--Themes, motives. | BISAC: ART /
 American / General. | ART / Criticism & Theory. |
 ART / History / General.

Classification: LCC N72.S6 C54 2017 (print) | LCC N72.S6
 (ebook) | DDC 701/.03--dc23

LC record available at https://lccn.loc.gov/2017002585

Front cover: Aaron Douglas,
Song of the Towers (detail, see p. 203).

Contents

NO REPRESENTATION

François Brunet

Introduction:
No Representation without Circulation

Argument

Art history finds one origin in the conservation and transmission of precious objects worth guarding against loss or theft, worth displaying, moving and removing, selling or ceding sometimes. Long-standing practices of the field include narratives of the lives and peregrinations of artists; connoisseurship of artworks as transient things, with histories of provenance, exhibition, publication, reception, and collection; and mapping of series of objects related by technique, subject, motif, or style, evincing geohistorical patterns of spread, migration, transformation, and influence. Such practices of connoisseurship have been made easier, indeed possible, by the expansion of techniques of reproduction. Art historians have long learned not only to make and use reproductions but to regard them as harbingers of a "conquest of ubiquity," in Paul Valéry's 1928 phrase, and of what Walter Benjamin called, in his famous 1936 essay, a "loss of the aura," or disconnection of the art object from its "hic et nunc." While early cinema participated in what Benjamin called a "liquidation" of tradition by recasting national histories and heritages into mass spectacles aimed at world stages, modernism, or some of its currents, capitalized on mechanically produced and reproduced imagery—from cinema, photography, and the illustrated press—as a new condition of art, its making, and its relationship to reality, space, and time. By the second half of the twentieth century, much thinking on art had come to identify reproduction and communication as defining categories of "modernity."[1] Since Pop Art, at least, the discourses of reproduction, multiplicity,

Gilbert Munger,
"Uinta Range, Colorado—
Canon of Lodore"
(detail, see fig. 2).

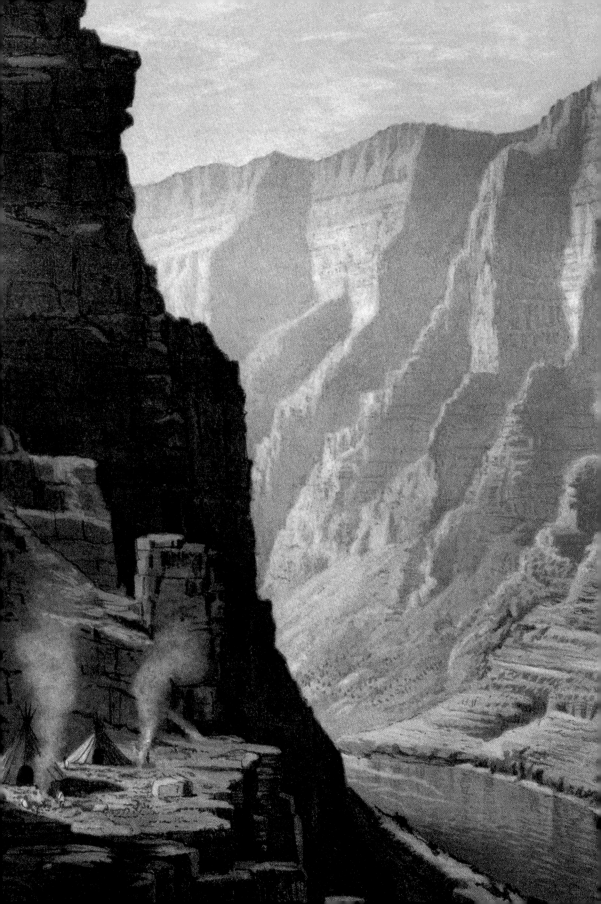

instantaneity, dematerialization, and de-territorialization have become prevalent in the production and reception of art and culture.

Thus in almost any account of art history or art theory, even before the end of the twentieth century, one is bound to encounter some notion of circulation: not, perhaps, in the original meaning of "circular" or cyclical motion, but in the looser modern sense of "transmission or passage"—of money, news, and just about anything—and, more broadly, "currency" or "use."[2] Whether we think of princely jewels and the histories of their transmissions, the writing of an entry in a catalogue raisonné, the spread of a "school" such as Impressionism, the reproductive trail of painting's icons from the *Mona Lisa* to *American Gothic*, or the patterns of exhibition and marketing of art in the twentieth century, we are readily convinced that any history of art is bound to be a geography, that it implies maps of locations, trajectories, and distributions of objects, images, and ideas, and that the history of modern art, especially, must rank circulation among its most significant phenomena.

Now if we turn to the digital era, which is also the era of globalization and the Internet, it is obvious that circulation has become more than just one significant aspect or context among others. Processes of dissemination and dematerialization have multiplied exponentially, fostering the common perception that the "old" question of reproduction (and its relationship to original, reality, simulacrum, etc.) is behind us and that something more powerful is altering the existence of images, texts, data, and objects. In the realm of the visual, the "lives of images," in W. J. T. Mitchell's terms,[3] consist in endless mediations and re-mediations of "visibilities" (and other modes of communicability) that need not retain any materiality or uniqueness to circulate virtually, and yet tend to lay claim to a strong link to reality—the reality of their own circulation, to begin with. Digital-native students expect images (if not objects) to move, multiply, and disseminate virtually and instantaneously; they measure the worth of digital things by the statistics of their circulation (somewhat like earlier generations did for news, ads, or television shows); they appraise virality before they observe form or content.

In this context, the naïve (but tempting) question arises: How did pictures "circulate" before the Internet? Or, in a slightly less naïve form: If today's *speed* (or ease) of image circulation is unprecedented, does it not point to a long-term *need* (or wish) for circulating pictures, at least in the modern period, in conjunction with the rise of the market economy and the increasing mobility of goods and people?

To generalize the point: Is it not the case, whether historians like it or not, that the power of circulation and discourses on circulation today tends to recast contemporary thinking on art history, if not history in general, in the prism of circulation, mobility, trade, and the "social life of things"?[4] Hence a methodological reformulation: How do we attend to the logic of circulation without projecting the economy of today's digital culture, its patterns of rapid expansion and its fantasies of total and immediate circulation, onto a long-term, general history of circulations?

Indeed, a collection of essays like this one cannot be merely an archaeology of today's modes and issues of circulation. When circulation is chosen as a theme for an installment in a series aimed at outlining key concepts in the field of American art history, its particular contemporary prevalence cannot in itself dictate the terms of a discussion that must reach far and wide. As a critical category, circulation requires a broad construction, which could be approached somewhat like this: How have pictures and objects—in different periods—acquired meaning, worth, agency, form, even aesthetic status, by moving, or, more generally, by gaining "currency" or "use"? In the present volume, then, circulation is understood in the broadest possible sense, that is, as something larger than movement, and also larger than reproduction: spatial, but also temporal; material as well as intellectual; international, intercultural, intermedial; always hinting at the possibility of circularity (when an artwork "returns," transformed or not, to where it came from); and always measured against the possibility and the reality of noncirculation. In other words, in this book "circulation"—like "picturing" in the inaugural volume of the Terra Foundation Essays—identifies a conceptual avenue for thinking about not just one facet or moment of American art but its total historical condition as a site of evolving relations between things, images, and ideas.[5] And consequently, this book's leading argument is that circulation can and must be construed as a shaping factor in the history of American art and its global reach, from the eighteenth century to the present.

This book aims, then, at a long-term history of circulations in and of American art—or art of the United States—shaped as it has been from its earliest period by constant intercourse with other political, economic, and cultural forces and situations both within and outside of North America. The Revolutionary era is well known for its efforts in multiply-ing and circulating American pictures, as exemplified by Gilbert Stuart's prolonged output of commissioned likenesses of George Washington, a striking blend of economics and aesthetics that answered an equally striking conception of "original copies."[6] This early context inspires the

title of this introductory essay, which alludes to the American colonists' rallying cry against taxation, suggesting that the social and political economy of circulation is, in the American context, a recurring, long-standing condition of making art, and acknowledging at the same time that while the regime of representation is traditionally defined as aesthetic, concepts such as circulation and mobility echo an increasingly prevalent economic approach to culture.[7] The negative, "no representation," is here to remind the reader that not all images circulate in equal volumes or similar modes: the history of circulations encompasses the history of noncirculations. In the American context, understood as a succession of historical situations rather than an essentialized cultural identity, failure of circulation has often amounted to failure of representation; and if one had to draw a "lesson" from the contributions in this volume, perhaps it would be that, in the history of American art, imperatives and impacts of circulation have often preempted choices of representation.

As already suggested, this argument may seem obvious today, or at least easily accepted in view of contemporary trends in American art history, where scholars increasingly engage with the broader field of visual culture, often defined as the integration of moments and forms of "picturing" in broad political and economic circuits.[8] In fact, however, this argument concerning circulation is not so obvious when one considers a longer stretch of historiography and criticism; and it is useful here, as a way of better characterizing the relative novelty of this approach, to briefly consider, by contrast, two opposing conceptions that, although considered obsolete by most now, previously were vastly influential. The first one is modernism, or rather one formulation of its aesthetic theory, as it addresses the relationship of art to "life" and as it opposes, in art history, the methods associated with historicism. The second is nativism, an older and longer tradition of thinking on American art, as it attempts to construe the Americanness of American art in isolation from foreign scenes and models. This discussion eventually leads us back, through more recent critiques of these conceptions, to the state of circulation today and in this volume.

Circulation, Its Opponents and Proponents

Modernism is a much deeper and more complex trend than is often claimed;[9] and in this section, I am only alluding to a well-known theory, loosely associated with modernism, that defines the work of art as a self-contained, autonomous, and stable vessel of meaning, with meaning construed, in this framework, as essentially ideal and

　　　　François Brunet

ahistorical. I am referring to the writings of Clement Greenberg (1909–1994), specifically to his landmark essay "Avant-Garde and Kitsch" (1939).

Greenberg's text not only ignores circulation but barely uses the vocabulary of motion, unless it is to define "kitsch" in opposition to true art. If the "avant-garde" does "move" in this essay, it is only to "'detach' itself from society" and "keep culture moving" along a high ridge of pure aesthetic progress, away from the "public" and "subject matter." The avant-garde is not only separated from material conditions such as motion and the "public" scene, implicitly dominated by utilitarian and mercantile concerns. It is separated from social "meanings" because it is ontologically defined as a form of art that "cannot be reduced in whole or in part to anything not itself." Conversely, Greenberg pictures "kitsch," a "product of the industrial revolution," as art that moves—materially, geographically, socially. In its worldwide expansion, kitsch "wipes out" all preexisting culture, turning art into something commercial and industrially uniform: "today the native of China, no less than the South American Indian, the Hindu, no less than the Polynesian, have come to prefer to the products of their native art, magazine covers, rotogravure sections and calendar girls."[10]

The explanation for this "triumph" lies not in social-historical conditions, such as economics or propaganda, or, obviously, in a latter-day conception of circulation as a sort of macrotechnological or anthropological structure, of the kind Marshall McLuhan theorized thirty years later in *Understanding Media* (1964). It lies in an inherently "predigested" status of kitsch or low art, an art that, as in the historical paintings of the Russian Ilya Repin (1844–1930), and, superlatively, in Norman Rockwell's cover art for the *Saturday Evening Post*, delivers ready "effect" for the enjoyment of the masses, instead of demanding this effect from the spectator's reflection. The opposition of "avant-garde" and "kitsch" reflects a sociocultural opposition between the "cultivated spectator" and the "unreflective" one. For the purposes of this discussion, it is striking to observe that kitsch is to avant-garde what motion is to stillness, or motion to emotion, and to highlight the "values" associated with either polarity. The "peasant" who enjoys Repin's paintings values effect, drama, and, at bottom, subject matter, continuity of art and life, and narrative power. The cultivated spectator values "plastic qualities" insofar as they are a "cause" for an effort of his or her own, an exercise of reflection that builds on discontinuity, "remove," or abstraction from any context. There is no room in this

conception for the notion of circulation as anything but external, if not detrimental, to the proper, "reflective" pleasure of art, which belongs to a separate realm of the ideal, and is best evidenced by abstract form (as is made further evident in Greenberg's 1955 essay on "American-type painting"). Conversely, kitsch is permeated not only by excessive intelligibility but, ultimately, by continuity, or contiguity: it manifests itself by its expansion in space and culture; it succeeds by staging effects contiguous to their causes; like the higher form of art, but in a much more ostensible way, it rejects "discontinuity between art and life"; it requires and generates narratives, instead of "absolute" aesthetic ideas. Circulation, in this reading, might almost be called the criterion of Greenberg's divide between avant-garde and kitsch.

Does this mean that in elevating circulation to a category of art history, we run the risk of confusing (American) art and kitsch? It should be noted, here, that Greenberg's conception is critical rather than historical, that it is rooted in the context of the 1930s, and that his stringent demand to separate art from kitsch and reflection from circulation was not shared by all art historians of his day. Published in the same year as Greenberg's essay on "avant-garde and kitsch," Erwin Panofsky's *Studies in Iconology: Humanistic Themes in the Art of the Renaissance* was developed after the author's move to Princeton and written in English, and it introduced to American academic readers methods of iconography, more generally the so-called historicist tradition. While the so-called modernist model would often define itself in opposition to historicism, Panofsky's book offers, I would argue, a global approach to art history as a history of circulations and contexts.

Without rehearsing the theoretical framework of iconology, I want to draw attention to Panofsky's method of analysis of his immediate subject field, "humanistic themes in the art of the Renaissance." This field is constructed entirely as one of migrations and mutations — we might say circulations, although Panofsky does not use this word. He analyzes the humanistic themes of the Renaissance as the accumulated results of historical mutations and geographical migrations, where a given "motif" or portion of a motif changes forms and meanings with different cultural and economic conditions. The analysis relies crucially on the careful mapping of migrations of motifs over space and time, as in the example of the ambiguous "type" of Salome-Judith, or the young woman portrayed with a decapitated head and either a sword or a platter, where Panofsky — with the help of photographic reproductions — follows the transformative migration of the motif over northern Europe in the sixteenth century. Following

the method developed by Aby Warburg in his *Mnemosyne Atlas* project in the 1920s, Panofsky establishes spatial and temporal circulation— of artists, but also of their patrons; of ideas, as well as motifs and some materials, such as pigments, for instance—as a primary mechanism of the history of art. His history functions primarily on the iconographic level and yet constantly foregrounds spatial circulation in the analysis of artistic reinterpretation, reformulation, or what Panofsky calls "pseudomorphosis," a notion that today might be called "refiguration." It is certainly worth noting, as a clue to the relevance of this method to American visual culture, that Panofsky introduces pseudomorphosis visually with a reproduction of an American bank logo of the 1930s reemploying the motif of "Father Time" (fig. 1).[11] This is, then, an art history that gives governing power to circulations of objects, artists,

1

"Father Time," from
Erwin Panofsky,
*Studies in Iconology:
Humanistic Themes in
the Art of the Renais-
sance* (1939; New York:
Harper & Row, 1972), 69.

III. FATHER TIME

PIERO DI COSIMO'S secular compositions, based as they are on an almost Darwinian evolutionism and often harking back to a primitive world prior to every historical age, are an extreme and practically unique manifestation of the general tendency to revive the *'sacrosancta vetustas'* As a rule this tendency confined itself to resuscitating antiquity in the historical sense of the term, Piero him-self was, as we have seen, an archaeologist, as well as a primitivist. However,

the reintegration of classical motifs and classical themes is only one aspect of the Renaissance movement in art. Representations of pagan divinities, classical myths or events from Greek and Roman history which, icono-graphically at least, do not reveal the fact that they were products of a post-mediaeval civilization, exist of course in large numbers. But even larger, and much more dangerous from the viewpoint of orthodox Christianity, was the number of works in which the spirit of the Renaissance did not confine itself to reinstating classical types within the limits of the classical sphere, but aimed at a visual and emotional synthesis between the pagan past and the Christian present. This synthesis was achieved by various methods which could be applied separately and in combination.

The most widely used method might be called the *re-interpretation* of classical images. These images were either invested with a new symbolical

69

and motifs in space and time, down to this implausible occurrence of an ancient pagan emblem in the commercial landscape of modern New York, where meanings are essentially linked to forms, but where both forms and meanings are unstable, historical, and linked to material and intellectual *movements*.

Thus at the same time Greenberg sought to extricate modern art from contexts and meanings in order to locate form as a "reflective" realm of aesthetic pleasure, conceived as an antidote to the stultifying effects of what Theodor Adorno and Max Horkheimer would describe a bit later as the "culture industry,"[12] Erwin Panofsky explored the opposite path, seeking to historicize artistic forms and meanings as the traces of material and intellectual circulations. The fact that both texts (along with Benjamin's essays) were published on the eve of World War II—after Panofsky fled Nazi Germany for the United States, and as Greenberg witnessed the contest of commercial and political propagandas—reminds us that art history, and particularly the history of circulations, is not a peaceful field of abstract speculation. In this last connection, it is worth mentioning artists of the interwar period, especially those affiliated with Futurism, Dadaism, and Surrealism, whose work foregrounded circulation and mobility as both sources for artistic creation and pressing realities of life and art in ominous geopolitical contexts: one thinks more particularly, in the American context, of Francis Picabia and his "mecanomorph" portraits of the 291 circle in the late 1910s, and of Marcel Duchamp's *Boîte-en-valise*, begun in 1935 and hastened to completion during the period of the artist's forced exile in 1940–1941.

In the 1930s, meanwhile, neither the modernist nor the historicist models of art theory and history could suffice to characterize a period of American art that was deeply impregnated by domestic sociopolitical issues and, more specifically, the quests for American pasts, American scenes, and American arts.[13] Without entering into a discussion of regionalism and its battles with high modernism and abstraction, I use this juncture as a transition to an older and larger conception of American art, one associated with the label "nativism," which needs to be mentioned here precisely on account of its durable defense of native genius as a spontaneous, homegrown value, and therefore as something independent from historical patterns of circulation. What needs emphasis here is that in the nativist tradition, circulation is paradoxically a very relevant, arguably overarching issue—but negatively, as something to be either denied or rejected as beyond the pale of what concerns the history of American art. One only needs to

leaf through the pages of William Dunlap's *History of the Rise and Progress of the Arts of Design in the United States* (1834) to observe how the author establishes, emphatically if parenthetically, circulation and noncirculation of American artists within and outside of the United States as the subject of his book. Thus the beginning of the first chapter, devoted to the painter of portraits and genre scenes Charles Robert Leslie (1794–1859), states that in spite of British claims to the contrary, "Charles Robert Leslie is an American, and received his first instruction as a painter in America, and imbibed his taste and love for the art before he left the country to study systematically in Great Britain."[14] Similarly, in Dunlap's long chapter 9, unequally divided between Henry Inman (1801–1846) and Thomas Cole (1801–1848), the historian insists on the latter's passion for America and its landscapes and extensively quotes the artist about his disappointments in Europe. Dunlap nonetheless reveals the necessities of circulation in Cole's early and mature career, from the urge to escape what Neil Harris later called the "burden of portraiture" to his reluctant decision to travel to England to perfect and, like earlier and later American painters, to display his work.[15]

This story of laborious emancipation by overt or tacit confrontation with what Ralph W. Emerson called "the muses of Europe" was repeated over and over for more than a century. Thus one finds a familiar pattern of argument in James T. Flexner's 1962 *History of American Painting* (though Flexner's history begins in the colonial period and is therefore a history of painting in America rather than in the United States), specifically in its third volume, *That Wilder Image*.[16] Flexner essentially rehearses the nativist doctrine that had been Dunlap's and Cole's biographer Louis Legrand Noble's when he insists in his foreground that "some of the most effective exemplars of the Native School never went abroad. Those who did cross the ocean set out, even if quite young, not as raw students. . . . They had no desire to be born again." Urging readers to quit their "French eyeglasses," Flexner gives nativism its modern formulation, reminiscent of Frederick Jackson Turner's frontier hypothesis, when he defines American genius as the reflection of "broad environmental forces," rather than the reaction to "the influence of painters on painters, of pictures on pictures."[17]

While this "environmental" conception of American art's originality was furthered by major exhibitions and publications at least into the 1970s, I do not need to prolong this presentation, or detail the subsequent, powerful revisions that have transformed the understanding of

Thomas Cole's approach to landscape, history, and nationality, the American "school" of landscape painting, and the nativist construction as a whole.[18] Beyond landscape, recent discussions of the national paradigm in the history of American art have shown increasing reluctance to adopt the nativist argument, seen as a form of exceptionalism, and a growing concern to reframe, if not to relinquish, the whole discussion of the "Americanness of American art," particularly by seeking to internationalize the writing of its history.[19] This has meant, among other measures, substituting historical processes of "Americanization" for the essentialist view of "Americanness," and, perhaps most obviously, emphasizing exchanges and encounters with diverse "non-American" or non-WASP artistic and cultural traditions, as well as the input and heritage (or lack thereof) of these traditions in currents and institutions of American art.[20]

From the standpoint of this volume, however, attempts at internationalizing or decentering narratives of American art remain of limited importance, because their main operative concept is that of identity (and its subcategory, nationality), conceived often as condition, sometimes as meaning, of the artwork, and echoing older approaches of art as a window onto civilization. Increasingly sophisticated studies of international patterns of encounter and exchange, leading up to the approach known as transnationalism, have emphasized mediation, migration, hybridization, and even circulation as key concepts.[21] Still, international and transnational approaches have often remained bound to the primacy of message over medium, of identity over dissemination, or of representation over circulation. The departure from this approach—the notion that mobility presides over representation—is what gives importance to Jennifer Roberts's *Transporting Visions: The Movement of Images in Early America* (2014). A critical summary of Roberts's compelling thesis on the "movement of images" in the Early Republic serves here to open up a refined formulation of the present book's argument.

Roberts starts by acknowledging a certain commonality between the eighteenth-century context and the present time, through the notion of "visual communication"; this may strike readers as an example of the archaeological stance I presented above as both tempting and questionable. Her next premise similarly echoes the argument on economics and aesthetics outlined above: pictures in colonial America and the Early Republic were often mixed with commodities, rather than subjected to the "normative conditions of visibility and aesthetic distinction" that had, in the European context, come to define art.

The economic basis of early American art links up to Roberts's main thesis, according to which pictures in this period, like commodities, could "register the complications of their own transmission" and include in their very composition a "formal preprocessing of the distances they were designed to span"; and yet in its successive chapters on John S. Copley (1738–1815), John J. Audubon (1785–1851), and Asher B. Durand (1796–1886), the book's argument goes well beyond an economic interpretation. In keeping with the frameworks of material culture and mobility studies, the thesis reverses the order of sequence and priority between the realms of composition (or representation) and transportation (or circulation). Here circulation (or "transit," as Roberts prefers to write) is not a peripheral story of display, publicity, spread, distribution, and influence, but something like a *motif*, visible in the "pictorial expressions" themselves. The major illustration of the thesis is Copley's *Boy with Squirrel* (1765), a painting that was designed for the purpose of being sent to London for exhibition. For Roberts, the water glass on the table represents in several ways "the plight of the task of the painting itself" in its planned transit across the ocean, while the "flying squirrel" serves not only as a projection of North American life and science on the London stage but, as a "convertible" body, as "the most perfect mammalian analogue imaginable of a stretched canvas in transit," and finally, in its "well-rounded" bodily presence, a kind of pictorial emblem of empiricism.[22] The title *Transporting Visions*, then, refers not only to material processes of transporting pictures but to the ways visions of America in transit could "transport" makers and viewers alike into a form of rapture over the immensity of such space and hardship.

This unusual form of reflexivity points, beyond the postcolonial situation, to what Roberts calls the paradox of portability. Portability, integral to the historical emergence of pictures from the Renaissance on, worked to "liberate [the picture's] internal space of representation from the external space through which it moved," and for this very reason it obscured the burdens of transportation. The "geographic autonomy of the picture format" eventually led to the "aesthetic autonomy" of art, in Kantian (and Greenbergian) terms. Roberts contends in contrast that "geography inhabits pictures," as objects that move in space. In North America and its transoceanic relations in the eighteenth century, the geographical determination of pictures was all the more tangible since distances were great and obstacles many. Distances, obstacles, and delays, according to Roberts, were "not merely passive intermissions" but productive systems themselves. Art, like business,

confronted these obstacles and participated in the "systems devised to minimize the effects of delay, decay, and mistransmission."[23] The perplexed economy of transit stands in contrast to André Malraux's somewhat utopian notion of a "museum without walls," and all the more forcefully to the digital era's fantasy of immediate dissemination. It foregrounds weight, scale, materiality, time, and space as primary constituents of not just circulation but picturing, reminding readers of the digital age that pictures are objects and emphasizing transmission and mistransmission as long-standing issues. Yet at the same time Roberts's thesis produces a striking paradox.

While Roberts thus establishes a seductive "aesthetics of transit" as a recurring *motif* of early American art, the thesis also oddly amounts to a re-centering of art history's task on "pictorial expression." To put it bluntly, it is as if, starting from an anti-Greenbergian approach, identifying art as visual communication, and claiming a productive intervention of "life" into "art," or of "context" into the "text," Roberts came full circle in the end to reinstate the art object as an absolute, self-reflexive, and self-sufficient totality, which preregisters the imagined curve of its own movement so vividly that it no longer requires any "outside" documentation to deliver the full history of its circulation. This is a caricature. Roberts's book as a whole fully demonstrates that the history of the movement of images is far more complex than any particular picture maker could inscribe in a painting. Furthermore, it argues compellingly for including art history in a more material history, a history of things (and especially of commodities and the monetary system, in Audubon's case), thereby drawing further away from a Greenbergian model. Still, this attempt to make movement a component of the picture itself carries the risk of neutralizing the more mundane circulation of pictorial objects, or rather, of marginalizing aspects of circulation (not to mention noncirculation) that are beyond the pictorially expressible. Hence the relevance of what I call an "a-pictorial" approach of circulation.

The A-pictorial Approach: Photography, Reproduction, and Circulation

Circulation is both more and less than movement, and it far exceeds the realm of the pictorially representable. The history of art is filled with examples of circulations that were never destined to happen: reuses of objects that were never imagined to be reused, apparitions of pictures that were never intended to be seen. Most importantly, reproductive media have fostered an unchartable dissemination of

pictures over space and time. Their multiplicity is invisible; their history is unrepresentable. Reproduction, as such, opens up a space of multiple circulations that defeat the picturable process of physical transit, or even mobility. In fact, reproduction has frequently been motivated by the effort to counter the countless risk factors affecting the integrity of pictures and objects, especially in transit. War, fire, theft, confiscation, death, forgetting, loss—not to mention acquisition, relocation, reuse, appropriation, reinterpretation, recycling, and so on—have determined the historical courses and cultural meanings of (art) objects to a very large extent, while reproduction has been, historically, born out of the urge not only to distribute but to safeguard copies of originals. This perspective on reproduction inspires the "a-pictorial" approach of circulation, which I illustrate by turning to photography.

Upon publication of the first photographic processes in 1839, the greatest promise associated with the new invention, at least from a utilitarian perspective, was the unimaginable ease with which it "reproduced" visible objects. Though the fidelity of such "reproductions" would be debated for decades, we should not underrate the appeal of the idea of reproducing the visible world: in the nineteenth century, the most obvious cultural effect of photography was a new portability—of pictures (as early as the 1850s, specialized photographers made a business of reproducing works of art) but also of sights of the world. Let us recall Oliver W. Holmes (1809–1894) musing on stereoscopic travel ("I stroll through Rhenish vineyards, I sit under Roman arches, I walk the streets of once buried cities, I look into the chasms of Alpine glaciers, and on the rush of wasteful cataracts") and the attendant experiences, or fantasies, of de-corporealization ("and leave my outward frame in the arm-chair at my table, while in spirit I am looking down upon Jerusalem from the Mount of Olives"). Holmes predicted dematerialization: "Every conceivable object of Nature and Art will soon scale off its surface for us." Immaterial forms would contribute to stereographic collections and "a comprehensive system of exchanges."[24] Armchair travel and the promise of what Holmes called in the same text a photographic "Bank of Nature" were two horizons of photographic reproduction that motivated the oft-repeated link, in nineteenth-century discourse, of photography, telegraphy, and the railroad as agents of what the post-Romantic generation called the "annihilation of space and time." These new media did not necessarily express motion: photographic views were usually supposed to function simply as transparent windows on other places. They nonetheless acted as powerful "conducting" channels, emblematic of the Industrial Revolution.[25]

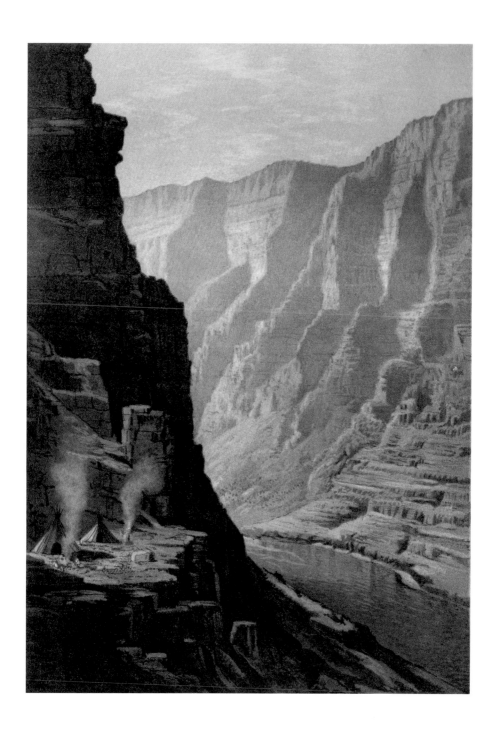

2
Gilbert Munger, "Uinta Range, Colorado—Canon of Lodore," from Clarence King, *Report of the Geological Exploration of the Fortieth Parallel*, vol. 1, *Systematic Geology* (Washington, DC: Government Printing Office, 1878), plate V. Chromolithograph, 8½ × 6 in. (20 × 15 cm). US Geological Survey, Ft. Collins, CO.

François Brunet

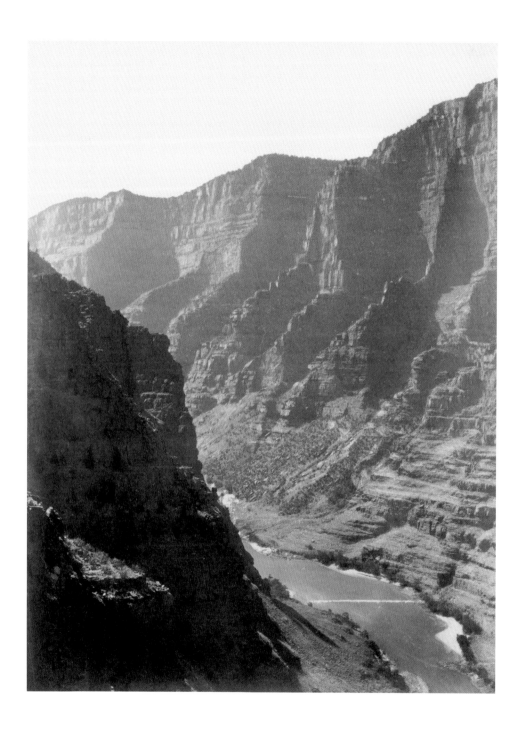

3
Timothy H. O'Sullivan, "Canon of Lodore, Green River," 1872, for Clarence King, *Geological Exploration of the Fortieth Parallel.* Albumen print from glass-plate negative on card mount. Library of Congress, Washington, DC. Prints and Photographs Division, LOT 7096, no. 72.

The archival record of nineteenth-century surveys of the American West is a great case in point. It comprises not only thousands of photographs but a whole array of graphic art including paintings, prints, maps, panoramic views, and atlases, as well as a huge shelf load of illustrated books, a prodigious amount of archival matter including hundreds of geographical, botanical, and mineralogical drawings, and an untold number of natural objects and artifacts.[26] Survey art, as it is sometimes called, was geographical in several senses. Aimed at depicting the land, it produced a pictorial record that included many "first" views of little-known places, usually made in a detailed, legible style. The makers of "views," whether painted, drawn, or photographed, were artists working in collaboration and sympathy with explorers, such as painter Gilbert Munger (1837–1903) and wet-plate photographer Timothy H. O'Sullivan (1840–1882) with geologist Clarence King (1842–1901) (figs. 2–3).[27] These views served both the "immobility" of archives and mapping (the purpose of preservation and centralized representation) and the movement of "traveling knowledge" (the purpose of circulation).[28] They were transported, reproduced, and disseminated for the sake of geographical science, American expansion, and American art. Gilbert Munger's oil pictures, which the painter usually preferred to finish on the spot, were transferred to color lithographs in illustration of King's reports, but also for the art market; research on Munger has shown that he became a prominent painter in the 1870s–1880s, especially after he moved to Europe and started to paint in a style closer to Barbizon.[29] Recent research on the photographs of the Geological Exploration of the Fortieth Parallel, or "King Survey," has revealed the extent of their international circulation in the 1870s, through European world's fairs, geographical congresses, and the international stereoview business.[30] The following discussion aims at illustrating how pictorial and a-pictorial polarities can be combined in the analysis of circulation.[31]

In an album of King Survey photographs preserved at the Library of Congress are two large views by Timothy O'Sullivan of a ridge of basalt "columns" in Nevada, which are captioned "Karnak, Montezuma Range, Nevada" (figs. 4–5, one caption with quotation marks around "Karnak" and the other without). These, like all others in the album, are pictures that "registered the complications of their own transmission." All "views" produced by the wet-collodion-on-glass method registered these complications, whether unwillingly through specks of dust, cracks in the glass, overexposure, or underfixing, or felicitously as demonstrations (not necessarily ostensible) of skill, care,

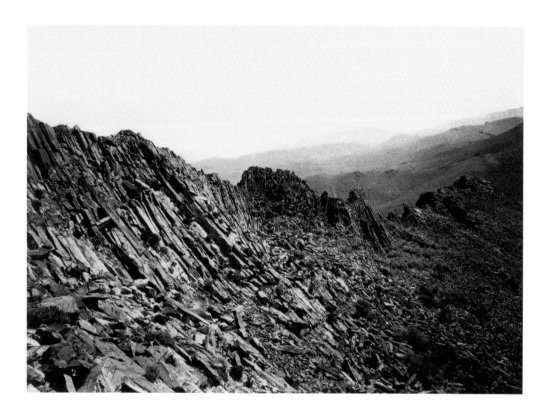

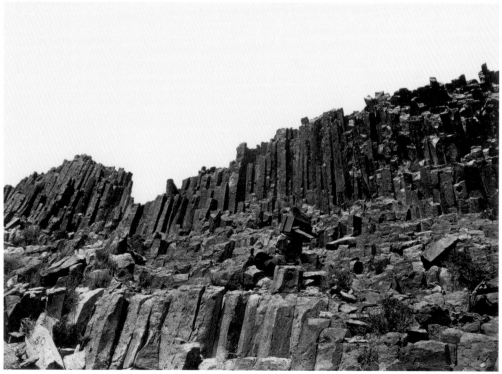

and caution in successfully producing, preserving, and transporting as perfect (or, we might say, *pictorially invisible*) "views" as possible of remote, inaccessible places unknown to the world at large. When the scene depicted was as strange, eerie, and even forbidding as this ridge in Nevada, there was, as often noted, a dimension of awe. Perhaps this awe is what O'Sullivan intended to foreground by frequently inserting in the view an observer figure, usually visibly intent on the serious work of scrutinizing a rock structure, but also sometimes animated by a semiburlesque attitude of bemusement, skepticism, or sheer theatricality. By doing this, Clarence King's photographer did engage in a measure of compositional reflexivity that may, at least from our vantage point, be interpreted as a pictorial expression of the projected transit of the "view" to some remote, urban setting in New York or London where other observers unfamiliar with the scenes would gaze on them.

When Clarence King or his team labeled this site and these views "Karnak, Montezuma Range, Nevada," they performed an act of "naming the view," in Alan Trachtenberg's words,[32] that was less geological than it was artistic, intercultural, and intermedial, though it is difficult to determine to what extent the names designated observable, visual, or pictorial features of the scenery. The name "Montezuma" was inspired by the Aztec emperor—popularly associated with gold—and used a metaphorical reference to a bygone "Indian" empire to signify the rise of a white American one. (Incidentally, as Martha Sandweiss has demonstrated, the significance of photographs of the West lies as much in the omissions they embodied and circulated as in their existence as "views.")[33] The ridge of crumbling basalt "columns" was named Karnak, King explained, for pictorial reasons: "The steep slopes are formed of sharply divided columns, still in situ, resembling a pile of architectural ruins and suggesting the name of Karnak."[34] "Karnak" was a place-name and a cultural icon, popularized by an abundance of travel literature and imagery, that triggered cultural references to Egypt, architecture, possibly religion, and certainly antiquity; in Nevada, it participated in the ongoing monumentalization of the West. It is even possible that O'Sullivan's photographs were inspired by anterior photographs of Karnak, Egypt, such as those made in the 1850s by the American calotype artist John B. Greene (1832–1856) (figs. 6–7), or the more popular stereographs made by Francis Frith (1822–1898) for the London Stereoscopic Company. Such high-profile photographic endeavors definitely involved, among other contexts, scientific and artistic competition with European precedents and references. Thus, with this caption, O'Sullivan's views of "Karnak"

6

John B. Greene, "Karnac. Salle hypostyle. Mur du Nord. Face extérieure Nº 1," 1853, from the album *Sculptures et inscriptions égyptiennes* (Paris, 1853–1854), plate 92. Salt paper print from calotype negative, 8 5/8 × 11 7/8 in. (22 × 30 cm). Bibliothèque de l'Institut de France, Paris, Folio Z129C, Pl. 92.

7

John B. Greene, "Karnac. Salle hypostyle. Mur du Nord. Face extérieure Nº 3," 1853, from the album *Sculptures et inscriptions égyptiennes* (Paris, 1853–1854), plate 94. Salt paper print from calotype negative, 9 × 11 7/8 in. (23 × 30 cm). Bibliothèque de l'Institut de France, Paris, FolioZ129C, Pl. 94.

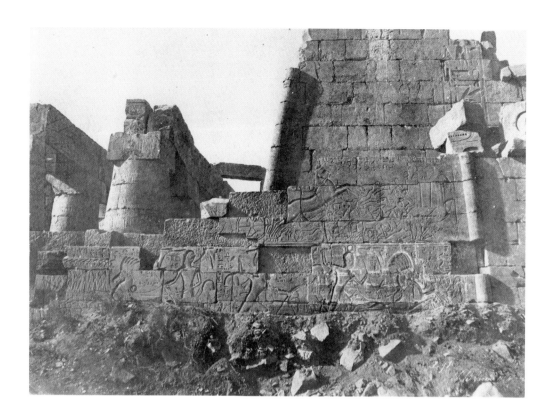

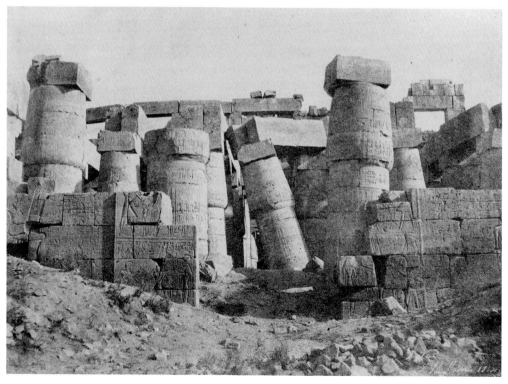

Introduction

"Karnak" Montezuma Range Nevada

| PARALLEL

may be said to function as pictorial expressions not only of sites in Nevada but of their cultural destinations as learned (and creative) geographical images.

In one of the two handwritten captions at the Library of Congress, however, "Karnak" is put between quotation marks (fig. 8), suggesting jocularity or uncertainty about this exotic appellation, and reminding us that such captions are ephemeral and context sensitive. The same views were labeled differently in other sets: "Rhyolite ridge, Trinity Mountains" in the Ashburner collection at the Bancroft Library; "Ridge of columnar trachyte, Western Nevada" in a large portfolio preserved at the Paris Société de Géographie. The quotation marks and the existence of more sober "geological" captions concur with the noncommittal postures of the observer figures to suggest that the photographs were also intended as "views," pictorially unremarkable images, "reproductions" of sites destined for circulation and recirculation in endlessly renewable purposes of communication. Some may say that such a relativist view of visual expression as semantically open communication is really suited to images, especially utilitarian ones, and what Jennifer Roberts calls the "incomplete subjectivity" of moving pictures,[35] in opposition to what is called art, understood even in loosely Greenbergian terms as a realm of objects that are defined and appreciated independently from their circulations. As it is one of the purposes of this volume to explore the ways in which circulation *makes* American art, I can only begin here to answer this objection.

Photographs from the nineteenth-century surveys of the West have not only circulated (and recirculated) in countless contexts as documents, first for geographical purposes, later as historical sources. Perhaps more than any other component of the rich legacy of the surveys, they have been rediscovered and recirculated, since the twentieth century, as significant creations of American culture and ultimately of American art. Given the number of books and exhibitions devoted to them, their ever-increasing value on the art market, and their conspicuous presence in major museum collections, and after so many rephotographic, experimental, and iterative art endeavors have engaged these survey photographs, it has become necessary to consider the photographic "record" of the nineteenth-century surveys as a full-fledged artistic heritage.[36] With this conviction one is led to revisit their original circumstances, and notice among other things that they were not only destined to function as illustrative material but also clearly envisioned for exhibition purposes (in world's fairs, especially). Circulation and recirculation of these photographs resulted not only in spreading a visual knowledge and an aesthetic appeal of western landscapes but, with the passage of time and the growing appreciation of photography, in creating a corpus of "primitive" American landscape art. Views initially destined to circulate as transparent images of remote sites came later to recirculate—in part thanks to the large "wake" left by their original circulations—as key works of a native American tradition: an important example of how art can be made by circulation and recirculation.

Many other examples of this process of making (American) art by circulation or recirculation could be added here, such as the photographic collection of the Farm Security Administration, in which delayed, redirected, and renewed circulations of "documentary" photographic enterprises originally supported by institutional strategies with professed utilitarian goals served as channels for making American art. Certainly the logic of artistic recycling is not limited to institutional photography, as is suggested by the recent valorizations of collections of amateur photographs, or even the recent reemergence of the once-suppressed corpus of lynching postcards—a case of "delayed circulation" that has generated a lot of attention.[37] But circulation does not interest us, the contributors to this volume, only in the way it mixes art with nonart, or makes art out of what was once at the furthest remove from acceptable or accepted definitions of art. Circulation concerns us, first and foremost, as a generic procedure to be acknowledged in the social history of American art. In sum, then,

we propose to use circulation (and noncirculation) as a methodological concept that is apt—particularly in the American context—to supplement the more abstract notions of visibility and invisibility, and to anchor the logic of representation and nonrepresentation in a material history.

Scope and Outline of the Book

Our book, then, envisions the phenomenon of circulation in its broadest extension—and not as a merely spatial and synchronic phenomenon. Once again, circulation is not only motion; it is also currency, and, at least to a certain extent, circularity, recirculation, or recurrence of signs and objects within a given cultural territory; reproduction, reuse, re-mediation, repurposing, and return of the same are components of circulation just as essential as physical transportation, as are noncirculation, suppressed circulation, and delayed circulation. This makes the "field" immense, and any encyclopedic ambition pointless. Thus we agreed to approach the theme through a series of transversal investigations, focusing on specific objects, rather than through a more formalized catalogue of media, genres, or periods. Four of the five essays focus on one broad trend of American art, associated with one historical moment but not limited to it, and examine within this framework a variety of modes of circulation. One essay takes the opposite route, by offering a case study of one specific art object. Thus this book aims at indicating the boundless diversity and the convergent pervasiveness of circulations in the history of American art.

A greater diversity of objects and horizons could certainly be envisioned. This volume tends to adopt a fairly traditional topology, positing American art primarily in relation to western Europe and especially France. This transatlantic orientation may be seen as a bias, and as such it is open to criticism. Nevertheless, it also has a virtue, which lies in its affiliation with the nativist tradition: whereas in this tradition, circulation to and from Europe tends to be bracketed out, in this volume, circulation or communication with Europe—as well as other regions—is presented as a factor of development, and, perhaps more importantly, of the growing reach of American art. The transnational "bonus" of circulation—in the many cases of American artists, works, and pictures that were exported to Europe to gain visibility and "came back" richer or more creditable as art—is recalled and given new illustrations, while in the cases of photography, cinema, and the illustrated press especially, circulation of American productions is

François Brunet

shown to produce not just new American art but new international artistic standards. As already said, however, we do not construe circulation as purely or primarily an international phenomenon; and while Europe is on the horizon of the essays, their true focus is on the general economy of circulation. Indeed, while the geographical framework of this volume may be traditional, it is less conservative in its choice of media, since every chapter but one addresses reproductive media (printed illustrations, press photography, cinema, and popular imageries), following our primary attention to the modern conditions of circulation as dissemination—synchronic multiplicity and diachronic recycling. Finally, because no obvious artistic or conceptual hierarchy of media, works, or subjects emerged from the contributions, we thought it efficient to present the "story" in a roughly chronological order, which takes readers from the American Revolution to the so-called digital revolution—two key events, certainly, for any history of circulation.

The American Revolution and the transatlantic traffic of memorial or civic art it generated is a classic as well as a new field for studying circulation in American art, which has recently followed the "Atlantic turn" of political and cultural history.[38] Our volume opens with the essay by J. M. Mancini, entitled "American Art's Dark Matter," which takes up our concern with the economy of reproduction and recirculation by tracking visual histories of the American Revolution over a period of more than a century, through the comparison of a 1783 French collection of engravings to a landmark illustrated text of American history from 1898. Mancini sets out to uncover processes of forgetting and suppression—concerning particularly the role of Spain and its imperial aspirations, more generally the "clash of empires," in the Revolutionary sequence. These processes must be considered against the better-known phenomena of visual circulation and their effects of repetition and concentration. Circulation works "negatively" as well as "positively"; besides the more direct procedures of iconoclasm, destruction, and censorship, the repetition and concentration resulting from repeated selective circulation of landmark episodes and their illustrations end up producing what Mancini calls "uncirculation" (i.e., willful or at least "not-random" noncirculation) of other episodes and images—in this case in the service of nationalist or imperialist narratives. Independently of its specific argument, this essay fittingly introduces our perspective by addressing circulation jointly with recirculation and noncirculation, and aligning these complex processes with the history of reproduction and illustration.

Stimulating links are thus established with the next contribution, Thierry Gervais's essay, "Shifting Images," a synthetic history of American news photography between the Civil War and World War II. The essay's first focus is on the little-known early development of photojournalism during the imperial wars of the turn of the twentieth century (especially the Russo-Japanese War of 1904), revealing how the categories of "art" and "history" were fused in the illustration of current events. Like treatments of the Spanish-American War by both press illustrators and more-famous artists, illustrations of the "new" wars incorporated overt and covert reminiscences of earlier wars and their images. Gervais's larger emphasis is on a history of press illustration as art, rather than mere circulation of photographic records or reproductions. This approach leads to a valuable description of the several layers of circulation that align the history of news illustration with a history of art envisioned, in a roughly Panofskian model, as a history of migrations and mutations: the movement of images between different media, and the ways in which processing and reprocessing photographs transform them into artificial, artful, and artistic pictures; the movement of published images between different publications, which also demonstrates the interplay of the professional cultures of picture editors, designers, and publishers with those of photographers; and the movement of picture makers, designers, and even publishers between different national and professional contexts. In so doing, the essay also significantly renovates a history that has often been approached in strictly American and strictly photographic terms, focusing excessively on the single story of *Life* magazine.

The turn of the twentieth century, and a certain Henry Adams–like anxiety over the course of American history, again form the backdrop of our third contribution, which is also our case study, placed at the center of this volume for both chronological and substantive reasons. Hélène Valance's essay on Whistler's *Portrait of the Artist's Mother* takes us through a long history of the painting's life, extending from 1871 to the present day, to show in some detail how inseparable the meaning (or, one might say, the proper iconological reading) of James McNeill Whistler's most famous picture — perhaps the most famous pre-1900 American painting in France — is from the rich and contradictory history of its circulations, recirculations, and noncirculations. Valance gives a glimpse of today's culture industry of digital spoofs of this and other "icons" of American painting, which serves as a token example of digital circulation. But the story of Whistler's painting is also an illustration of a larger effect, which one might call

"felicitous miscommunication," and which, like Roberts's "mistransmission," has been a significant part of the history of American art. In Valance's title, the phrase "rematriating Whistler" strikingly encapsulates a process of "miscommunication" that is not only international, but manifold, and not the result of any one critic's particular mistake, but rather the reflection of Whistler's own effort at multiplying the picture's meanings through its circulation. The essay's task is not to reveal Whistler's "true" artistic intention, or his "true" relationship to his mother, but rather to demonstrate how the artist exploited the combined circumstances of the painting's genesis and his situation in Paris to serve an unambiguous ambition of *circulating* this picture, with its ostensible iconography of filial piety, as a statement of modern art.

A partially similar method, aimed at characterizing international circulation as the source of a transnational American art, is taken up in Tom Gunning's essay, which asks humorously, "Did the French invent the American cinema?" It is important to remember here, as Gunning does in his introduction, that early cinema emblematized the twentieth-century version of "connecting" or "circulating" pictures, not only because, like lithographs and stereographs in the nineteenth, its industrial base used mass production technology to distribute similar images everywhere, but because these were moving images, which, more efficiently than the colors of lithographs or the 3-D effect of stereographs, maximized the illusion of transporting "life" into a picture. Gunning's main point, however, is more about felicitous miscommunication than about illusionism. The essay takes up the well-known "international" story of the beginnings of cinema to probe patterns of exchange and interpenetration between not only competing technological models of moviemaking and movie viewing, but also cultural and critical approaches of what constituted cinema as art, primarily in somewhat-forgotten French texts of the pre–World War II period and then in the better-known context of the *Nouvelle Vague*. Again, however, the transnational construction of American art is only part of the story; what is observable here is not just the critical hybridization of national characters—for instance, the encounter of a certain highbrow, snobbish French taste with the display of raw virility in American westerns—but another example of how American pictures were transformed into American art by virtue of being circulated outside their explicitly intended audiences.

Finally, Frank Mehring's essay, "How Silhouettes Became 'Black,'" brings the same methodology to perhaps maximal expansion, spatially and chronologically as well as theoretically. The essay retraces the

complex and largely unexplored ways in which the eighteenth-century art of the silhouette, a typically white "bourgeois" mode of imaging the self, later applied to racialist stereotyping, "became 'black'" in the context of the Harlem Renaissance—again, through a dense network of international transactions that need to be viewed as willful recirculations, or decontextualizations—to serve later, in the language of Apple products, as the depoliticized surrogate for a fantasized universal code of communication. With this dense narrative of what is actually a very large history, Mehring brings together many of the shared concerns of our volume. As an image traced, so to speak, by its subject, the silhouette is a modern echo of myths of the invention of picturing as a double process of transfer of "life" into "art" and dissemination of images in society. As a pervasive mechanism of imagery of European bourgeois selfhood, converted into a visual trope of racial typology and then reappropriated by African American and Africanist artists in the service of a generalized "positive" image of blackness, the silhouette emblematizes the ways in which processes of circulation and recirculation tend to deindividualize particular pictures and specific historical moments of picturing (picturing identity, especially) to produce, eventually, the kind of catchall, empty symbolic forms exemplified by the iPod ads and, more generally, by Internet memes.

As this brief summary confirms, the range of topics covered in this volume is all too limited. Our hope, of course, is that our choices may stimulate further discussion. For this purpose perhaps it is not idle to rephrase, in closing, some of our main shared ideas. First, as far as spatial circulation is considered, this volume repeatedly addresses the transatlantic conversation that has long stood as a pillar of American art history. While it also seeks to reckon with other histories, as well as reversals, digressions, and various material patterns of mobility, above all this volume aims at redirecting this transatlantic conversation toward other horizons than the Americanness of American art, by positing circulation not as a factor of, or hindrance to, artistic identity (or nationality) but as a general condition of the making of American art. It is well known by now that intercultural circulations opened American art to transcultural constructions. What emerges from this collection of essays is that the logic of circulation marginalizes the notion of identity because it exceeds the transit of representations, and especially representations of identity, national or other. Turning to Jacques Rancière's work, we might propose that circulation works toward what he calls a generalized "aesthetic regime": in a nutshell, a regime where anything and everything can be or

become art—especially by being circulated out of its "native" context, and in which American art has perhaps better and more constantly succeeded than European art of the same period.

By the same token, it is clear that circulation exceeds the spatial dimension and requires diachronic perspectives. Our volume charts some examples of the unpredictable trajectories of recycling, derivation, and re-mediation that accompany or directly ensue from circulation. In so doing, it combines the two paths of analysis I called pictorial and a-pictorial. Indeed, in this volume, artworks are often approached as archival and communicational objects, composite image-texts, generic images, and even ideas of images, as much as singular, specific "picturings." Several of the essays scrutinize the productivity of these archival or ideal objects, pictures and texts intertwined, in patterns of reception and appreciation but also in the processes of making art. And here lies the great benefit, as well as the greatest risk, of instating circulation as a critical category: because the analysis of circulation constantly and necessarily exceeds the description of material, spatial movements, or transmissions of singular images, circulation stands to become, ultimately, another name for history. Such a generalized and dematerialized view of history is perhaps what the digital culture of seemingly total, immediate circulation in a website gallery invites everyone to embrace. It is not, probably, one that most art historians would readily accept.

This is why in closing it is useful to recall our insistence on the "negative" histories of circulation. For every object that circulates, how many don't? For every picture that appears, how many disappear? For every archive that is digitized, how many are destroyed? Ultimately, if, as we suggest, circulation has been a shaping factor of American art, to what extent have noncirculations, absences, invisibilities, negations, and destructions also been determining factors in its history? To what extent, then, is it true that what has not been circulated has not been represented, or made into art for that matter? In the age of the Internet and the digital image, this is certainly a relevant question, as students, if not scholars themselves, work under the fantasy that every picture that exists must exist online and the parallel fallacy that what is not visible online does not exist. May this volume offer a reminder of the allied modes of presence and absence, speech and silence, visibility and invisibility, and, against the fallacy of a totally and definitely visible history, a reminder of the visual historian's task to constantly contest and renovate received "galleries" by circulating or recirculating what has not, or not sufficiently, been circulated before.

This essay was nourished by my conversations with the contributors to this volume, especially during a seminar at Université Paris Diderot in 2014–2015. I acknowledge the valuable input of the anonymous reviewers and that of Rachael DeLue, series editor.

1 See Hollis Clayson, "Circulation," in *Is Paris Still the Capital of the Nineteenth Century? Essays on Art and Modernity, 1850–1900*, ed. Clayson and André Dombrowski (New York: Routledge, 2016), 189–93.

2 See *Oxford English Dictionary*, s.v. "circulation" (2009 draft additions especially), for the analysis of the phrases "in circulation" and "out of circulation." The word originated in the sixteenth century in the sense of "circular motion" or "rotation" before acquiring that of "distillation" of liquids and that of "circuit of the blood" in the seventeenth century and the modern sense of "transmission" in the nineteenth century.

3 W. J. T. Mitchell, *What Do Pictures Want? The Lives and Loves of Images* (Chicago: Chicago University Press, 2006).

4 Arjun Appadurai, ed., *The Social Life of Things: Commodities in Cultural Perspective* (London: Cambridge University Press, 1986).

5 Rachael Z. DeLue, introduction to *Picturing*, ed. DeLue, Terra Foundation Essays (Chicago: Terra Foundation for American Art, 2016), esp. 21–23.

6 See Linda J. Docherty, "Original Copies: Gilbert Stuart's Companion Portraits of Thomas Jefferson and James Madison," *American Art* 22, 2 (Summer 2008): 85–97, esp. 88–89.

7 On a generalized economics of "exchange" as a paradigm for the analysis of cultural modernity, see Stephen Greenblatt, ed., *Cultural Mobility: A Manifesto* (Cambridge: Cambridge University Press, 2009).

8 For a definition of visual culture as a primarily sociopolitical field of meaning production, see Nicholas Mirzoeff, *An Introduction to Visual Culture*, 2nd ed. (London: Routledge, 2009). DeLue argues for a more inclusive approach in the introduction to *Picturing*, 23–25.

9 See Rosalind Krauss, *The Originality of the Avant-Garde and Other Modernist Myths* (Cambridge: MIT Press, 1985); T. J. Clark, *Farewell to an Idea: Episodes from a History of Modernism* (New Haven, CT: Yale University Press, 1999); and Michael Leja, *Reframing Abstract Expressionism: Subjectivity and Painting in the 1940s* (New Haven, CT: Yale University Press, 1997). In an echo to Michael Leja's exploration of Abstract Expressionism as an artistic form resonant with mainstream cultural expressions, Jacques Rancière, in *Aisthesis: Scenes from the Aesthetic Regime of Art* (2011), trans. Zakir Paul (New York: Verso, 2013), traces a long history of modernism as seeking the fusion of art and life, against the vision of modernism as an elitist, separatist artistic culture.

10 Clement Greenberg, "Avant-Garde and Kitsch," in *Art and Culture: Critical Essays* (Boston: Beacon Press, 1971), 5, 6, 9, 12.

11 Erwin Panofsky, *Studies in Iconology: Humanistic Themes in the Art of the Renaissance* (1939; New York: Harper & Row, 1972), 12–14, 70–71, 69.

12 Theodor Adorno and Max Horkheimer, *Dialectic of Enlightenment: Philosophical Fragments* (1944), ed. Gunzelin Schmid Noerr, trans. Edmund Jephcott (Stanford, CA: Stanford University Press, 2007).

13 Wanda Corn, *The Great American Thing: Modern Art and National Identity, 1915–1935* (Berkeley: University of California Press, 2001).

14 William Dunlap, *History of the Rise and Progress of the Arts of Design in the United States*, new ed. (Boston: C. E. Goodspeed, 1918), 1.

15 Neil Harris, *The Artist in American Society: The Formative Years* (1966; Chicago: University of Chicago Press, 1978), 56–89.

16 James T. Flexner, *History of American Painting*, vol. 3, *That Wilder Image: The Native School from Thomas Cole to Winslow Homer* (1962; New York: Dover, 1978). See my extended commentary in "Toward a Transcultural History of American Landscape Images in the Nineteenth Century," in *A Seamless Web: Transatlantic Art in the Nineteenth Century*, ed. Cheryll L. May and Marian Wardle (Newcastle upon Tyne, UK: Cambridge Scholars Publishing, 2014), 3–10.

17 Flexner, *That Wilder Image*, xii–xiv.

18 Angela Miller, *The Empire of the Eye: Landscape Representation and American Cultural Politics, 1825–1875* (Ithaca, NY: Cornell University Press, 1993); Alan Wallach, *Thomas Cole: Landscape into History* (New Haven, CT: Yale University Press, 1994); Andrew Wilton and Tim

Barringer, eds., *American Sublime: Landscape Painting in the United States 1820–1880* (Princeton, NJ: Princeton University Press, 2002).

19 See Barbara S. Groseclose and Jochen Wierich, *Internationalizing the History of American Art: Views* (Philadelphia: Penn State University Press, 2009), esp. 6–7.

20 See the following major surveys: Frances Pohl, *Framing America: A Social History of American Art*, 3rd ed. (London: Thames & Hudson, 2012); David Bjelajac, *American Art: A Cultural History*, 2nd ed. (London: Pearson, 2004); and, more crucially, Angela L. Miller, Janet C. Berlo, Bryan Wolf, Jennifer L. Roberts, eds., *American Encounters, Art, History, and Cultural Identity* (Upper Saddle River, NJ: Pearson-Prentice Hall, 2008).

21 See especially Miller et al., *American Encounters*; and, for a larger framework of transnational studies, Chiara de Cesari and Ann Rigney, eds., *Transnational Memory: Circulation, Articulation, Scales* (Berlin: De Gruyter, 2014).

22 Jennifer Roberts, *Transporting Visions: The Movement of Images in Early America* (Berkeley: University of California Press, 2014), 1–2, 17, 49.

23 Ibid., 2–4. Roberts explains her debt to the various poststructuralist critiques of transparency (pp. 9–10 and notes).

24 Oliver W. Holmes, "The Stereoscope and the Stereograph," *Atlantic Monthly* 3, 20 (1859): 746–48.

25 See Leo Marx, *The Machine in the Garden: Technology and the Pastoral Ideal in America* (Oxford: Oxford University Press, 1964), 194.

26 Although there is still no comprehensive study of this vast corpus as a whole, useful approaches to several aspects of it are found in Edward C. Carter III, ed., *Survey-ing the Record: North American Scientific Exploration to 1930*, Memoirs of the American Philosophical Society (Philadelphia: American Philosophical Society, 1999).

27 See Weston Naef, ed., *Era of Exploration: The Rise of Landscape Photography in the American West* (New York: Metropolitan, 1975).

28 Jennifer Tucker, "How Well Do Photographs Travel? Some Reflections on Photographs as Moving Images" (keynote address, "Exchanging Photographs, Making Knowledge," De Montfort University, June 21, 2014).

29 Michael D. Schroeder and J. Gray Sweeney, *Gilbert Munger: Quest for Distinction* (Afton, MN: Afton Historical Society Press, 2003).

30 François Brunet, "Showing American Geography Abroad in the Victorian Era: The International Reception of the King Survey Work," in *Timothy H. O'Sullivan: The King Survey Photographs*, ed. Keith Davis and Jane Aspinwall (Kansas City, MO: Hall Family Foundation/Yale University Press, 2011), 185–93, and references cited therein. See also Carol M. Johnson, "Through Magic Lenses: Timothy H. O'Sullivan's Stereographs from the King and Wheeler Surveys," in *Framing the West: The Survey Photographs of Timothy H. O'Sullivan*, ed. Toby Jurovics (New Haven, CT: Yale University Press/Smithsonian Institution, 2010), 161–73.

31 The section that follows borrows, in revised form, from my essay cited above, "Toward a Transcultural History of American Landscape," 10–20.

32 Alan Trachtenberg, "Naming the View," in *Reading American Photographs: Images as History, Mathew Brady to Walker Evans* (New York: Hill & Wang, 1989), 119–64.

33 Martha Sandweiss, *Print the Legend: Photography and the American West* (New Haven, CT: Yale University Press, 2002).

34 Clarence King, *Systematic Geology*, 644, quoted in Toby Jurovics, "Framing the West," in Jurovics, *Framing the West*, 225n33.

35 Roberts, *Transporting Visions*, 11.

36 See especially Mark Klett et al., *Third Views, Second Sights: A Rephotographic Survey of the American West* (Albuquerque: Museum of New Mexico Press, 2004).

37 On lynching photographs and their "re-mediation," see Ken Gonzales-Day, *Lynching in the West, 1850–1935* (Durham, NC: Duke University Press, 2006); and the artist's projects, "Hang Trees" and "Erased Lynchings."

38 See "Objects in Motion: Art and Material Culture across Colonial North America," ed. Wendy Bellion and Mónica Domínguez Torres, special issue, *Winterthur Portfolio* 45, 2/3 (Summer/Autumn 2011), esp. the editors' introduction.

AMERICAN ART'S

J. M. Mancini

American Art's Dark Matter: *A History of Uncirculation from Revolution to Empire*

Shortly after the American Revolution, the engraver to the Comte d'Artois, Nicolas Ponce (1746–1831), and the royal engraver François Godefroy (1743–1819) published the *Recueil d'estampes représentant les différents événemens [sic] de la guerre, qui a procuré l'indépendance aux États Unis de l'Amérique* (Paris, ca. 1783–1784; hereafter *Collection of Engravings*). This was the first circulating visual history of the war and the peace produced in France—and possibly anywhere—and one that aimed at a comprehensive presentation of its subject. This is attested to by its inclusion of sixteen plates depicting important episodes and actors in the conflict, maps of significant sites, and summaries of the war and the peace, as well as by the approach taken within the individual plates. The plates combined images with dense text panels, and in some cases, they employed a crammed, composite treatment that juxtaposed multiple vignettes of the war's disparate events within a single busy page (fig. 1).

Despite its synthetic approach and its historical proximity to the American Revolution, however, the *Collection of Engravings* would likely strike present-day viewers as puzzling, even illegible. For example, viewers might reasonably expect the volume's geography of war and peace to center on the thirteen colonies that waged war for their independence. Yet this was not its geographical focus. Rather, fully half the plates in the *Collection of Engravings* represented scenes from events in places that most present-day American viewers would not

Nicolas Ponce and
François Godefroy,
"Précis de cette guerre"
(detail, see fig 4).

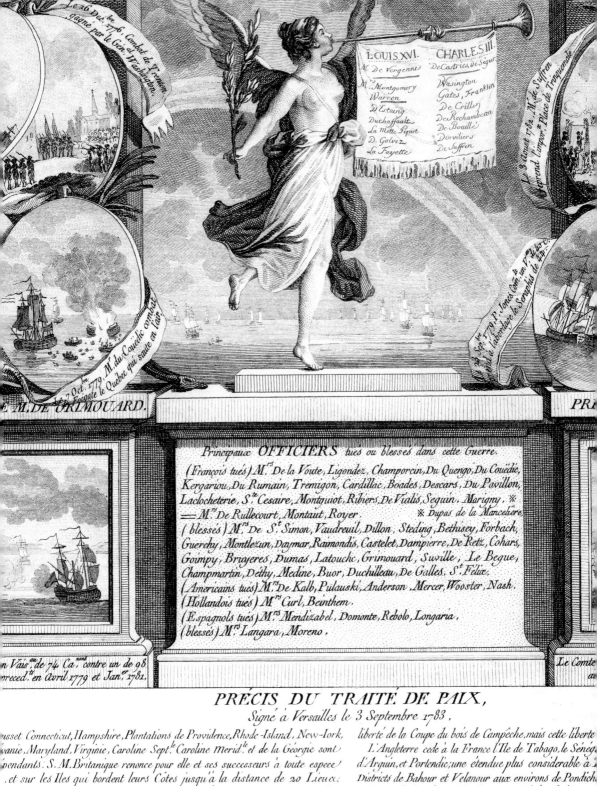

Le 26 Dbre 1776, Combat de Trenton gagné par le Gen.al Washington.

Le 7 Oct.re 1779, M. du Couëdic combat la frégate le Quebec qui saute en l'air.

M. DE GRIMOUARD.

Le 3 Aout 1782, M. de Suffren reprend Trinquemale. Place de Trinquemale.

Le 23 Sep.re 1779, P. Jones Com.t un V.au à la labourdonaie, de Seraphis de 44 C.

PRI...

LOUIS XVI. / **CHARLES III.**

LOUIS XVI.	CHARLES III.
M. De Vergennes	De Castries, de Segur
M. Montgomery	Wasington
Warren	Gates, Franklin
D'Estaing	De Crillon
Duchaffault	De Rochambeau
La Motte Piquet	De Bouillé
D. Galvez	Dorvilliers
La Fayette	De Suffren

Principaux OFFICIERS tués ou blessés dans cette Guerre.

(François tués) M.rs De la Voute, Ligondez, Champorcin, Du Quengo, Du Couëdic,
Kergariou, Du Rumain, Tremigon, Cardillac, Boades, Descars, Du Pavillon,
Laclocheterie, S.te Cesaire, Montquiot, Ribiers, De Vialis, Seguin, Marigny. ※
= M.rs De Rullecourt, Montaut, Royer. ※ Dupas de la Mancelière.
(blessés) M.rs De S.t Simon, Vaudreuil, Dillon, Steding, Bethisey, Forbach,
Guerchy, Montlezun, Daymar, Raimondis, Castelet, Dampierre, De Retz, Cohars,
Goimpy, Bruyeres, Dumas, Latouche, Grimouard, Suville, Le Begue,
Champmartin, Dethy, Medine, Buor, Duchilleau, De Galles, S.t Félix.
(Americains tués) M.rs De Kalb, Pulauski, Anderson, Mercer, Wooster, Nash,
(Hollandois tués) M.rs Curl, Beinthem.
(Espagnols tués) M.rs Mendizabel, Domonte, Rebolo, Longaria,
(blessés) M.rs Langara, Moreno.

...n Vais.au de 74 Ca.nons contre un de 98
...preced.t en Avril 1779 et Jan.er 1781.

Le Comte...

PRÉCIS DU TRAITÉ DE PAIX,
Signé à Versailles le 3 Septembre 1783.

...usset Connecticut, Hampshire, Plantations de Providence, Rhode-Iork, New-Iork,
...vanie, Maryland, Virginie, Caroline Sept.le Caroline Merid.le et de la Géorgie sont
...pendants. S. M. Britanique renonce pour elle et ses successeurs à toute espece
...et sur les Iles qui bordent leurs Côtes jusqu'à la distance de 20 Lieues,
...epublique sont fixées, au Nord, par la Riviere S.te Croix et par une ligne tirée
...lui des Bois, à l'Ouest, par le Fleuve Missisipi; au Sud par les Florides aux -
...la Riviere Marys, et le 31.me degré de Latitude; et à l'Est par la mer.
...gne l'Ile Minorque, la Floride Orient.le et la Floride Occid.le. Elle conserve la

liberté de la Coupe du bois de Campêche, mais cette liberté
L'Angleterre cede à la France l'Ile de Tabago, le Sénégal,
d'Arguin, et Portendic; une étendue plus considérable à
Districts de Bahour et Velanour aux environs de Pondich...
Elle annulle les clauses des derniers Traités relatives aux
et aux Garnisons des Iles S.t Pierre et Miquelon.
La Hollande cede à l'Angleterre la Ville de Négapat...
Restitution mutuelle entre les Puissances belligérantes.

TABLE DES ESTAMPES QUI COMPOSENT CETTE SUITE

even associate with the Revolution: for example, St. Kitts, Pensacola, Senegal, and Minorca. In contrast, the volume presented only four plates that depicted episodes taking place within the thirteen colonies (namely, at Boston, Lexington, Saratoga, and Yorktown, the setting for the surrender of Cornwallis); it also contained a "carte des États Unis." Moreover, the single Boston plate, Godefroy's "John Malcom" (see fig. 9)—whose subject was the punishment of customs official John Malcom (sometimes Malcolm or Malcomb) by a Revolutionary mob—was unrepresentative of most American images. Although two mezzotints of this event (see figs. 10 and 11) did precede Godefroy's treatment of it, neither had been made in America but originated in England instead, where they were published by the well-known London printers Carington Bowles (1724–1793) and Robert Sayer (1725–1794).

The introduction to this volume ends with a complex, multipart question about circulation:

> *For every object that circulates, how many don't?*
> *For every picture that appears, how many disappear?*
> *For every archive that is digitized, how many are destroyed?*
> *Ultimately, if, as we suggest, circulation has been a*
> *shaping factor of American art, to what extent have*
> *noncirculations, absences, invisibilities, negations, and*
> *destructions also been determining factors in its history?*
> *To what extent, then, is it true that what has not been*
> *circulated has not been represented, or made into art for*
> *that matter?*

These are difficult questions to answer. How might we account, in a general sense, for the essential *unevenness* of circulation, copying, and related processes of forward articulation—the relentless repetition of certain objects and subjects but the apparent vanishing of others? What methodology might be pursued to trace the history of an "object," "picture," or "archive" that has been negated? And what name might be used to describe this process of negation—a term which, perhaps too strongly, implies conscious suppression—or noncirculation, which implies, again perhaps too strongly, that the process by which images are not circulated is a random one?

These are difficult questions, but important ones nonetheless. Thus, in this essay, I propose, as a counterpart but also as a companion to the many works that study the lives of images that have been

1
Nicolas Ponce and François Godefroy, "Précis de cette guerre," from *Recueil d'estampes représentant les différents événemens [sic] de la guerre, qui a procuré l'indépendance aux États Unis de l'Amérique* (Paris, ca. 1783–1784). Etching and engraving, 7 ⅜ × 8 ¼ in. (18.8 × 21 cm). Rare Book Division, Department of Rare Books and Special Collections, Princeton University Library, New Jersey, (Ex) 1081.752.

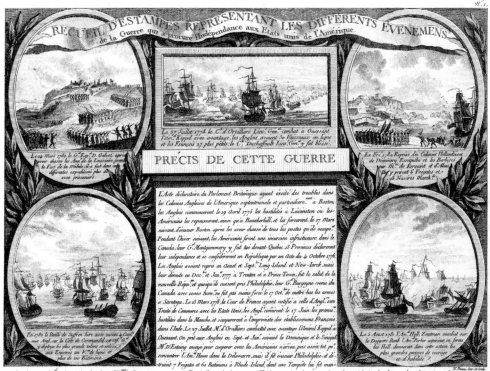

circulated, a tentative case study of Ponce and Godefroy's *Collection of Engravings* as an object—as an archive of images—that may be seen to be subject to *uncirculation*, a term I have chosen to reflect the not-quite-suppressive but not-quite-random quality of the process by which images cease to have purchase on later viewers and makers (or by which they may cease to exist). I have selected this example for two reasons. The first is the immediate contrast between the unrecogniz-ability of Ponce and Godefroy's imagery—a sure sign of its lack of purchase within subsequent visual culture—and the extreme familiar-ity of other images and objects with a Revolutionary provenance. That is to say, the American Revolution is, at once, an event that generated visual images that virtually define circulation—it would be impossible

to catalogue, for instance, the number of reproductions of Paul Revere's *Bloody Massacre in King-Street*—and an event that itself is known through its imagery. Thus, the circulation of Revere's print is a cardinal source of our knowledge that Boston was at the center of the conflict, and it also informs us of what kind of conflict the Revolution was: an anticolonial struggle against a monarchical master whose soldiers fired into the Boston crowd.

The second reason for choosing Ponce and Godefroy—and the Revolution—is precisely because the Revolution's importance and its distance from the present allow for reflection on the longevity and contingency of both circulation and uncirculation as historical processes. The forward articulation of the Revolution as a visual or material-cultural phenomenon is something that continues even today, and whose past contours—whose ebbs and flows, whose negations and promulgations—cannot be separated from the stream of history within which each of the actors who circulated or "uncirculated" (as I express it) a particular vision of the Revolution made his or her choices. Hence, this essay has more to say about certain moments in the past when Americans were especially inclined to use circulation and uncirculation as methodologies for articulating their own self-conscious identity with the Revolution (e.g., during periods of conflict, including the Civil War and the period of imperial conquest in the 1890s). And although I pay some attention to particular methodologies or techniques of circulation or uncirculation, I am more interested in exploring the intersections between the processes of circulation and the processes of history than in providing a history of circulation per se.

Such a distinction is important, because one risk of elevating circulation (or rather the history of circulation) as a subject of study is technological determinism. Consider the example, invoked in the introduction, of Clement Greenberg's account of the sinister spread of kitsch, which casts the emergence of late nineteenth and early twentieth-century print technologies as "wiping out folk culture" with "magazine covers, rotogravure sections and calendar girls."[1] As François Brunet notes, "Greenberg's conception is critical rather than historical," but it still has purchase among those who would view each new visual technology as the harbinger of a wholly new era of circulation—and the death knell of some prelapsarian age. In contrast, I take my cues from recent scholarship in early American art, whose investigations make it abundantly clear that a world unconditioned by circulation never existed in the United States or its precursor colonies—and that in order to understand circulation, it is as important to untangle

2
Nicolas Ponce after Lausan, "Prise de Pensacola," from *Recueil d'estampes*... (Paris, ca. 1783–1784). Etching and engraving, 7 ⅛ × 7 1 ⁵⁄₁₆ in. (18.1 × 20.2 cm). Rare Book Division, Department of Rare Books and Special Collections, Princeton University Library, New Jersey, (Ex) 1081.752.

the mechanisms of historical processes, such as the workings of empire, as it is to explain the impact of a specific technology.[2]

The War of Independence according to Ponce and Godefroy

Let us turn now to Ponce and Godefroy's *Collection of Engravings* to see the view of the American Revolution it attempted to circulate. Unlike many if not most representations of the American Revolution, past and present, which conceptualize the war as solely an anticolonial struggle for sovereignty between an incipient, revolutionary, protostate and its monarchical master, the *Collection of Engravings* emphasized another side of the War of Independence: that is, its dual status as, on the one hand, a revolutionary insurgency fought between the thirteen colonies and Britain, and, on the other, an interimperial war for global

PRISE DE PENSACOLA.

American Art's Dark Matter

supremacy among Britain, France, and Spain (and, to a lesser extent, the Dutch), which may have been occasioned by the insurgency in the thirteen colonies and certainly affected the outcome of that insurgency, but whose origins also lay in the prior history of global geopolitics and global conflict.

The *Collection of Engravings'* emphasis on the Revolution as interimperial war may be seen from its geographical orientation. As has been suggested, the volume's geographical focus cannot be said to lie within the thirteen colonies, as fully half the sixteen plates represented actions undertaken by France (which recognized the colonies' independence in 1778) and/or Spain (which joined the war as a cobelligerent to France in 1779, and which, like France, provided the insurgency with significant logistical and material assistance even before declaring war) in places within the British empire but outside the thirteen colonies. Examples include Godefroy's "Prise de la Dominique," depicting the French forces mounting the walls of the British fort on Dominica; Ponce's "Prise du Sénégal," depicting the French recapture of the Fort of Saint-Louis, which had been taken by British forces during the Seven Years' War (1754–1763); and the "Prise de Pensacola," showing the recapture, on May 9, 1781, of the capital of West Florida (a Spanish colony ceded to Britain by treaty as a result of the Seven Years' War) by the forces of Don Bernardo de Gálvez (fig. 2). Yet another image anthologized, in the form of a composite map, concessions made by England to France and Spain in the 1783 treaty (fig. 3). Moreover, the first and last plates, summarizing the war and the peace, presented smaller vignettes of subjects, such as action off the Coromandel Coast (see fig. 1), that again prioritized the war's global aspect.

The *Collection of Engravings* also emphasized the interimperial side of the War of Independence in its treatment of historical issues. In particular, the accompanying texts interpreted the Bourbon interventions against the British as an episode within a long-running rivalry between the European empires, and emphasized how the War of Independence was a corrective to the cataclysmic Seven Years' War. For example, the text to the "Prise de Pensacola" (Taking of Pensacola) noted, "This Place and the 2 Provinces of Florida were ceded to Spain in the Peace of 1783. These were very precious possessions to the English for the illicit Trade that they made with New Spain, and might through their likely yields, have replaced in part the void that the loss of Colonies of North America has made this Power feel."[3] Similarly, the composite map depicting the treaty concessions (see

CARTES PARTICULIERES
Des Concessions faites par l'Angleterre à la France et à l'Espagne par le Traité de 1783.

Le Sénégal qui avoit été conquis par l'Angleterre dans la guerre de 1756, étoit resté à cette Puissance par la Paix de 1763. Les objets de commerce qu'on tire de cette vaste contrée, l'ivoire, la gomme, la Poudre d'or &c. rendent sa possession très utile à la France qui voit encore augmenter sa richesse par l'exportation des Negres qui fertilisent ses Isles à sucre, et dont une partie est tirée de ce Pays.
Tabago placé comme la Barbade au Vent des autres Antilles, disputé longtems, ensuite neutre, et puis cédé à l'Angleterre par la Paix de 1763, assure à la France, par sa position, un lieu de relâche très commode pour ses vaisseaux et une communication entre la Guyanne et ses Isles de l'Amerique, son terroir très fertile produit beaucoup de Coton et est encore susceptible de nouveaux défrichemens: La sureté de ses ports où les gros Vaisseaux sont à l'abri des ouragans furieux qui désolent les Antilles, 3 mois de l'année, rendent sa possession infiniment précieuse.
Depuis la conclusion de la paix, on a reçu des nouvelles de l'Inde: Mr. de Suffren a livré un 6e. Combat le 20 Juin 1783, à la hauteur de Goudelour, dans lequel il a eu l'avantage, quoiqu'il n'eut que 15 Vaisseaux contre 18. Cet Officier, parti Capitaine de Vaisseau en 1781; a été fait Vice-Amiral, et Chr. des Ordres du Roy en 1784. Mr. de Bussy commandoit les troupes de terre s'est aussi fort distingué dans un Combat donné sous Goudelour le 13 Juin, contre une armée trois fois plus forte que la sienne.

les deux Florides avoient été cédées à l'Angleterre, à la Paix de 1763, en échange de l'Isle de Cuba dont cette puissance venoit de faire la conquête. Cette perte étoit d'autant plus sensible pour l'Espagne qu'elle mettoit à découvert ses plus riches Colonies d'Amérique, en donnant à sa rivale des ports dans le fond du Golphe de Méxique qui facilitoient une Contrebande très préjudicable à ses intérêts.
L'Isle Minorque, dont l'Angleterre avoit fait la conquête en 1708, avoit été cédée à cette Puissance par le Traité d'Utrecht: En tems de guerre, elle y entretenoit une flotte considerable qui hivernoit à Port Mahon; Cette position donnoit à cette Nation la plus grande influence sur les affaires d'Italie, comme on l'a vu dans la guerre de 1746. Par cette perte, la prépondérance que les Anglois avoient dans le Levant est détruite; Gibraltar devient un fardeau inutile pour eux, et le commerce qu'ils peuvent encore faire dans la Méditerranée devient fort précaire.

A.P.D.R.
A Paris chez M. Ponce, Graveur de Mgr. Comte d'Artois, rue St. Hyacinthe No. 19. et chez M. Godefroy, rue des Francs Bourgeois porte S. Michel.

fig. 3) reiterated the Pensacola image's claims about the significance of the Floridas as hubs for a contraband trade that caused a systematic disturbance to Spain's interest, and reminded viewers that this disturbance had originated in the 1763 settlement to the Seven Years' War. The loss of the Floridas, according to the text, "was particularly sensitive to Spain because it exposed her richest American colonies by giving her rival ports in the bottom of the Gulf of Mexico that facilitated a Contraband that was very prejudicial to her interests."

Within this framework, the *Collection of Engravings* also presented a vision of the relationships between France and Spain and between the two intervening powers and the revolutionaries. Here,

the volume treated this relationship as one of amity, and more specifically as amity that has been sealed in the sacrifice of death. For example, the final plate, the "Précis du traité de paix" (Summary of the peace treaty), features a central winged figure bearing an olive branch and trumpet (fig. 4). Beneath the trumpet, this figure unfurls a banner headed by the names of Louis XVI of France and Charles III of Spain. Below are inscribed the names of significant American, French, and Spanish figures, including two revolutionaries killed in the conflict, the Irish-born Richard Montgomery and the Roxbury-born Joseph Warren, as well as Washington, Franklin, Lafayette, and, just above Lafayette, Don Gálvez. This is most likely the aforementioned Bernardo de Gálvez: the Spanish governor of Louisiana and architect

of a series of political and military actions (including the taking of Pensacola) that prevented Britain from using the Gulf of Mexico or the Mississippi River as a back route to victory against the insurgency. But given the inclusion of the diplomat Franklin, the name might refer to Bernardo's uncle, José de Gálvez, a key adviser to Charles III.

In keeping with these emphases, Ponce and Godefroy also presented a particular interpretation of Spanish combatants in the War of Independence: one that cast them in heroic roles comparable to those of the sons of France and the sons of Liberty. Of particular note is the treatment of Gálvez, whose name, as noted, is inscribed on the banner of amity. His name and figure appear repeatedly in the volume. In the "Précis de cette guerre," he is the subject of a vignette depicting how "on the 14th of March 1780 the Spanish General Don Galvez, after having chased the English from Louisiana, takes the Fort of Mobile." And in the "Prise de Pensacola," Gálvez is the central figure in a chain of events that Ponce and Godefroy represent as a key loss to Britain in the conflict because it disrupted Britain's contraband trade.

The Story of the Revolution

The *Collection of Engravings* tells a number of stories about the Revolution that are largely illegible today: about the geography of the conflict, which places mattered in the eighteenth century, and even which events mattered within those places; about the key figures in the war and the peace; about the relationship of the War of Independence to prior conflicts; and even about the stakes and character of the war. All these stories have a basis in what we might call "historical fact." So how, then, might we account for the forgetting, or unmaking, or uncirculation, of the view of the Revolution embodied in the *Collection of Engravings*?

In any attempt at providing an account of "uncirculation," it is obviously difficult if not impossible to follow a conventional A-to-B narrative that shows how one particular view ceased to circulate. Rather, perhaps artificially, I have chosen to begin at the end of my story: with a work that, despite being similar to the *Collection of Engravings* in terms of its subject matter (the history of the Revolution) and form (an illustrated history or image archive), clearly rejected Ponce and Godefroy's view of the Revolution—*The Story of the Revolution* written in 1898 by Henry Cabot Lodge (1850–1924). Here my aim is to explore the contrasts between the two, but also to consider what was at stake in the circulation of a view of the Revolution that eclipsed Ponce and Godefroy's.[4]

4
Nicolas Ponce, "Précis du traité de paix," from *Recueil d'estampes . . .* (Paris, ca. 1783–1784). Etching and engraving, 7¼ × 8⅛ in. (18.4 × 20.6 cm). Rare Book Division, Department of Rare Books and Special Collections, Princeton University Library, New Jersey, (Ex) 1081.752.

I did not choose *The Story of the Revolution* at random, but rather because it encapsulates an "official" or "canonical" view of the Revolution circulated at the end of the nineteenth century. Lodge was, arguably, the most influential American author ever to assemble an illustrated history of the American Revolution. He was the first person granted a PhD from Harvard, and as such he represented the new wave of professional historians coming to influence in the United States in the last decades of the nineteenth century. Lodge was not only a charter-generation "professional" historian but also one of the most powerful political figures of his day. By the time he published *The Story of the Revolution*, he had been elected senator from Massachusetts: he was identified as such in the serialized version of the book published by *Scribner's Magazine*.[5]

Thus another reason for focusing on *The Story of the Revolution* is that it clearly was intended to circulate, not only among the readers

5
"The Old North," from Henry Cabot Lodge, *The Story of the Revolution* (New York: Charles Scribner's Sons, 1898), 1:31.

THE FIRST BLOW 31

Lexington, and that munitions of war were stored at Concord, a few miles farther on. It was thereupon determined to seize both the rebel leaders and the munitions at Concord. Other expeditions had failed. This one must succeed. All should be done in secret, and the advantage of a surprise was to be increased by the presence of an overwhelming force. The British commander managed well, but not quite well enough. It is difficult to keep military secrets in the midst of an attentive people, and by the people themselves the discovery was made. Paul Revere had some thirty mechanics organized to watch and report the movements of the British, and these men now became convinced that an expedition was on foot, and one of a serious character. The movement of troops and boats told the story to watchers, with keen eyes and ears, who believed that their r i g h t s were in peril. They were soon satisfied that the expedition was intended for Lexington a n d Concord, to scize the leaders and the stores; and acting promptly on this belief they gave notice to their chiefs in Boston and determined to

THE OLD NORTH

The Signal Lanterns of
PAUL REVERE
displayed in the Steeple of this church
April 18 1775
warned the country of the march
of the British troops to
LEXINGTON and CONCORD.

of the book itself, but also among other bodies of readers and live audiences. Thus, in addition to being published as a two-volume book (reprinted in 1903) and as a series of illustrated articles in *Scribner's Magazine*, it was circulated as a short picture book, as an exhibition held at the Art Institute of Chicago in April 1898 displaying work by Howard Pyle (1853–1911), Ernest Peixotto (1869–1940), F. C. Yohn (1875–1933), Harry Fenn (1837–1911), Carleton T. Chapman (1860–1925), and others, and as an exhibition catalogue published by Scribner's.[6]

To begin to compare Lodge's account of the Revolution to Ponce and Godefroy's, let us turn to the geography of the conflict as *The Story of the Revolution* visualized it. Not surprisingly, Lodge's version of the Revolution prominently featured Massachusetts. It had more than ten images of Lexington and Concord (including, in the latter case, Ernest Peixotto's engraving of the memorial sculpture *The Minute Man at Concord Bridge* by Daniel C. French [1850–1931], itself dedicated in 1875 on the centennial of the "shot heard round the world"), as well as a view of Boston's Old North Church and Cambridge's Washington Elm. These were further contextualized with textual elements: in the Old North image, a cartouche employing an authenticity-lending but well-obsolete long "s" (fig. 5); and in Peixotto's print of the Cambridge elm—a site that was, perhaps, less familiar to readers without Cambridge connections—a caption explaining, "In the background, enclosed by a fence and with a tablet marking it in front, is the historic tree under which Washington took command of the army."[7]

Massachusetts was the most commonly featured location in *The Story of the Revolution*, but the volume gave ample representation to the thirteen colonies as a whole. Indeed, in a post–Civil War context, Lodge seems to have been at pains to afford sufficient visual representation to the South. Hence the inclusion of some rather obscure sites: for example "The Home of Chancellor Wythe at Williamsburg, where Washington Stopped on His Way to the Siege of Yorktown." This postsectional emphasis is also reflected in the work's portraits, and more specifically in their titles: for example, "Peyton Randolph, of Virginia, the First President of the Continental Congress" and "Richard Henry Lee, of Virginia" (both after paintings by Charles Willson Peale [1741–1827]) in which Randolph and Lee are identified specifically as Virginians, while various figures from northern colonies are not.[8]

Lodge's geography also included some sites adjacent to the thirteen colonies, notably Quebec (in F. C. Yohn's "The Attack on

Quebec" and two drawings by Peixotto, "Cape Diamond" and the "Citadel and Tablet on the Rocks of Cape Diamond Bearing the Inscription 'Montgomery Fell, Dec'r 31, 1775'") and Falmouth, Nova Scotia (in Carleton T. Chapman's "The Destruction of Falmouth, Now the City of Portland, ME"). However, such representations were limited to continental locations adjacent to and north of the thirteen colonies. In striking contrast to the *Collection of Engravings*, *The Story of the Revolution*'s visual geography did not extend to the Caribbean, the Mediterranean, India, or Africa. Nor did Lodge include images from the Gulf Coast—despite the tumultuous presence of the conflict in the Floridas and Louisiana, and despite the fact that these contested places, like Falmouth, would eventually become part of the United States.[9]

A second set of comparisons may be drawn between the treatments Ponce and Godefroy's and Lodge's albums respectively gave of the war's personnel and the relationships among them. First, Lodge's cast of characters was larger than Ponce and Godefroy's. Indeed, it is bewildering in its scope, with portraits of more than two dozen military, political, and diplomatic personages, including George Washington, Thomas Jefferson, Paul Revere, John Jay, John Adams, Samuel Adams, "Joseph Warren, Killed at Bunker Hill,"[10] Thomas Paine, General Israel Putnam, General Nathaniel Greene, General Philip Schuyler, General Horatio Gates, Benjamin Franklin, Lafayette, Baron Steuben, Roger Sherman, Robert Morris, General John Stark, Colonel Daniel Boone, General George Rogers Clark, General Benjamin Lincoln, General Andrew Pickens, and General Daniel Morgan.

If Lodge's pantheon was larger than Ponce and Godefroy's, however, it was also more one-dimensional, with French figures limited to Lafayette, Rochambeau, and Vergennes, and with Gálvez and other Spaniards omitted entirely. Lodge's pantheon also visualized a different hierarchy from that depicted by Ponce and Godefroy. Although Ponce and Godefroy did present multiple visual references to some figures (Gálvez has already been given as an example), their volume's images are not organized in a way that clearly presents a single overall image (or its subject) as being more important than another. Moreover, the banner of amity in the "Précis du traité de paix," while placing Louis XVI and Charles III at the top, included Montgomery, Warren, Gates, Franklin, and Washington prominently among their French and Spanish peers. In contrast, Lodge's compendium chose an image of Washington as the frontispiece for each volume: for volume 1, an engraving after Gilbert Stuart's 1795 portrait; and for volume 2, Yohn's *Washington's Farewell to His Officers* (officers who, it should be

noted, are not identified by name in the caption). Further, Washington's image is duplicated to a degree that far exceeds any other figure, with the additional inclusion of, for example, an engraving after Charles Willson Peale's 1772 portrait, captioned "George Washington at the Age of Forty"; "Washington Taking Command of the Army"; and "Washington Showing the Camp at Cambridge to the Committee, Consisting of Franklin, Lynch, and Harrison, Appointed by Congress."[11]

Lodge's preference for American subjects is, perhaps, unsurprising, but it speaks to a deeper issue: the way that his compendium cast the relationships between Britain's three antagonists. Here, *The Story of the Revolution* diverged radically from the *Collection of Engravings*, for Lodge not only refused to see this relationship in terms of amity and shared death, but in the case of Spain, also cast it in terms of enmity. In order to analyze this, it is necessary to begin with Lodge's text rather than the images for a (seemingly) simple reason: Lodge did not include any images that referred specifically to the Anglo-Spanish seat of conflict or that depicted Spanish participants. In the text, Lodge did present some bare facts about Spain's role in the War of Independence: that Spain had, through the French foreign minister, the Comte de Vergennes, sent $200,000 in aid in 1776, and that it "was finally drawn into war against England" in 1779.[12] However, in general, he cast Spain in the role of an exceptional enemy to the United States. For example, Lodge generally emphasized, as important to victory, the success of American diplomacy in obtaining "if not actual support, at least a benevolent neutrality" on the part of the powers of Europe.[13] Yet, he refused to apply this general logic—that any power that refused to assist Britain assisted the revolutionaries—in Spain's case. Thus, he interpreted Spain's participation in the conflict as a cobelligerent against Britain—a stance that surpassed neutrality—in negative, rather than in positive, terms. He wrote, "One European power, however, showed itself distinctly hostile, and that was the very one upon which the Vergennes [*sic*] relied for support, and which was finally drawn into war against England. This was Spain, which showed an instinctive hatred of a people in arms fighting for their rights and independence. To Spain, decrepit and corrupt, the land of the Inquisition, and the owner of a vast and grossly misgoverned colonial empire, nothing but enmity was really possible toward revolted colonists fighting for independence, free alike in thought and religion and determined to govern themselves." And just in case any of his readers had missed this point, he reintroduced reminders of the Black Legend at various points in the text: for example, asserting that "Spain was corrupt, broken, rotten to

the core, merely hiding her decrepitude under the mask of an empire which had once been great. Dragged into the war by France, she had no love whatever for the Americans—desired only to prey upon them and gather in what she could from the wreck of the British Empire."[14] Missing from this was, to be sure, any actual analysis of the Spanish intervention: how it drained British resources away from the colonial front; the psychological effects of the loss of Pensacola, Mobile, and other Gulf posts; and, via Gálvez's securing of New Orleans, the blocking of British entry via the Mississippi into the backcountry.[15]

In this context, Lodge's noncirculation of images of Gálvez and the Gulf—his divergence from Ponce and Godefroy's approach— begins to look less simple, particularly if one considers *The Story of the Revolution* as not only an assortment of individual images with meanings and individual histories of circulation, but also a compendium whose collective form could be marshaled to impart its own lessons.

Some of these lessons surrounded the authority of the work. Consider the volume's tendency toward visual overkill in, for instance, the sheer number of images it presented (over one hundred), its extension of visual representation to fairly obscure (but American) sites and combatants, and its inclusion of numerous multiviews—images of the same site from different perspectives, or portraits of the same figure. All these visual tactics contributed to an overall argument about the work: that the visual account presented therein was comprehensive and thorough, and not selective or tendentious. Or consider the textual framing of the images—for example, the caption to the portrait of General John Sullivan: "From the original pencil-sketch made by John Trumbull, at Exeter, N. H., in 1790. Now published, for the first time, by the permission of his grandson, in whose possession the original now is."[16] In this brief but ingenious caption, Lodge conveyed the provenance and authenticity of his sources and the superiority and depth of his own research—not to mention his personal links to descendants of Revolutionary figures. What this implied, again, was that nothing important could be missing from his account.

Beyond bolstering his authority, Lodge's use of images taught more-subtle lessons about the nature of history, lessons that also arguably discouraged readers from thinking too deeply about what was missing from the album. Here, for instance, one might return to Lodge's liberal inclusion of *memorials* to the Revolution—that is, public sculptures and other works created after the fact—among images depicting the Revolution's contemporary people, places, and things: for example, maps and views of sites where important events took place, and facsimiles of

ık only of the firing at sun-
ı Lexington Green, and of
ight skirmish at the old
Bridge in Concord. We
:one to forget that apart
these two dramatic points
was a good deal of severe
ıg during that memorable
A column of regular Eng-
ɔops, at first 800, then 1,800
, had marched out to Con-
nd Lexington, and back to
ı, and had met some hun-
ɔf irregular soldiers, at best
. They retreated before
Minute Men for miles, and
d Boston in a state not far
ed from rout and panic.
ınning fight had not been
play by any means. The
cans lost 88 men killed
ounded ; the British 247,
ₛ 26 missing or prisoners.
were serious figures. Evi-
the British officers, who in the morning of that
ought the Americans had neither courage nor res-

THE MINUTE MAN AT CON-
CORD BRIDGE.

(Daniel C. French, Sculptor.)

documents such as Burgoyne's Articles of Capitulation "reproduced,
by permission, from the original document in the collection of the
New York Historical Society." Some examples have been mentioned
already: the fenced-and-tableted Cambridge elm, the marker com-
memorating where "Montgomery Fell," and Peixotto's engraving after
French's *Minute Man*—an image that, with its discontinuous frame
and blanked inscription, visually blurred the distinction between
archival records and new images of monuments (fig. 6). These are
only a few examples, however, as *The Story of the Revolution* contained
many other renderings of memorials—for instance, the unsigned
"A Glimpse of Bunker Hill Monument from Copps Hill Cemetery,"
"Monument Avenue, Bennington, at the Present Time," and another
monument to Montgomery: Peixotto's "The Monument to
Montgomery, St. Paul's Church, New York City." This conflation of
memorialization and history—facilitated, in the decades leading up

to Lodge's book, by the proliferation of historical commemoration—inculcated a tautological view of history in which what is important is that which has been memorialized (and in which, as a corollary, things that have not been memorialized are unimportant or irrelevant). And, to be sure, in creating this conflated American commemoration history, Lodge did not stop with the publication of the book but went on to participate directly in the further proliferation and circulation of new monuments to the Revolution.[17]

Toward Empire

If nothing else, a comparison between Lodge's *Story of the Revolution* and Ponce and Godefroy's *Collection of Engravings* shows the profound divergence between two visualizations of the Revolution that, although interpreting the same conflict, were separated by time and space. However, there was much more at stake than interpretation alone in Lodge's account. After all, Lodge was not just an influential historian of the Revolution: he was also one of the architects of the Spanish-American War, as well as a leading advocate of the US "retention" of the Philippines, which was ultimately effected through conquest in the Philippine-American War. Indeed, Lodge himself explicitly invited readers to link the American Revolution to the Spanish-American War. He dedicated *The Story of the Revolution* "to the Army and Navy of the United States, Victors of Manila, Santiago and Porto Rico, Worthy Successors of the Soldiers and Sailors Who under the Lead of George Washington Won American Independence." And, in his summary section on the legacies of the War of Independence—the " coming of a new force into the western world of Europe and America"—he wrote,

> *Italy broke away from Austria and gained her national unity; representative systems with more or less power came into being in every European country, except Russia and Turkey; the wretched little tyrants of the petty states of Germany and Italy, the oppressive temporal government of the Pope, have all been swept out of existence, and given place to a larger national life and to a recognition more or less complete of the power and rights of the people. Even to-day, in obedience to the same law, the colonial despotism of Spain has perished from the face of the earth because it was a hideous anachronism.*[18]

Thus, in Lodge's formulation, these two events were not only linked but linked in a particular way.

Lodge would have had good reason to want to control the interpretation of the American Revolution, the US interventions that began in 1898, and the relationships between them—and, in particular, to "uncirculate" both the interpretation of the War of Independence as one among many interimperial wars and the view of Spain as a power whose intervention had contributed to the successful achievement of US independence. After all, if the two moments were parallel instances of interimperial war, and if in the latter instance the United States (alongside Spain's rebellious colonial subjects) was fighting the empire of Spain, then that might make the United States an empire (rather than the keeper of a mysterious power of teleology). And if Lodge did not appoint the "Army and Navy of the United States" as Washington's successors, then it was possible that, for example, the Filipinos who waged revolution against Spain to obtain independence might be able to claim that position of descent—and, like the American revolutionaries before them, to obtain recognition as an independent state. Indeed, if we disregard Lodge's guidance, it is possible to map unfolding events in the Philippines onto the War of Independence in a very different way than he did: that is, to imagine an American Revolution in which Spain (or perhaps both the Bourbon powers) intervened in the War of Independence and helped defeat their shared enemy Britain, but then followed that intervention by occupying the thirteen colonies, negotiating a treaty with Britain to grant legal standing to the occupation, and fighting a second war against the revolutionaries in order to keep their new imperial territories.

A History of Forgetting

Lodge's *Story of the Revolution* thus provides a stark example of the rejection—the uncirculation—of Ponce and Godefroy's global, interimperial version of the War of Independence. And because of Lodge's joint role as a maker of illustrated history and a maker of US empire, it also provides a sharp reminder of the relationship between the uncirculation of histories that are no longer useful and the substitution of different historical "stories" more suited to contemporary political needs—most pressingly in this case, the need for unambiguous enmity toward Spain. Yet, to be sure, Lodge's *Story of the Revolution* was published more than a century after Ponce and Godefroy's album—and might, as such, be interpreted as uniquely the product of the jingoistic 1890s. Thus, it is necessary to turn back to that intervening

century, in order to gauge whether that is the case, or whether Lodge's *Story of the Revolution* is embedded within a larger process of forgetting or uncirculation.

To consider this question, it is necessary to return to the relationship between how Ponce and Godefroy represented the American Revolution and how Americans presented it in images, objects, exhibitions, and the like. There were, to be sure, some points of intersection. For example, from the war's end onward, Americans produced countless images and objects of Franklin and Washington. Furthermore, Lafayette clearly enchanted American painters and sculptors nearly as much: in the Smithsonian American Art Museum's Art Inventories Catalog, there are 86 entries for "Portrait male — Lafayette, Marquis de"; 55 for "Portrait male — Lafayette, Marquis de — Bust"; 50 for "Portrait male — Lafayette, Marquis de — Full length"; and 5 each for head, profile, and waist-length portraits. Moreover, both in the case of the American founders and in the case of Lafayette, the proliferation of paintings and sculptures was accompanied by the production and circulation of prints, medallions and/or coins, and other circulating forms that multiplied their presence within American visual culture. Further, the striking of such multiples intersected with memorialization: for example, the Lafayette medal made to commemorate the unveiling of a centennial statue of him in New York in 1876.

As clearly, however, American image and object makers departed from Ponce and Godefroy on the subject of Spain and Gálvez. The Smithsonian art inventory (which, like all inventories, is subject to omissions, but which is probably the most comprehensive inventory available) only lists a handful of images of Gálvez, all of which were made in the late twentieth century, and all but one of which were made in 1976 or thereafter, in the context of another period of centennial commemoration with different political imperatives. Moreover, the process of multiplication via numismatics that attended images and objects of Lafayette and various American revolutionaries did not take place in Gálvez's case. Indeed, even the name of Gálvez is absent as a visual and material presence in places where we might reasonably expect it — for example, Benjamin Franklin French's *Historical Collections of Louisiana and Florida* (1869). In a typical appeal to historical veracity through the use of images of "original" sources, this volume began with a "facsimile of original autographs of the French and Spanish governors of Louisiana" from de la Salle to the Baron de Carondelet. However, this list of signatures proceeded directly from Alejandro

O'Reilly to Carondelet—excising Gálvez as well as his successor, Estevan Miró, who was also involved in Gálvez's campaigns in the Gulf. Across a range of media, then, it would appear that Gálvez, and, perhaps, Spain as a cobelligerent whose intervention helped secure American independence, was not only uncirculated but, in a sense, "disappeared" from the historical record.[19]

This excision of Spain as a Revolutionary cobelligerent carried forward into the 1890s, as may be seen in a work that is generally not thought of in visual or material-cultural terms: *The Influence of Sea Power on History*, published in 1890 by Alfred Thayer Mahan (1840–1914), one of Theodore Roosevelt's most important mentors. At first glance, Mahan appears to present a radically different vision of history than Lodge. Unlike Lodge, Mahan dwelled extensively on the Seven Years' War and emphasized its global aspects. Moreover, and quite strikingly, Mahan also cast the Revolution, as Ponce and Godefroy did, as a global war. As such, he analyzed actions off the coasts of India and the Cape Verde islands and in the Caribbean, as well as in the thirteen colonies, sustaining such analysis through the extensive employment of diagrams of fleet actions. Nonetheless, Mahan's *Influence of Sea Power* does foreshadow Lodge's *Story of the Revolution* in one important respect. In the section dealing with the Revolution, Mahan included something like a dozen images—an inclusion that not only lent credence to his analysis of the outcome of particular battles, but also bolstered his overall interpretative scheme in much the same way that Lodge's visual overkill enhanced his historical authority. Not one of these images depicted actions involving Spain, even though Mahan could have visualized events such as the action of August 9, 1780 (in which Spanish Admiral Luis de Córdova y Córdova and his French allies captured a British convoy in the Atlantic, leaving the British with £1.5 million in losses); those depicted by Ponce and Godefroy, such as the taking of Pensacola or the Spanish-French recapture of Minorca; or, for that matter, the failed Spanish invasion of Gibraltar, which drained Britain of ships, personnel, and resources (and which, in the guise of British victory, was the subject of John Singleton Copley's monumental *Defeat of the Floating Batteries at Gibraltar, September 1782* [1791]).[20] Instead, Mahan chose to display only instances of Anglo-*French* combat such as "Keppel off Ushant July 27, 1778" and "D'Estaing and Byron July 1, 1779." Moreover, the index to *The Influence of Sea Power*, like French's frontispiece and index, excised Gálvez as well as the geographic keywords to Spanish cobelligerency such as "Pensacola" and "Mobile."[21]

EXHIBITION OF

ARMS AND TROPHIES,

IN BEHALF OF THE

𝔐𝔢𝔱𝔯𝔬𝔭𝔬𝔩𝔦𝔱𝔞𝔫 𝔉𝔞𝔦𝔯,

IN AID OF THE UNITED STATES SANITARY COMMISSION.

To Open March 28th, 1864.

The people of the United States know well the object for which a Metropolitan Fair is to be held in this city.

The Sanitary Commission, in aid of which the Fair is undertaken, is the representative of the organized devotion of the American people, of every age, and sex and class, to the comfort and care of the brave men who stand between the nation and its enemies. Gathering up and blending into harmonious being the countless scattered elements of kindred love and common charity, with "bounty boundless as the sea, and love as deep," the Commission stands one of the noblest evidences of the civilization of the country—a consolation in the midst of war. Through the smoke of battle, and by the pale watch-fire of the camp, its form may be seen stooping to give its healing care to the sick and the wounded, or to whisper in the ear of the dying soldier the last earthly comfort.

To add to the interest of the Fair, the Managers have resolved to combine exhibition with sale, and to attract visitors by the display of a variety of objects.

This Committee propose to carry out this double purpose.

1st. By obtaining arms and trophies of war from States, corporations, and individuals; and relics of American wars, from the early struggles of the Colonies to the present time; whatever may recall the memory of the war with the Indians, or the old French war, when England and France fought out on American soil their ancient struggle; whatever precious relics of the Revolution, in which our Fathers won for us our liberties, and ushered into being the nation whose life we now defend; whatever remain of the trophies well-earned by land and sea in the contest of 1812; whatever won in that later war with Mexico, under the hero whose form is a living trophy, will be welcomed.

Banners which have floated proudly over citadel and fort, carried by victorious hands, or stripped from the hand of the enemy; flags stained with heroic blood, whose fading lustre is lighted up by the bright light of fame; ensigns which have waved victory from the mast-head of gallant ships-of-war—all will be welcomed, and amid the more practical contributions, will draw the mind to a contemplation of the guerdon for which the true soldier fights—the glory and defence of his country. Medals voted by Congress, or by States; early and celebrated commissions; swords won in action; presentation swords, and arms of every kind, from the crowned and garlanded cannon of Louis XIV, to the plain Dahlgren and Parrott, which frown on modern battlements; and from the tomahawk of the Indian to the broken musket from the last battle-field, will have their appropriate place.

All such articles will be cared for, guarded with watchful eye, and promptly returned to their owners.

2d. It is proposed to gather the friends of those gallant and devoted men who have laid down their lives in this holy war, such personal relics as they may be willing to unveil to the sympathizing interest of the world. Exposed together, and as a tribute of respect to the dead, these touching evidences of individual patriotism will make an interesting feature in the Exhibition.

3d. The patriotic public are requested to send in to this Committee such articles of the above named nature as they may be able to control, for sale, as well as for *exhibition*.

Dealers in arms are especially invited to contribute largely of their stock for sale, for the benefit of the Fair, and to none does the Committee apply with more hope, than to those whose fortune it has been to profit by the sale of implements of war.

Every object of interest, no matter how trifling, which the soldiers in the field may send, will be received and cared for.

Donations in money may be sent to any of the Committee, and receipts will be returned by the Treasurer of the General Committee in the name of the Committee on Arms, Trophies, &c.

All packages sent to WILLIAM T. BLODGETT, Chairman of the Committee, No. 2 Great Jones Street, by any of the Express Companies in the United States, will be free of charge.

A special committee on SPORTING MATERIAL is connected with this Department, of which Mr. DWIGHT TOWNSEND is Chairman.

COMMITTEE.

MRS. GEORGE B. McCLELLAN,	MRS. C. M. KIRKLAND,
" JOHN C. FREMONT,	" A. BAIRD,
MRS. JOHN PAINE, CHAIRMAN.	MISS CARRIE P. DUNN, SECRETARY.

GEN'L CHARLES C. DODGE,	COL. J. FRED PIERSON,	WILLIAM KEMBLE,
" EGBERT S. VIELE,	" D. T. VAN BUREN,	BURR W. GRISWOLD,
COL. ELLIOTT F. SHEPARD,	CAPT. JOHN ERICSSON,	SMITH ELY, JR.,
" GEORGE BLISS, JR.,	" JAS. R. GOULD,	DWIGHT TOWNSEND,
" STEWART L. WOODFORD,	JOHN A. C. GRAY,	J. BUTLER WRIGHT.
WILLIAM T. BLODGETT, CHAIRMAN.		JOHN AUSTIN STEVENS, JR., SECRETARY.

Participatory Circulation

Another way of making this absence present, and hopefully for getting from the Revolution to Lodge's era of imperial conquest, is to turn to another process: American uses of circulation to articulate conflicts across time. It is well known that some American painters joined the Revolution to subsequent conflicts—an example is Richard Caton Woodville's *Old '76 and Young '48* (1849), linking the Revolution to the Mexican-American War—and that such works circulated as prints (in this case, in Joseph Ives Pease's print after Woodville [1851]).[22] But, just as important, during periods of conflict, Americans also explored other methodologies for circulating imagined linkages between those conflicts and the Revolution. One important example from the Civil War is the exhibitions of conflict objects and/or art undertaken under the auspices of the national and regional Sanitary Commissions—for instance, the US Sanitary Commission's New York Metropolitan Fair and the North-Western Sanitary Commission and Soldiers' Home Fair in Chicago. These exhibitions are noteworthy for their multivalent and participatory approach to circulation: for instance, one of the ways in which they obtained objects to display was to circulate broadsheets among the public soliciting donations of privately held objects. The 1864 broadsheet circulated in advance of the "Exhibition of Arms and Trophies, in Behalf of the Metropolitan Fair" (fig. 7), for example, implored citizens to lend "whatever precious relics of the Revolution, in which our Fathers won for us our liberties, and ushered into being the nation whose life we now defend" as well as "whatever remain of the trophies well-earned by land and sea in the contest of 1812; whatever won in that later war with Mexico, under the hero whose form is a living trophy." These objects of the Revolution and empire would then be joined to objects from the ongoing conflict, as the organizers "proposed to gather from the friends of those gallant and devoted men who have laid down their lives in this holy war, such personal relics as they may be willing to unveil to the sympathizing interest of the world"—to be put on display at exhibition, but also to be recirculated in exhibition catalogues and the like.

As the broadsheet suggests, while this process was participatory, it was also exclusive: for example, the Revolutionary objects it solicited did not include "relics" of the broader interimperial war—only those pertaining to "the nation whose life we now defend." Moreover, in the displays that were created—and the circulating catalogues made after them—Spain and Gálvez were featured only by their absence. For instance, the New York Metropolitan Fair's *Catalogue of the Museum*

7
Broadsheet advertising for the "Exhibition of Arms and Trophies, in Behalf of the Metropolitan Fair," 1864. John Shaw Pierson Civil War Collection, Box 1, Folder 6, Rare Book Division, Department of Rare Books and Special Collections, Princeton University Library, New Jersey, (W) 2015-0082F.

of *Flags, Trophies and Relics* (1864) contained both "relics" belonging to friends (e.g., the "Camp Kettle used by Lafayette") and "trophies" pertaining to enemies (such as the "bowie knife from a rebel mail carrier" and "Santa Anna's Sash"), but it had absolutely nothing attending to the more ambivalent Gálvez or Spain.[23]

The act of not soliciting and not circulating Spanish "relics" in Civil War exhibitions severed the potential links between Spain's intervention in the American Revolution and subsequent US history, and arguably facilitated the US march to war with Spain in 1898. But the proposal of a mystical connection, through conflict objects, between the Revolution and future US wars—and the proposal of that connection through a participatory form of circulation that encouraged potential viewers to contribute their own objects—also contributed to broader changes in US political culture. An example is the forging of a pro-war consensus that included not only the native-born but also heterogeneous immigrant and religious communities who had an uneasy relation to the US state, perhaps exemplified by the endorsement, in the controversial 1900 election, of William McKinley

and the conquest of the Philippines by the prominent Irish-American and Catholic bishop of St. Paul, John Ireland (himself a former Union chaplain). Although better known for other reasons, one of the sanitary fairs' clear objectives was to enlist support for the Union cause among these politically unwieldy parts of the US population. The organizers of Chicago's North-Western Sanitary Commission and Soldiers' Home Fair, for instance, explicitly approached Catholics, sending a targeted broadsheet appeal for needlework, books, and relics that featured twinned images of the Virgin Mary and the shield and fasces of the Sanitary Commission. They also appealed to Irish immigrants, whose ambivalence about the Civil War was, infamously, expressed in the New York City draft riots of 1863. Such efforts appear to have worked: in 1865, even the nationalist Fenian Brotherhood donated the proceeds of its annual ball to the Sanitary Fair (fig. 8).

If the circulation of an articulated history of war joined heterogeneous US constituencies, however, it also fueled the making of negative political distinctions. As is suggested by the foregoing discussion, the makers of the sanitary fairs mapped the objects they displayed onto the polities that had participated in US conflicts, marking out allies from enemies—and, just as important, categorizing different *kinds* of polities and combatants. Most obviously, conflict objects circulated in this way reinforced the sense that the United States was a legitimate polity whose wars were "holy." But they also reinforced the tendency to see enemies of the United States as unlawful and illegitimate—rebels, guerrillas, pirates. Such distinctions would be crucial to American empire during the conquest of the Philippines, allowing the United States to define resistance to US rule not as a legitimate "revolution" (or, for that matter, as the action of a functioning, if unrecognized, state) but as an illegitimate "insurgency"—and, in 1902, to redefine those who continued to resist as criminal "bandits."[24]

Moderate in Their Vengeance

Up to now, this essay has explored one way in which American makers of Revolutionary images "uncirculated" Ponce and Godefroy's depiction of the Revolution: their excision of Spanish cobelligerency from the visual and material record. This visual "uncirculation," I have argued, and the substitution of a "story of the Revolution" that emphasized Spanish perfidy intersected substantively with the growth of American empire in the 1890s. Yet, as has been noted, other aspects of Ponce and Godefroy's version of the American Revolution are also at odds with the canon of highly circulated US images. An important

example, mentioned at the start of the essay, is Godefroy's scene from Boston, "John Malcom"—whose subject, like Gálvez and Pensacola, appears neither as image nor as index entry in Lodge's *Story of the Revolution*, despite the superfluity of images and of Massachusetts scenes in the book.

Thus, to continue the analysis of uncirculation—and the relationship of uncirculation as a visual and material practice to the creation of history—in this section I turn to "John Malcom," looking first at how Godefroy treated this subject, and then exploring how that treatment related to the views from London and the United States. The aim of such comparisons is to examine not only the way that makers of Revolutionary images circulated (or "uncirculated") the particular subject of the image—the punishment of a customs official—but also its more general theme: revolutionary violence.

Regarding "John Malcom," it may be said that one of the most striking aspects of the print is its ambivalence, even unease (fig. 9). On the one hand, it aims to explain and to exculpate the event: its long accompanying text not only accounts for the "Origin of the American Revolution" but also praises the Bostonians for being "moderate even in their vengeance" by not killing Malcom. Yet, on the other hand, it is also, unmistakably, an image of bodily suffering. Malcom, to whom the viewer's eye is immediately drawn both because of his white, voluminous frilled shirt and because he is at the apex of a writhing triangle of assailants, has been tied up: his hands are bound behind him, and a rope has been looped across his chest. Objects in the scene indicate the narrative that is unfolding: the figure to his left, whose reaching arm forms the left side of the triangle, is about to dip his ladle into a bucket of tar that has been set on the boil. This figure and the other assailants stand on a hay cart, harnessed to a horse, which may be pulled out from under Malcom at any moment, leaving him to dangle from the window above.

Godefroy's treatment of the scene also conveys a disturbing sense of the physical strain of upward and downward force on Malcom's body: the rope cuts upward into the volume of his shirt, even as the hands of the man to his right pull Malcom's body and his hosiery downward with a firm hand on Malcom's buttocks and ankle. This up-down, push-pull motion is further echoed in the smaller triangle of by-standing Boston gentry to the right, as one of the ladies grips a parasol ballooned by an otherwise unnoticeable breeze. Here, the ladies watch and the gentleman points, but only the child makes a gesture that could be interpreted as one of resistance or supplication.

9
François Godefroy, "John Malcom," from *Recueil d'estampes* . . . (Paris, ca. 1783–1784). Etching and engraving, 7 9⁄16 × 8 11⁄16 in. (19.2 × 22.1 cm). Rare Book Division, Department of Rare Books and Special Collections, Princeton University Library, New Jersey, (Ex) 1081.752.

J. M. Mancini

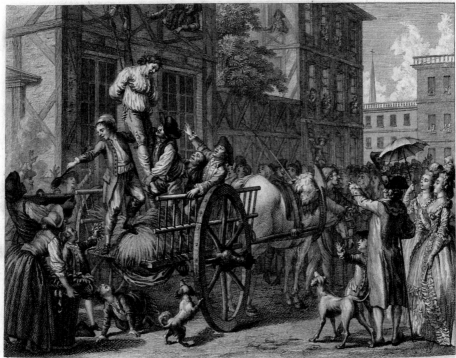

JOHN MALCOM.

Dessiné et Gravé par F. Godefroy
de L'Académie Imp.le et R.le de Vienne &c.

Le 25 Janvier 1774 la populace irritée pénétra sans armes dans sa maison. Il blessa plusieurs personnes à coups d'épée: mais les Bostoniens, moderés jusques dans leur vengeance, le saisirent, le descendirent par la fenêtre dans une charrette; ensuite il fut dépouillé, goudronné, emplumé, mené sur la place publique, battu de verges, et obligé de remercier de ce qu'on ne le punissait point de mort: puis on le ramena chez lui sans autre mal.

ORIGINE DE LA REVOLUTION AMERICAINE.

Les Provinces de la Nouvelle Angleterre jouissaient du droit de s'imposer elles-mêmes dans leurs assemblées: les officiers du gouvernement et les juges étaient nommés par le roi, mais aux gages du peuple. L'Angleterre éprouvant des besoins de finances, et voulant les faire partager aux Américains, fit paraître un bill le 4 avril 1764, à l'effet de les taxer, au mépris des chartres sur la foi desquelles les émigrants de l'ancien monde s'étaient établis dans le nouveau. Cette démarche était d'autant plus inconsidérée, que pendant la guerre précédente, le ministère envoyant chaque année un mémoire des besoins publics à ses colonies, et la réalité de ces besoins étant discutée dans leurs assemblées, les secours d'hommes et d'argent surpassèrent toujours ce qu'on attendait de leurs facultés. C'est ce dont les actes de la Chambre des communes font foi: ils rendent aussi témoignage que les succès de cette guerre dont l'Angleterre se glorifie sont dus presque tous au zèle et à la force de ses colonies.

Après de longs débats, l'Angleterre y établit des douanes le 29 juin 1767 pour faire exécuter des prohibitions de commerce sous l'inspection de commissaires nommés et gagés par le roi. Partout on s'opposait à l'exercice de leurs fonctions, et le 18 mai 1770 la populace de Boston arrêta un commis pour avoir saisi un petit bâtiment sous prétexte de contrebande. elle le dépouilla, et l'ayant barbouillé de goudron et couvert de plumes, le promena par la Ville. John Malcom, officier des douanes, fut traité de même en 1773 pour le même motif; mais on eut le menagement de ne le point dépouiller. Ce fier malôtier ayant dit que le roi et le parlement le vengeraient bientôt de cette canaille, la multitude attendit qu'il lui fournit l'occasion de le punir avec plus de sévérité; ce qui arriva le 25 janvier 1774.

A Paris chez M.r Godefroy rue des Francs-bourgeois, Porte S.t Michel.
Et chez M.r Pence, rue S.t Honoré N.° 19. A. P. D. R.

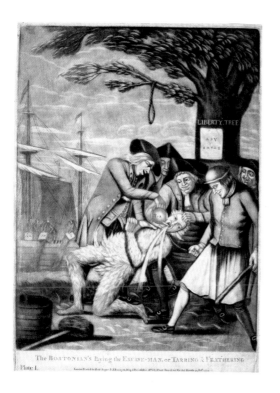

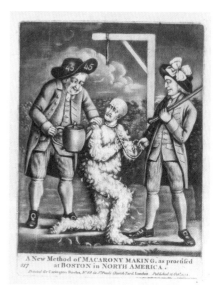

A New Method of MACARONY MAKING, as practised at BOSTON in NORTH AMERICA.

The Bostonian's Paying the Excise-Man, or Tarring & Feathering. Plate I.

As such, Godefroy's image differed from the London images in significant respects. These images lacked Godefroy's exculpatory textual gloss—and indeed reminded viewers of the Bostonians' other outrages with, in "The Bostonian's [*sic*] Paying the Excise-Man, or Tarring & Feathering" (1774), the inclusion of a background scene of the Boston Tea Party and a sheet marked "Stamp Act" tacked upside down to a tree helpfully marked "Liberty Tree" (fig. 10). Moreover, the London images also treated the perpetrators of Malcom's punishment differently than Godefroy. Although both Godefroy and the London image makers' figures are undertaking mob action, in Godefroy's case they are differentiated by gender, age, face, and dress (the crowd includes both well-coiffed ladies and gentlemen with ruffled cuffs, as well as the banded-cuffed craftsmen who actually do the job). In contrast, Sayer's Bostonians lack such individuality or complexity. Rather, they are sneering, flattened ghouls with lank, unkempt hair and strange peasant dress—demons, rather than men and women. And, in a further important contrast, the London prints focus on later moments in the narrative than Godefroy. In Bowles's "A New Method of Macarony Making, as practised at Boston in North America" (1774), the moment depicted is the point at which Malcom already has been tarred and feathered

and partially hanged, and is about to be force-fed from a giant teapot; and in the Sayer image, it is the moment in which the Bostonians torture the rigid, praying Malcom by drowning him with tea beneath a "Liberty Tree" draped with a hangman's noose (fig. 11). As such, the London images lack the ambivalence of Godefroy's.

Nonetheless, there are points of intersection between Godefroy's image and the London prints. For example, the Sayer and Godefroy prints are interconnected iconographically by the tar pot and ladle to the lower left of both images; and compositionally, they are both marked by the push-pull dynamic discussed above. Indeed, in the Sayer print, Malcom is leaning backward, balanced on one knee, with only the leg of one of the Bostonians to hold his upper body, but he still appears to be springing upward: two colonists' hands visibly restrain his shoulder and head, and another grasps the rope still attached to his neck.

How, then, does Godefroy's "John Malcom" relate to American visual articulations of the Revolution, and particularly of revolutionary violence? Here, it is difficult to make a direct comparison, insofar as American image makers—and not just Lodge—appear to have studiously avoided both the punishment of Malcom and the more general theme addressed by the Malcom imagery: unregulated, nonbattlefield revolutionary violence perpetrated on living British bodies. Again in contrast to Lafayette, the Art Inventories Catalog has no entries for John Malcom or for works of art locatable by keywords such as "tarring and feathering," "excise-man," or similar. In fact, it appears that American artists did not take up this theme until the 1830s, when the humorist, actor, and controversialist David Claypoole Johnston (1798–1865) made lithographs after both the Sayers and the Bowles mezzotints in Boston in 1830; and Johnston's efforts do not seem to have been further emulated by later US artists. Indeed, the only early nineteenth-century American "image" of this particular form of revolutionary violence that might be seen to have had a long-term purchase on the American imagination was the literary image created by Nathaniel Hawthorne, in the same decade as Johnston's prints, in his harrowing and deeply ambivalent short story "My Kinsman, Major Molineux" (1831).

If American artists avoided the iconography of the noose, the tar bucket, and the suffering British body, what, then, to make of this absence? Or, to put it another way, how might we interpret prints and paintings that were never made and never circulated? One possibility is to contextualize the nonmaking, and noncirculation, of images of this particular *kind* of revolutionary violence—again, unregulated,

nonbattlefield American violence perpetrated on a living British body—within the broader depiction of revolutionary violence. That is to say, was American reticence toward the depiction of John Malcom's punishment indicative of a broader reluctance to portray and circulate images of violence? And if US makers of Revolutionary images did depict, and broadly circulate, images representing *other* kinds of revolutionary violence—may it be inferred that the selective representation of violence is significant?

A first step here is to identify other kinds of revolutionary violence. Perhaps most obviously, these include the violence used by British troops against Americans—for example, in the Boston Massacre. But revolutionary violence also included American violence that was directed not against living Britons but rather toward images of Britons, and particularly against the image of the most important body in the British Empire, that of the king. As Brendan McConville argues—and as the recent work of Wendy Bellion explores—American revolutionary iconoclasm took many forms, including the pulling down, inverting, beheading, and defacing of images of George III. Moreover, as with the Boston Massacre and the punishment of John Malcom, representations of revolutionary iconoclasm generally centered on a single event: the destruction of the gilded lead equestrian sculpture of George III on New York's Bowling Green in 1776.[25]

What, then, about the visual afterlives of these three events? In the first case, it is obvious that the circulation of images of British violence eclipsed those of American violence. Beyond even the reiteration of Revere's print, the Boston Massacre is painted into the very fabric of the Capitol Building, has been cast in bronze, and has produced its own spin-off series in the form of images of victim/hero Crispus Attucks.[26]

Revolutionary political iconoclasm also experienced a robust, circulating afterlife. As in the case of the punishment of Malcom, the first visual reiterations of the destruction of the statue of George III, as Arthur S. Marks argues, came from European critics of American mob violence—in this case, Franz Xavier Habermann's image published in Augsburg in 1776. However, the subsequent history of iconoclasm images was to take a different turn. While the attack on the living Malcom was only partially rehabilitated by Godefroy as an example of American moderation "even in their vengeance," the attack on the sculptural king was transformed by American image makers and circulators into an act of revolutionary

glory and national celebration. And while the punishment of Malcom attracted few Americans willing to magnify the event by reiterating it, the destruction of the royal statue spawned so many reiterations that the act of reiteration outstripped the event itself. Thus, in a sense, the visual history of American revolutionary iconoclasm paralleled at least one prior moment of political icono-clasm: the English Civil War, when, as Julie Spraggon argues, iconoclasts not only destroyed images and objects pertaining to the old regime but also created circulating visual memorials to that spoliation. "In suppressing a traditional ideology," she writes, "whether religious or political, papal or monarchical—it was not enough merely to remove from sight the objects which defined that ideology, but they must also be *seen* to be *destroyed*."[27]

The history of the recirculation of the destruction of the statue of George III cannot be fully recounted here, but consider the following: in the early part of the nineteenth century, American prints of the event were circulated sufficiently widely that, in the 1830s, the travel writer John Lloyd Stephens wrote of seeing one in a tavern in Russia. This was followed by the making of paintings including William Walcutt's *Destruction of the Statue of George III by New York Patriots* (1854) and *Pulling Down the Statue of George III* (n.d.,) and Johannes Adam Simon Oertel's *Pulling Down the Statue of King George III, New York City* (1859).[28] Such visual efforts were also accompanied by the creation of texts recounting and memorializing the iconoclasm—for example, Benson J. Lossing's best-selling *Pictorial Field-Book of the Revolution* (1855). In turn, nineteenth-century paintings of the event themselves generated further circulating images. For example, the New York printmaker John C. McRae based his engraving "Pulling Down the Statue of George III by the 'Sons of Freedom,' at the Bowling Green, City of New York, July 1776" (ca. 1875) on Oertel's painting. Moreover, by this time—the 1870s—the circulation of revolutionary iconoclasm became enmeshed within the memorial-izing practices that attended the centennial, in that it was one of three "'76" prints McRae produced, the others being "'Raising the Liberty Pole,' 1776" (1876) and "The Day We Celebrate" (1875)—the latter made after a painting by F. A. Chapman and presented at the 1876 Centennial International Exhibition in Philadelphia.[29] Indeed, these three prints may be viewed as a narrative triptych of US history from the Revolution to the centennial, beginning with the ritualistic destruction of George III and ending with contemporary Americans, in contemporary dress, performing the rituals of the Fourth of July.[30]

By the end of the century, this association between iconoclasm and celebration had become normal, even casual, as may be seen by returning, finally, to Lodge's *Story of the Revolution*—which included its own iteration of the iconoclasm in Frederick Yohn's "Tearing Down the Leaden Statue of George III, on Bowling Green, New York, to Celebrate the Signing of the Declaration of Independence" (fig. 12). Yet despite the great deal of movement in the scene—fists pump, fingers waggle, heads turn—this is a curiously chaotic image whose movement does little to push events forward. The ropes attached to

12
Frederick Coffay Yohn, "Tearing Down the Leaden Statue of George III., on Bowling Green, New York, to Celebrate the Signing of the Declaration of Independence," from Lodge, *Story of the Revolution*, 10:173.

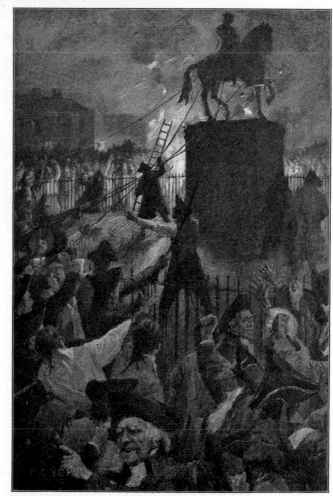

TEARING DOWN THE LEADEN STATUE OF GEORGE III., ON BOWLING GREEN, NEW YORK, TO CELEBRATE THE SIGNING OF THE DECLARATION OF INDEPENDENCE.

The lead was later moulded into bullets for the American Army.

the sculpture of the king are curiously slack, the figure in the fore-
ground is not even watching, and while the grins and jeers of the
crowd indicate that something naughty is being done to the British,
there is little sense of danger or of real harm being inflicted.

As such, Yohn's treatment of "tearing down the leaden statue of
George III" may be interpreted as a kind of neutralization of the
violence of iconoclasm. Yet Lodge's representation of this type of
violence — violence against *representations* of the British monarch —
may also be related back to the kind of revolutionary violence Lodge
declined to use in *The Story of the Revolution*: the punishment of
Malcom and other *living* British bodies off the field of battle.
Specifically, I contend that the prolific circulation of iconoclasm
images enhanced or intensified the uncirculation of punishment
images — and helped unmake a history of the Revolution in which
such violence, and the iconography of the tar bucket, the scaffold, and
the waterspout, could be easily visualized and remembered. Moreover,
I argue that such uncirculation had consequences not only for how
Revolutionary history was constructed but also for how US imperial
war would be visualized: hence, when the visual traces of Malcom's
Revolutionary drowning by tea reappeared in US photographs and
prints of the "Water Cure" during the Philippine-American War, it is
telling that these images staged this torture as a practice administered
by Filipinos and learned in the era of Spanish rule — and not as an
American practice with roots in the Revolution.[31]

Conclusion

In the end, Brunet's provocative questions regarding the "noncircula-
tions, absences, invisibilities, negations, and destructions" of images
cannot be definitively answered: it will always be more difficult to
establish a negative history than a positive one. With this in mind, this
essay does not offer a definitive account of "uncirculation." Rather,
I have pursued a more limited aim. This has been to provide a con-
crete example of his claim that, for every image, object, or archive that
circulates, there are others that do not — and, further, to endorse the
possibility that such uncirculated images, which might be thought
of as the dark matter of American art, can tell us as much about the past
as the images we can see.

1 Clement Greenberg, "Avant-Garde and Kitsch," in *Art and Culture: Critical Essays* (Boston: Beacon Press, 1971), 12.

2 I am thinking specifically of Kevin R. Muller's wide-ranging discussion of Jan Verelst's portraits of the four "Indian Kings." Muller amply demonstrates the centrality, even in the first decade of the eighteenth century, of transatlantic negotiation and circulation (including the circulation of the Iroquois "Kings" themselves) to painting *and* politics; also, and just as important, he demonstrates the ultimate inseparability between Verelst's paintings and the mezzotints after them that circulated "from Palace to Longhouse," performing the delicate work of diplomacy between the British Crown and the Iroquois Confederacy. Muller, "From Palace to Longhouse: Portraits of the Four Indian Kings in a Trans-Atlantic Context," *American Art* 22, 3 (Fall 2008): 26–49.

3 Translations are my own unless otherwise noted.

4 Henry Cabot Lodge, *The Story of the Revolution*, 2 vols. (New York: Charles Scribner's Sons, 1898).

5 Hence it is not surprising that the copy of *The Story of the Revolution* in the library of the University of California bears the bookplate of the historian H. Morse Stephens (one of the authors of the American Historical Association's 1899 *The Study of History in Schools* and, eventually, its president); and that the edition of the book in the Library of Congress belonged to Lodge's fellow friend of Theodore Roosevelt, the jurist Oliver Wendell Holmes. For the serialized version, see, for example, Henry Cabot Lodge, "The Story of the Revolution.—The Burgoyne Campaign and Its Results," *Scribner's Magazine* 23, 5 (May 1898): 551–71.

6 For the picture book, see *The Revolutionary Pictures Illustrating "The Story of the Revolution" by Henry Cabot Lodge* ([New York]: Scribner's Magazine, 1898); and for the exhibition, see *Catalogue of the Revolutionary Pictures . . . Illustrating the Story of the Revolution by Henry Cabot Lodge: And the American Navy in the Revolution by Captain A. T. Mahan* ([Chicago?]: Scribner's Magazine, 1898).

7 Lodge, *The Story of the Revolution*, 1:51, 31, 101.

8 Ibid., 2:189, 1:8 (both Lee and Randolph).

9 Ibid., 1:111, 107, 108, 119.

10 Ibid., 1:89.

11 Ibid., 1:9, 99, 147.

12 Ibid., 1:267, 2:6.

13 Ibid., 1:270–71. Lodge noted, "Russia refused troops to England and manifested a kindly interest in the new States. Holland, who had herself fought her way to freedom, and could not forget her kindred in the New World, not only refused to give troops to George III., but openly sympathized with the rebels, and later lent them money, for all which she was to suffer severely at the hands of England. The northern powers stood aloof and neutral. Austria sympathized slightly, but did nothing. . . . The Americans had at least succeeded in alienating Europe from England, which at that time seemed to enjoy her 'splendid isolation' less than she has professed to do in more recent days" (ibid.).

14 Ibid., 2:6 ("distinctly hostile"), 125 ("corrupt, broken").

15 For discussion, see Carmen Reparaz, *Yo Solo: Bernardo de Gálvez y la toma de Panzacola en 1781* (Barcelona: Ediciones de Serbal; Madrid: Instituto de Cooperación Iberoamericana, 1986); and Jonathan R. Dull, "Mahan, Sea Power, and the War for American Independence," *International History Review* 10, 1 (Feb. 1988): 59–67.

16 Lodge, *The Story of the Revolution*, 1:17.

17 *A Record of the Dedication of the Monument on Dorchester Heights, South Boston Built by the Commonwealth as a Memorial of the Evacuation of Boston, March 17, 1776 by the British Troops* (Boston: Printed by the Order of the Governor and Council, Wright & Potter Printing Company, 1903).

18 Lodge, *The Story of the Revolution*, 2:226, 227–28.

19 B. F. French, *Historical Collections of Louisiana and Florida* (New York: J. Sabin & Sons, 1869), frontispiece (quotation).

20 Copley's *Defeat of the Floating Batteries at Gibraltar, September 1782* is in the collection of the Guildhall Art Gallery, London.

21 A. T. Mahan, *The Influence of Sea Power upon History 1660–1783* (Boston: Little, Brown and Company, 1890); C. Ernest Fayle, "Shipowning and Marine Insurance," in *The Trade Winds: A Study of British Overseas Trade during the French Wars, 1793–1815*, ed. C. Northcote Parkinson (1948; repr., New York: Routledge, 2006), 25–48; Dull, "Mahan, Sea Power, and the War."

22 Woodville's *Old '76 and Young '48* is in the collection of The Walters Art Gallery, Baltimore, and the Pease print is in the collection of the Library Company of Philadelphia.

23 Department of Arms and Trophies, Metropolitan Fair, *Catalogue of the Museum of Flags, Trophies and Relics Relating to the Revolution, the War of 1812, the Mexican War, and the Present Rebellion* (New York: Charles O. Jones, Stationer and Printer, 1864).

24 Certain US military historians still refuse to use the term "Philippine-American War" on the grounds that Philippine combatants did not have a legitimate state: see, for example, Brian McAllister Linn, *The Philippine War, 1899–1902* (Lawrence: University Press of Kansas, 2000). The passage of the "Brigandage Act," or "Bandolerismo Statute," is discussed in J. Zwick, "Mark Twain's Anti-imperialist Writings in the 'American Century,'" in *Vestiges of War: The Philippine-American War and the Aftermath of an Imperial Dream, 1899–1999*, ed. Angel Velasco Shaw and Luis Francia (New York: New York University Press, 2002), 38–56.

25 Brendan McConville, *The King's Three Faces: The Rise and Fall of Royal America, 1688–1776* (Chapel Hill: University of North Carolina Press, 2006), 295–99, 306–11. Wendy Bellion, "Rituals of Iconoclasm in the Eighteenth-Century British Atlantic World" (lecture, Maynooth University, Feb. 26, 2015).

26 See, for example, Mitch Kachun, "From Forgotten Founder to Indispensable Icon: Crispus Attucks, Black Citizenship, and Collective Memory, 1770–1865," *Journal of the Early Republic* 29, 2 (Summer 2009): 249–86.

27 Julie Spraggon, *Puritan Iconoclasm in the English Civil War* (Woodbridge, UK: Boydell Press, 2003), 81.

28 William Walcutt's *Destruction of the Statue of George III by New York Patriots* is in the collection of Gilbert Darlington, Walcutt's *Pulling Down the Statue of George III* is at Lafayette College, Easton, Pennsylvania, and Johannes Adam Simon Oertel's *Pulling Down the Statue of King George III, New York City* is at the New-York Historical Society.

29 The McRae "'76" prints are available at the Library of Congress.

30 Arthur S. Marks, "The Statue of King George III in New York and the Iconology of Regicide," *American Art Journal* 13 (Summer 1981): 61–82; John Lloyd Stephens, *Incidents of Travel in Greece, Turkey, Russia, and Poland*, 2 vols., 7th ed. (New York: Harper & Brothers, 1839), 2:29, 33–34.

31 See, for example, "Macabebe Scouts 'Water Curing' a Tagalo Official," *Deseret Evening News*, May 10, 1902.

American Art's Dark Matter

IMAGES

Thierry Gervais

Shifting Images: *American News Photographs, 1861–1945*

Between the Civil War and World War II the illustrated press in America gradually came to use photography as a news medium. This major development in visual information was the outcome not simply of technical advances enabling recording of the visible with a minimum of human input,[1] but also of complex cultural changes involving a host of different players.[2] This essay uses specific examples to investigate the circulation factors at work in the publication of press photographs, with a view to a better understanding of the goals and issues involved. Before reaching the reader, a photograph went through technical transitions symptomatic of editorial requirements; the circulation of images from one magazine to another was an indication of the divergent roles assigned to them in different countries; and relocation by press figures triggered transfers of ideas and skills that were subsequently adapted to the new context. Analysis of these transitions from one medium to another and of the circulation of images, subjects, and personnel is particularly appropriate to the booming American setting, but equally important is the need for a wider perspective that stresses the links with Europe. This approach also entails eschewing strict notions of information and authenticity, in favor of close focus on images whose aesthetic analysis sheds light on the editorial requirements and rationales that have guided the publication of news photographs through the decades. In this volume's introduction, François Brunet highlights how several corpuses of

"Brigadier-General George A. Custer," from *Harper's Weekly*, March 19, 1864 (detail, see fig. 6).

A JOURNAL OF CIVILIZATION.

377.]

NEW YORK, SATURDAY, MARCH 19, 1864.

$1,00 FOR FOUR M
$3,00 PER YEAR IN A

Entered according to Act of Congress, in the Year 1864, by Harper & Brothers, in the Clerk's Office of the District Court for the Southern District of New York.

1
Mathew Brady, *Lt. Gen. Ulysses S. Grant Standing by a Tree in Front of a Tent, Cold Harbor, VA*, 1864. Collodion glass plate, 8 × 10 in. (20.3 × 25.4 cm). The National Archives, Washington, DC, 524455.

2
"Lieutenant-General Grant at His Head-Quarters," from *Harper's Weekly*, July 16, 1864. Ryerson Image Centre, Toronto.

American photographs (from nineteenth-century surveys to Farm Security Administration campaigns, especially) entered the history of American art through multiple moments and modes of circulation and recirculation. In his recent analysis of the market of portrait photographs in 1850s London, Geoffrey Batchen advocated for "a history *for photography* rather than a history *of photographs*," which would explore the role of photographic reproducibility.[3] This paper adds another layer to these considerations on reproduction and circulation by analyzing examples of three modes of circulation—technical, editorial, and human—through which photographs have been embedded in the illustrated press. In doing so, it aims to highlight the specific, concrete ways in which they have contributed to the dissemination of visual news, but also to stress the extent to which, in the American context most particularly, press photography has operated as a "formal paradigm in . . . the field of artistic creation," in Gaëlle Morel's terms.[4]

Technical Transitions

Photography became a tool in the news illustration process—as it did in the practice of painting—in the mid-nineteenth century.[5] The earliest recorded use dates from August 26, 1843, when the French weekly *L'Illustration* published an engraving "from a daguerreotype"

Thierry Gervais

HARPER'S WEEKLY.

A JOURNAL OF CIVILIZATION.

VOL. VIII.—No. 394.] NEW YORK, SATURDAY, JULY 16, 1864. [$1.00 FOR FOUR MONTHS. $3.00 PER YEAR IN ADVANCE.

Entered according to Act of Congress, in the Year 1864, by Harper & Brothers, in the Clerk's Office of the District Court for the Southern District of New York.

LIEUTENANT-GENERAL GRANT AT HIS HEAD-QUARTERS.—[PHOTOGRAPHED BY BRADY.]

3
"Sherman and His Generals," from *Harper's Weekly*, July 1, 1865. Ryerson Image Centre, Toronto.

4
Mathew Brady, *General U.S.T. Sherman and Staff*, 1865. Collodion glass plate, 8 × 10 in. (20.3 × 25.4 cm). Library of Congress, Washington, DC, LC-BH831- 2063 [P&P].

of the San Juan de Ulúa Fort in Veracruz.[6] Nothing distinguishes this illustration visually from the others on the same page, apart from the specific mention of its photographic origin.[7] *L'Illustration* began publication in Paris in March 1843, a year after the *Illustrated London News* and four months before the *Illustrirte Zeitung* in Leipzig; all three used woodcuts to illustrate current events and in the process gave rise to a new kind of press entity. At the time, woodcuts were the sole means of producing images in relief that could be associated with type in the composition of a newspaper page. Whatever their provenance—drawing, painting, engraving, photograph—all the images offered to the editors of these weeklies had to pass through the hands of a woodblock engraver if they were to appear in the press. Regularly, then, although not as a matter of course, the photographic halftones of landscapes, cityscapes, public celebrations, and, above all, portraits were transformed into black hatching by wood engravers.

In the United States, *Frank Leslie's Illustrated Newspaper* was launched in 1855 and was followed two years later by *Harper's Weekly*. Until the late nineteenth century, these two periodicals were the country's main sources of visual information: on the eve of the Civil War, they enjoyed a combined print run of 250,000.[8] War photography has since drawn considerable attention, and such exhibitions as WAR/PHOTOGRAPHY: *Images of Armed Conflict and Its Aftermath* (2012–2013, Museum of Fine Arts, Houston) and more specialized ones like *Photography and the American Civil War* (2013–2014, Metropolitan Museum of Art, New York) have been accompanied by meticulously documented benchmark catalogues.[9] In both of these examples, however, the matter of press diffusion of war photographs is scarcely, if at all, addressed; thus the context in which these images found a broad public and contributed to the shaping of a shared visual culture has been neglected. Many Civil War photographs were used as models by engravers working for *Harper's Weekly* and *Frank Leslie's Illustrated Newspaper*. A recent count shows 344 war engravings bearing the caption "from a photograph" in *Harper's Weekly* and 203 in *Frank Leslie's Illustrated Newspaper* over a similar period.[10] In terms of subject matter, these images include numerous portraits of soldiers, war-damaged buildings, and a few photographic curiosities such as horses in movement. A third of this corpus is attributed to Mathew Brady (1823?–1896).

Some of the images published at that time have met with considerable critical success, among them one of General Grant outside his headquarters tent in 1864 (fig. 1), reprinted in the photojournalism

Thierry Gervais

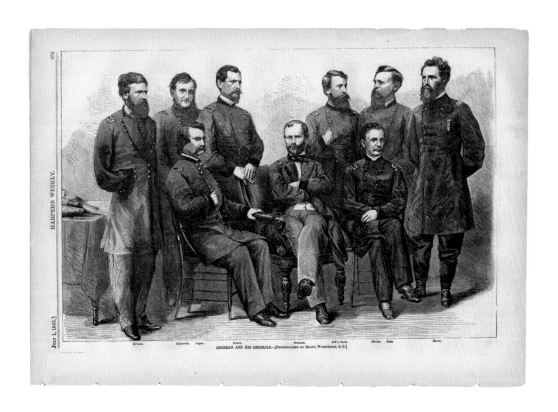

SHERMAN AND HIS GENERALS.—[Photographed by Brady, Washington, D.C.]

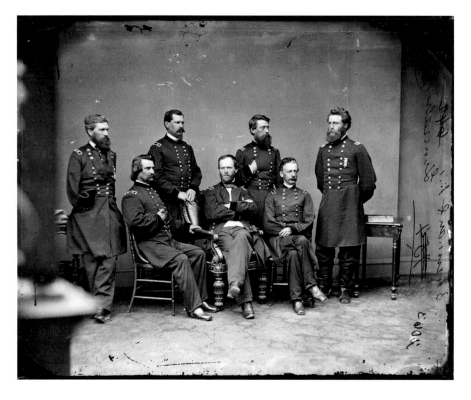

Shifting Images

chapter of Beaumont Newhall's seminal history of photography, first published in 1937.[11] Credited to Brady and now in the National Archives in Washington, DC, this big (8 × 10 inches) wet collodion negative was taken in Virginia, most likely after the Battle of Cold Harbor in which thousands died and victory went to Confederate general Robert E. Lee. In Newhall's book, tight focus on the subject has eliminated all the visual flaws characteristic of collodion plates, which enables a revealing comparison with the cover of *Harper's Weekly* of July 16, 1864 (fig. 2). Should we see in this portrait of Grant— leaning against a tree, staring wearily into space—a man utterly dejected after a last bloody attack he will maybe regret all his life? I will settle here for comparing the original with the reproduction as a way of grasping the passage from one medium to another. As Newhall points out, the illustration "lacks photographic quality."[12] Nonetheless, the reproduction is fairly faithful and adheres to the overall composition of Brady's photograph. We do notice ostensibly "visual" modifications, such as the branch added on the left to balance the one on the right in an image vertically divided by the tree trunk Grant is leaning on, the way the blurred foreground has been corrected by the engraver to make it recognizable, and the addition of shadows of the chair, the tree, and Grant, creating a mass of interlocking geometric shapes on the tent. Despite these pictorial modifications, though, the most radical change is technical. The engraver has shown real savoir faire in conveying the halftones of the Brady photograph, but there can be no mistake about the *Harper's* image: this is an engraving, an image made of black hatching. In the transition from one medium to another, the technological "translation" and stylistic additions have made it impossible to recognize the photographic origin of the weekly's image of General Grant— except by referring to the caption that reads "Photographed by Brady."

A year later, on July 1, 1865, *Harper's Weekly* published a group portrait captioned "Sherman and His Generals. — [Photographed by Brady, Washington, D.C.]" (fig. 3). The original, now in the Library of Congress, was taken at the Grand Army Review, held in the capital May 24–25, 1865, to celebrate the end of the war (fig. 4).[13] The solid poses, the gazes avoiding the lens, and the hands plunged into pockets, hidden behind the back, or resting on the back of a chair all add up to a somewhat curious scene for the contemporary eye; they are, however, characteristic of the long exposure times required by wet collodion studio photography. In the reproduction in *Harper's Weekly*, we once again observe the technical alteration that stamps the transition from photograph to engraving, but equally striking this time are the

engraver's changes to the configuration. Brady's picture is perfectly composed, with the six generals set on either side of the central figure, Sherman, and regularly spaced in a way allowing those seated in the foreground to be intercalated with those standing behind them. We immediately perceive the *Harper's Weekly* engraving as more crowded and lacking the visual rhythm of the placement of the figures in the photograph. In fact, two new figures have been added: General Kilpatrick (upper left) and General Blair (upper right), both of whom took part in Sherman's march to the sea but were absent when Brady's photograph was taken. To give a more accurate idea of Sherman's staff, the engraver has added in what was missing from the photograph. There are other modifications, too, of a more aesthetic order: the small table to the right of the group has been removed and the one to the left, blocked in the photograph by an unfortunately placed post, has been retouched to round off the image in the manner of a studio portrait. The illustration is indeed captioned "photographed by Brady,"

5
George N. Barnard,
*Sherman and His
Generals*, ca. 1864–
1865, printed 1866.
Albumen silver print,
10.078 × 14.095 in.
(25.6 × 35.8 cm).
National Gallery of
Canada, Ottawa, 20711.1.

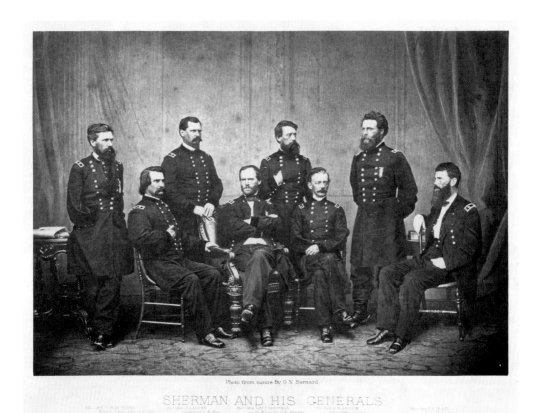

Photo from nature By G N Barnard

SHERMAN AND HIS GENERALS

but the editors have attached more importance to the factual composition of Sherman's staff and the rules of the classical (group) portrait than to an accurate rendering of the photographic record.

In 1866, a year after its publication in *Harper's Weekly*, Brady gave George Barnard (1819–1902) permission to reproduce the image in his album *Photographic Views of Sherman's Campaign*: sixty-one albumen prints showing the main stages of the final offensive (fig. 5).[14] The result contains similar alterations: General Blair has been added on the right (seated), elegant geometrical shapes emerge on the rug, and the composition is framed by a heavy curtain to the right and a perfectly outlined table to the left. Analysis of this move, not only from one medium to another (photograph to engraving), but also from one visual form to another (negative to positive), demonstrates that the authenticity value accorded to the photographic document was all but a nonissue for the press and for the producers of a war photography album aimed at an elite readership. At this level, photographs were seen as images intended to represent an event or idea as exactly as possible—content-wise and aesthetically—so as to capture the attention of a specifically targeted public. In this context, corrections and additions due to the engraver or the printer were considered not shameless manipulations of reality but a necessary formatting process shaped by a dual urge to please and inform.

Other examples illustrate even more overtly this need to adapt photographic forms to the editorial goals of the American press of the 1860s. To illustrate twenty-three-year-old George A. Custer's promotion to the rank of brigadier general, *Harper's Weekly* used an image—Custer urging a splendid steed along at full gallop—that only an illustrator could have produced (fig. 6). Likewise, the cover of *Leslie's Weekly* of January 28, 1865, featured Captain Loring and Lieutenant Colonel Flory's escape from a Confederate camp, "from a photograph by Lillienthal." Just how had Theodore Lilienthal (1829–1894), working with a heavy, cumbersome camera whose glass plates called for long exposure times, been able to capture the largely nocturnal flight of the two Union soldiers? In both cases, it is probable that while the illustrators resorted to photographic portraits for the faces, the narrative compositions and stylistic touches were entirely their own work. Thus photographs served as sources of inspiration for a picturesque staging of current events.

Examination of the circulation of these images from one medium to another makes it clear that photography created no great enthusiasm among editors and that the caption "from a photograph" was relatively

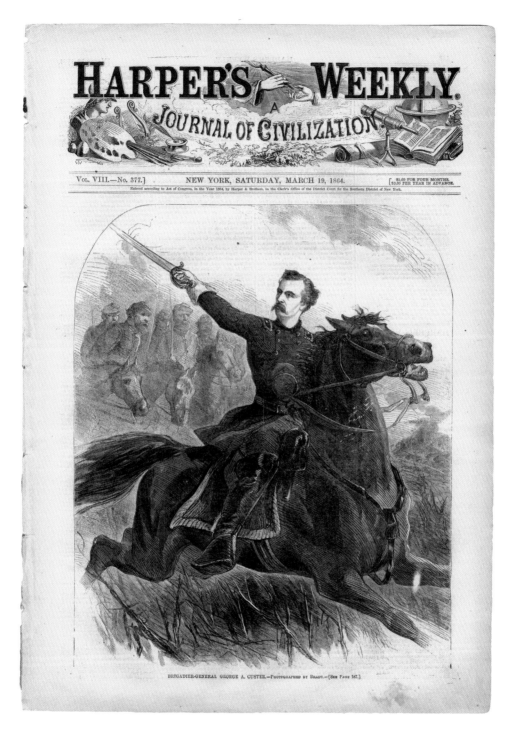

6
"Brigadier-General George A. Custer,"
from *Harper's Weekly*, March 19, 1864.
Ryerson Image Centre, Toronto.

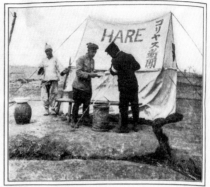

Frederick Palmer, Collier's war correspondent, at lunch in the village of Suk Chun, surrounded by a crowd of curious Koreans

James H. Hare, Collier's war photographer with General Kuroki's army, developing films in the field after the battle of the Yalu

AN HISTORICAL DAY ON THE YALU

By FREDERICK PALMER, Collier's War Correspondent attached to the Japanese General Staff in Manchuria

Note.—The following letter, giving an account of the first day's battle at the crossing of the Yalu River by the Japanese army, April 30, was delayed in transmission, reaching New York a week later than the story of the second day's battle, published in last week's Collier's.

WIJU, May 1

THERE is first the work of seeing the battle, which is a strain on eyes, mind, and body; next of selecting from a thousand impressions the few that space will allow; next of writing; next of finding the censor; finally of sending a messenger to Ping Yang, where it is hoped the wires are not congested, as they are at the front, with official messages. By cable—by cable to a weekly paper—I have striven to press a faint idea of the last two days' operations into a few abbreviated sentences. Pen free and paper free, with fatigue fighting against duty, I may begin the story where I please.

So, taking one man's point of view. I will begin with the guns, which have been my friend and guide. Riding from Ping Yang to Wiju, I heard fifty miles away that a battle had already been fought. Like all rumors, the terror of it was that Truth must sometimes ride in Rumor's company. With a road free of soldiers and thick with lines of straining coolies bearing supplies, twenty—thirty—miles I rode, and still the same report, with the smile and "I don't know" of the quartermasters, made scepticism grow into anxiety. Then I saw on a hillside artillery horses and nearby a battery; a mile further another battery; then two more, and how many more I shall not say. I no longer asked if there had been a general engagement, for there are not general engagements until the guns are up.

I had been at Wiju three days when they began to arrive. Every morning I looked out of my tent door to make sure they had gone no further. I saw the artillerymen starting out at dusk with their spades; I noticed spots on the hillsides where the earth had been freshly turned in preparation for an expected guest. Finally, day before yesterday morning, I saw that the guns and limbers had been swung into position ready for the teams, and that night I heard the rumble of their wheels as they took the roads which branch in every direction from the main highway. If this were not enough, there ran through the whole army the tremor which is unmistakable. This or that minor operation will cause a flutter of expectancy which a bare report and exaggeration may make portentous. When the hour of a great movement is at hand nothing can keep the secret which runs from man to man like some magical fluid. Before the guns began to move we had heard infantry fire at the right—that sacred right where no one except the officers and soldiers whose duty took them was allowed to go.

And by right I mean up the river from Wiju. While they were moving there came the intelligence, with the electric swiftness that conveys the shock of truth, that the Japanese had crossed. For this news, so far as we had known, we might have had to

wait for weeks, or we might have had to wait only for hours. The distance was not more than four miles, and the average citizen may ask why we did not ride to the spot and find out for ourselves. The correspondents are a part of this military organization in that they may go only where they are told. At four in the morning came the word from headquarters with the modest information that by going to a certain place we might see something of interest. The certain place gave one a view varying from one to ten miles.

On the way from camp no sign left any doubt in your mind that the great day had come. Where the guns had been on the more distant slopes were only a few transportation carts packed; where regiments had been encamped were only the ashes of camp-fire and sward that had been pressed by sleeping forms neighbor to that which the artillery horses had plowed with restive hoofs. Over another rise and you saw the lines of marching men moving steadily to the position where they were to be at call if wanted. A glance along any one of the roads which the army had built to lead up to its positions, told its story of a movement in force.

"There will be some artillery practice," said a Japanese officer politely, and he smiled the Japanese smile. It was a knoll high among its fellows to which the correspondent was assigned. There he could see everything except the one thing he wanted to see. Where was it that the Japanese had crossed? The bluffs to the right hid the upper reaches of the river, and you looked to the west as you had before. You saw the town of Wiju once more under the morning mist, with the tower on the bluff that hid it from the Manchurian bank. Nearby the gunners of a battery lay in their

Wounded Russian Officers Captured at the Battle of Chiu-Lien-Cheng, May 2

casemates bathing themselves in the first rays of the sun. Beyond were more shelving hills dipping to the river's edge, while the spreading stream made channels around low sandy islands. Those the Russians had held they had burned and evacuated yesterday. But the Japanese had not occupied them. Their line was still to be seen like a blue flounce to the line of willows that furnished them cover.

Only the creak of axles along the roads could be heard while we waited for the beginning of the great game. We saw orderlies going with the messages to the guns, and then we saw a flash from one of the bluffs, where a Japanese battery was concealed. Others followed, but you saw them not; you looked to see where the first shell struck. A wreath of blue smoke broke over some undergrowth where the Russians had a trench with the same flash as a sky-rocket, but with the difference that wickedly it spelled death instead of frolic, and a man resurrected from the age of crossbows would know instantly that it did. There is nothing in our every-day life comparable with shrapnel fire except lightning: it is the nearest thing to it that a human being can produce, and has the same awful theatricalism. As few men are killed by shell-fire, so few are killed by lightning. The soughing of the fragments of a shrapnel are those of the wind through a telegraph wire multiplied a thousand times and raised to a high key. It sometimes seems to a recruit like a file-tined fork scooping out his stomach and scraping the vertebra of his backbone. Such are his feelings then that his legs will not lift him out of his trench, or if they will, they carry him to the rear.

I was thinking of these things when the Japanese guns turned their attention to what we called the "conical" fort because of the shape of the rise on which this Russian battery was placed. From the first the conical fort had been saucy; from the first it got something like the worth of the money which brings guns and ammunition six thousand miles from Russia to the Yalu. These disturbers of the peace dropped shells into Wiju without an "After you, gentlemen," on a quiet routine afternoon, as the first signal of their presence. They informed the Japanese line on the lower islands what they might expect if they advanced. So far as we knew, there might be others where they came from. When they pleased they could shell the town, but the Japanese gunners remained in their casemates and let them. This was the day when the Japanese might pay off old scores with the unerring aim of days of calculation. A little tardily, but with good practice, as gunners call good killing, the conical fort came into action.

"We've been waiting for you—for you," the Japanese guns seemed to say, and they let go. They covered the position with shrapnel rings which hung still in the clear air, till so fast and thick was the fire in that circle that you saw only the flashes through the smoke. If the Russians would shoot they could not see. A rain of fragments overhead was not enough. The howitzers on the island to the

(Continued on page 29)

7

Page 14 from *Collier's Weekly*, June 25, 1904. New-York Historical Society.

COURRIER DE PARIS

Eh bien ! au risque d'être taxé de chauvinisme, j'avoue que je suis heureux de la victoire que vient de remporter le chauffeur français Théry. J'attends sans émoi les résultats du Derby ou du Grand Prix. Il m'importe peu qu'un poulain français triomphe ou qu'un pur sang britannique passe le premier le poteau. Mais ce n'est pas sans intérêt qu'on voit aux prises les industries de l'Allemagne, de l'Angleterre, de l'Italie, de notre pays pour la conquête de la coupe Gordon-Bennett. Un de nos compatriotes a battu tous ses concurrents. L'équipe française se classe première. Ce n'est point seulement pour nous une satisfaction sentimentale. Le succès aura nécessairement une répercussion dans le monde des affaires et il n'est point douteux que, sur le marché américain notamment, les marques françaises vont être fort demandées. Ajoutons que les adversaires se soient montrés courtois et que l'empereur d'Allemagne et M. Loubet aient échangé des dépêches correctes. L'essentiel est que nos constructeurs d'automobiles semblent avoir reconquis une suprématie qui, pendant plusieurs années, ne leur fut pas contestée.

Les chefs d'Etat encouragent ces épreuves. Le public les suit avec passion. Sur les routes passent et repassent des automobiles. Qui n'a pas sa voiture ? On les vend à crédit. Le rêve de tout employé est de posséder au moins un tricycle à pétrole. On n'entend parler que de direction, de manette et de carburateur. Suivez les quais de la Seine, lisses comme une piste, entre le pont de Billancourt et le pont de Sèvres. Vous apercevrez dans un champ une voiture à vapeur abandonnée. Elle ressemble un peu à ces lourds instruments qui servent à empierrer les rues. C'est dans ce véhicule que vint à Paris — il y a une quinzaine d'années — un des premiers adeptes de l'automobilisme. Cette machine primitive l'amena de la province, de Lyon, si je ne me trompe. J'ai vu passer cette masse. Elle avançait bien lentement. Les badauds riaient de ce mode de locomotion. A vrai dire, il n'était pas très pratique. L'infortuné chauffeur se ruina et finit par remiser son invention dans des terrains vagues. Je crois bien qu'il habite cette étrange voiture qui est rouillée et qui est triste comme une ruine.

Et je songe à la destinée mélancolique de cet homme qui est obligé à l'immobilité et qui, de sa voiture impuissante et qui semble préhistorique, voit défiler à toute vitesse les automobiles qu'il avait rêvées.

« Ne me vantez pas les automobiles, monsieur ! » Ainsi parle le cocher de fiacre. C'est un très vieux cocher. Du haut de son siège il a vu passer plusieurs régimes. Il est informé et doucement sceptique. J'aime ses phrases sages. Mais aujourd'hui il semble être de méchante humeur. Il s'en excuse. Il me fait observer que le Grand Prix vient d'être couru et que l'usage veut qu'à cette époque de l'année les cochers fassent valoir leurs justes revendications et se mettent en grève.

« Le public ne nous prend pas au sérieux, dit-il. C'est de là que vient tout le mal. Il est impossible d'entendre une revue de café-concert sans voir apparaître sur la scène deux personnages indispensables et grotesques : le cocher de fiacre et le sergent de ville. Le cocher de fiacre est toujours ivre, grossier et sale. Le sergent de ville est majestueux, beau parleur et sot. Ce sont des figures de pure convention. Vous êtes habitués à ces fantoches et c'est pourquoi vous n'écoutez pas attentivement nos plaintes.

« Nous sommes très malheureux. Le chansonnier Jules Jouy a déploré jadis notre misérable existence :

Nous sommes les cochers de place;
C'est un métier bien exigeant,
Car, pour y gagner de l'argent,
Il faut sortir quéqu'temps qu'il fasse.

« Nous sommes sans cesse exposés à la congestion pulmonaire et à l'insolation et nous gagnons des sommes dérisoires. Nous sommes trop nombreux et les tramways à traction mécanique, le métropolitain, les voiturettes qu'on peut acheter à bon marché nous font une cruelle concurrence. Les jeunes se transforment en chauffeurs, et ils ont bien raison. Mais les vieux tels que moi doivent se résigner à mourir sur leurs sièges.

« Les temps sont trop durs. Nous ne voulons plus mener à nos risques et périls l'exploitation de nos voitures. Nous désirons être les employés des propriétaires de fiacre, toucher un minimum et avoir un intérêt sur nos recettes. Ce changement ne peut se faire que si l'on adopte un compteur fidèle. On nous affirme que, dans quelques semaines, nos fiacres seront munis d'appareils précis et solides qui enregistreront les kilomètres parcourus par nos clients. Souhaitons que cet espoir ne soit pas déçu. Nous verrons s'ouvrir une ère nouvelle et des relations cordiales s'établiront entre notre corporation et les Parisiens.

« Mais, pour le moment, nous sommes dans la détresse. Nous sommes à la veille de la grève générale annuelle. Considérez que c'est un cocher de fiacre, ce sinistre malfaiteur qui détroussait la semaine dernière les promeneuses du bois de Boulogne. Voyez à quels expédients la gêne nous réduit ! »

Les personnes qui ne sont séduites ni par l'automobilisme ni par la vélocipédie reconnaissent, du moins, que ces sports ont une excellente influence sur notre éducation : ils nous apprennent à lire les cartes. Depuis qu'il *pédale* ou qu'il *chauffe*, le Français a perdu la fâcheuse réputation d'ignorer la géographie. C'est un merveilleux complément de nos études. C'est un point sur lequel on n'a peut-être pas assez insisté au cours des fêtes qui viennent d'être données en l'honneur de nos instituteurs.

Le président de la République a présidé la cérémonie qui avait été organisée dans le palais du Trocadéro pour rendre hommage à l'enseignement primaire. C'est le 19 juin 1872 qu'une ligue, dirigée par Jean Macé et Emmanuel Vauchez, demandait à l'Assemblée nationale de rendre l'instruction gratuite et obligatoire. Cet anniversaire a été célébré par les discours de M. Ferdinand Buisson et de M. Chaumié, ministre de l'instruction publique. Plus de cinq mille personnes acclamaient les orateurs. Des rubans de la Légion d'honneur furent remis à des instituteurs et à des institutrices. Ce fut une manifestation imposante et touchante.

A la sortie du Trocadéro, la foule s'ébranla en bon ordre pour gagner la galerie des Machines où était dressé un banquet pour dix mille personnes. Le repas était frugal, mais la bonne humeur ne cessa pas de régner. Après le banquet, des cirques et des théâtres installés dans la galerie des Machines donnèrent des représentations qui furent très appréciées.

Des fêtes semblables avaient lieu en même temps dans les grandes villes de France, en Algérie, en Tunisie. Partout on commentait le mot de Danton :

« L'instruction est, après le pain, le premier besoin du peuple. »

Et, si l'on n'aperçoit pas dans ces cérémonies des préoccupations politiques, on est heureux de voir fêter les braves gens qui enseignent avec tant de zèle aux petits Français la lecture, l'écriture, les notions d'arithmétique, qui leur donnent ces premières armes, — si indispensables, — pour soutenir la lutte pour la vie.

ANDRÉ FAGEL.

LES FRERES JOLIDAN

Nos lecteurs sont au courant de la réclamation de M. Alphonse Jolidon, huissier à Paris, relativement au titre du roman inédit de M. Michel Corday, dont nous avons commencé la publication dans notre dernier numéro.

Les Frères Jolidon garderont ce nom huit jours encore : la seconde livraison était été en effet imprimée, comme la première, avant l'intervention de M. A. Jolidon. Ils deviendront ensuite Les Frères Jolidan.

Aux lecteurs du premier chapitre du roman il est superflu de faire remarquer que l'un des deux frères qui en sont les héros — l'un grand auteur dramatique, l'autre grand comédien — ne joue un rôle ridicule, odieux, ou même simplement déplaisant. Si nous avons décidé, d'accord avec l'auteur, de modifier leur nom, c'est donc par pure courtoisie envers celui de nos abonnés auquel ils l'avaient fortuitement et bien involontairement emprunté.

LA PHOTOGRAPHIE A LA GUERRE

Nous présentions récemment à nos lecteurs le cinématographe fonctionnant en Mandchourie et enregistrant le passage d'une colonne russe. Leur plaît-il de savoir, maintenant, en quel équipage voyage un photographe correspondant de guerre ? Voici précisément le campement de notre correspondant, M. Hare, un Américain qui vient de remplacer là-bas M. Dunn, Américain lui aussi.

On se rappelle les documents toujours si pittoresques, si éloquents souvent, que nous envoya M. Dunn. Nous avons la certitude que M. Hare ne demeurera en reste ni d'ingéniosité, ni d'habileté professionnelle avec celui dont il vient d'aller occuper la place. Ses premiers envois nous en sont garants.

Sans parler des risques graves auxquels est exposé un correspondant de guerre, photographe ou journaliste, quand on sait dans quelles conditions sont obtenus ces résultats, avec quelles installations rudimentaires il faut opérer, sur le terrain, les manipulations si délicates de l'art photographique, on demeure un peu surpris et on ne songe pas à marchander son estime ou même son admiration à ces collaborateurs audacieux et fertiles en ressources.

Le reporter photographe rentré de son excursion quotidienne, le brassard au bras, le pesant appareil au dos, en quête du beau cliché, de la scène émouvante ou amusante, a, pour développer maintenant ses plaques ou ses films, son laboratoire ambulant à l'abri d'une frêle tente. On peut penser que le matériel y est

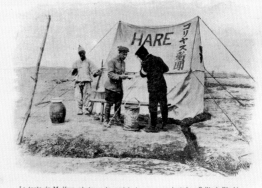

La tente de M. Hare, photographe américain, correspondant du « Collier's Weekly »
et de « l'Illustration », sur les bords du Yalou.

8

Page 422 from *L'Illustration*, June 25, 1904. Private collection.

89 Shifting Images

rarely attached to the illustrations published during the Civil War.[15] We see too that these Civil War photographs were used like all the other image material acquired by the weeklies: they contributed to the illustration process through the agency of the draftsman or the engraver, but their identity was sacrificed, together with their formal qualities, in the interests of a match with illustrational norms. It would seem, then, that while news images certainly conveyed information, they also met predetermined aesthetic criteria. As a guarantee of the efficacy of the images and the commercial success of the periodicals, this subtle balance was for decades endlessly considered and reconsidered by press editors and adapted to the requirements of their readership.

From One Magazine to Another

In the course of the 1890s, the use of the halftone process by the press brought serious competition for wood engravers. The earliest reproductions using this photomechanical method respected photography's shades of gray but were visually monotonous and lacked the powerful, eye-catching contrasts of wood engravings.[16] Nonetheless, for publishers they saved time and money and offered greater layout flexibility, factors which saw them gradually but definitively take over as news vehicles in the illustrated press. The visual adaptations previously effected by the engraver now fell to retouchers whose brushes eliminated superfluous details, corrected blur, and prioritized information within the image.[17] This new use of images also stimulated and facilitated the passage of photographs from one magazine to another—a new form of circulation that highlighted the different roles attributed to the same photographs in different countries.

During the Spanish-American War in 1898, *Collier's Weekly* published photographs by James H. (Jimmy) Hare (1856–1946), who had taken the initiative of covering the fighting.[18] Some years later, as relations between Japan and Russia became strained early in 1904, war had clearly become a major issue for the American press, and *Collier's Weekly* sent an entire team of journalists to Asia—including Jimmy Hare, who followed the Japanese army and sent regular batches of pictures not only to *Collier's* but also to European periodicals like the *Berliner Illustrirte Zeitung* and *Die Woche* in Germany, the *Illustrated London News* in England, and *L'Illustration* and the daily *Le Matin* in France.[19]

In their issues of June 25, 1904, *Collier's Weekly* and *L'Illustration* published the same picture of Jimmy Hare handling developing trays

TWO battalions of Russians of one thousand men each came down the road at 3 a.m., July 4, expecting, apparently, to find no force in front of them, and to take Motienling Pass. At the point a they bayoneted a Japanese picket. Then one of the battalions, belonging to the Twenty-fourth East Siberian Sharpshooters, took up position 2 in a ravine behind the hill b. The other battalion belonging to the Tenth East Siberian Sharpshooters found at c, in a Chinese farmhouse, thirty-six men of the first company, first battalion, Thirteenth Regiment, of Japanese infantry. Though surprised by an overwhelming force, they fought and extricated themselves and the twenty survivors of the hand-to-hand melee fell back, 6, and deployed at 7. The Russian battalion of the Tenth went on by 3 to the Japanese trenches, e, where they deployed in the darkness, after a fashion, and advanced to the position 5. Now the first company, to which the outpost belonged, was encamped at the old temple Kwantei at d. On hearing the shots from the outpost d, they assembled and advanced by 8 to the grove 9, and at its edge they found the twenty men grappling again with the enemy. The lieutenant, appreciating the fact that the rest of the company could not fire while he maintained his position, took his valiant score by the route 9 to the position 10, where he actually had the Russian line, 5, in flank. The third company

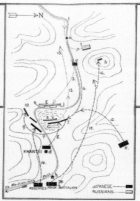

Diagram of the operations near the Kwantei Temples

the hills of the far end of the valley. These men were principally Siberian reservists. Of this type of former soldiers and migrants I once heard a Russian general say:

"There, sir, we have a force to defend Siberia—in these hardy settlers, living an outdoor life, knowing how to fight in a wild country. They have been in the army. They can ride and shoot. Our giants would make short work of the little fellows from Japan. But Japan will not be so foolish—never!"

While he was indulging in such toploftiness over vodka and cigarettes, the little fellows who fought this morning were smiling, smiling, smiling, and drilling, drilling, drilling, and their officers studying, studying, studying.

One of the captured non-commissioned Russian officers said that they thought the pass was lightly held, and they hoped to surprise its occupants. The surprise was of the nature that the elephant gives the man who puts an express bullet into its brain. It was conceived on information as inadequate as the elephant had.

At shortly after three the front of the Russian column bayoneted the Japanese picket who had at first in the darkness mistaken its advance for one of the Japanese patrols which were continually coming and going. This was at the ravine behind the big hill, which is transverse with the road. Here the battalion of the Twenty-fourth went in reserve behind the big hill. With them were their lumbering boilers on wheels, so that the men could have hot soup when they reoccupied Motienling. The battalion of the Tenth, without scouts or flankers, proceeded in column along the narrow valley road. Skobeleff used to do this sort of thing against the Turks, who had no outposts and only mass dispositions. It is sometimes successful against an inefficient enemy or a wild tribe that is being forced out of the path of a mushy empire's advance.

The Bayonet Fight in the Dark

The lieutenant in charge of the thirty-six men in the farmhouse had heard the belated challenge of his picket, and stuck his head out of the window to see the Russian column. His men sprang out with their rifles and ammunition and the clothes they were sleeping in. They fastened themselves on the head of the column with the clear-eyed fury of a mongoose. They had no idea of the numbers of the enemy. They saw forms and knew they were Russians. It did not occur to them to run, let alone surrender.

It was not worth while to shoot. Their natural instinct is to "close in" like torpedo-boats. They used their bayonets. They held on, like a small tackler holding on to the giant who is struggling on with the ball. Their gallantry turned their own surprise into a surprise for the Russians. They forced the Russians to deploy; they unnerved that long column marching peacefully—especially the men in the darkness to the rear. Indeed, they paved the way for the eventual Russian demoralization. In extricating his men from the melee, the lieutenant had to act as one of Cæsar's might in reforming a section of a legion which was broken and fighting desperately; the hand-to-hand the modern long-range rifle was the piece of use at its barrel's end.

But he succeeded in leading those who were not killed or wounded to the crest of the apron-like slope from the red temple grove's edge. There they actually formed a line. Many of the twenty survivors were cut and slashed, but all were game. While the thousand

The man who was wounded in the neck

Russians deployed in a kind of swarming irregularity over rough ground, the twenty waited for them on the one hand, and for support to come up on the other.

Enough shots had been fired to warn the company behind the hill near the outpost and the company in the grove by the old temple. They assembled and charged toward the sound of the firing. Beyond the grove facing the valley, and on the opposite side of the road, the Japanese had made some trenches. The Russians were already across these when the first company emerged from the grove. The Japanese fired and then clinched. It was still so dark that the form of a man could be made out only a few feet away. The Russians came up straggling, but with the power of ten to one. The Japanese were in perfect company order. For half an hour they held their ground with cold steel alone, the officers using their swords—that of Lieutenant Kono was nicked like a saw afterward. The momentum of numbers alone should have borne them back. But there was no light, and the Russian soldier is stupid. When the head of the column stopped, the rear stopped also. This they did as instinctively as the Japanese outpost took the offensive—and there you have the beginning of the explanation of the modern wonder of the East.

All the four Japanese companies engaged belonged to the first battalion of the regiment—the first being at the old temple, the third behind the big hill, and the second and fourth at the new temple in reserve. The third, being further away than the first, came up a little later and formed on the slope of the big hill to the right of the first. The twenty of the outpost were still standing their ground. The lieutenant saw he was in the way of his own company's fire. Such was his control over his men after their ordeal that he led them to the rear and formed them in a flanking position on the left of his own company, which soon after daylight had gained the trench on the other side of the road.

And now the second company came up to the assistance of the other two. With some of the thousand Russians still hanging on the slope, the mass were still at its foot. They had taken no opportunity of ground except to find cover. The battalion of the Twenty-fourth—with its soup kettles, remember—was still doing nothing in the ravine behind the big hill. When the battalion of the Tenth fell back under the flanking and plunging fire, they could have re-formed with the Twenty-fourth and had

was encamped at the position 11, guarding another road. It proceeded by the route 12, forming on to the line 7. From four until six o'clock the fight raged with bullet, bayonet, and sword. In the use of cold steel the Japanese proved himself altogether much cleverer than his antagonist. Then the Japanese, though outnumbered by four to one, drove the Russians out of the trench 4 and in full retreat, 13. The Japanese reserves were at the new temple k, and they proceeded, 14 and 15, with the support that decided the day. The company that went by 15 had a plunging and a flank fire, of course, when the retreat reached the ravine at k, with the battalion of the Twenty-fourth to assist. One of the Japanese companies did not join in pursuit. The major had learned of the presence of the reserve battalion behind the hill b, and the possibility of its striking his own force in flank and rear. So he sent the retained company by 16, where, firing from the heights, they soon made that battalion (which had waited in ck c order) retreat. Meanwhile the pass, which the Russians had attempted, was two and a half miles away. At no time did the Japanese have more than a third of the number of the enemy. The fight was illustrative of the inefficiency of the Siberian reserves, and of the courage and mobility of the Japanese infantry and the coolness, initiative, and cleverness of the under officers of the Japanese army

two thousand men against five hundred. Instead, this surprise party, which was going to eat its lunch in Motienling, piled on down the valley, and at six o'clock the Japanese were pursuing. By this time the Japanese Major Takakusagi knew all about the Russians, their numbers and position, even if the Russians did not know about him. The Russian battalion of the Twenty-fourth, which was in reserve, could come around the hill and on to the flank of the little Japanese force. One company was kept behind to guard against this possibility.

This it did by getting above the battalion and dropping bullets into the party of the soup wagons. So the Twenty-fourth—and its soup wagons—retreated too, and the lot were chased by one-fourth of their numbers right away to the white pagoda.

When you went over that field and saw the disposition which the Japanese had made of their advance force, it was perfect. That is much, and yet there is something that counts more—perfection in mobility. Far away is that cry that the Japanese are merely copyists. This is a terrain far different to that of their own land. They have evolved a system of their own for it. Considering that the Russians are Russians, they were wise not to go on. If they had, the prisoners and booty they would have lost would have been accordingly large. To the limit the Japanese knows his enemy; to the limit he knows his ground; he knows that he can depend upon any force of Japanese, however small, not to lose its nerve; and, finally, his troops have the verve and the mobility to make his dispositions effective. We smile now when we think of our fears about the Japanese cavalry; better than cavalry is it to have the Russians blunder along the valleys and catch them from the hills. But the Japanese himself is never caught in the valley. When the division advanced up from Feng-Wang-Cheng the main body always stopped behind one of the transverse sections of hills, while the advance guard cleared the way. What counts more is the superiority in training of the Japanese officers.

The Aftermath of Battle

All the above is from descriptions on the spot from the Japanese officers and from prisoners. When I arrived, shortly after nine, firing could still be heard from the end of the valley near the white pagoda, and as you came out of the grove of the old temple into the open, the near scene—tragically witnessing defeat, gloriously witnessing a marvelous little victory—did not permit you even to look the length of the green-walled valley. Here was the aftermath of action still reeking. The two companies that had first met the attack had broken ranks. Their rifles were stacked by the roadside. The field was theirs; their duty, to carry in the wounded and bury the dead. Parties armed with spades were already departing for their grim work. On the road itself still lay several of the Russian dead and wounded, these being distinguishable instantly by their size, their dark uniforms, and their big caps. The dead lay as they had expired.

Apart were three more wounded, with an unhurt Russian Red Cross man among them. He was seated in the dust, his arms resting on his knees. He followed the foreigners blankly by rolling his eyes, not by turning his head. The light had broken to find him among these strange, slant-eyed little men, who have already excited Russian superstition to the point of believing that the Japanese are veritable demons for cunning and shooting. It is hard to keep confidence in your god when you are always being beaten. When

Ivan, the jovial Russian prisoner

Bringing in the trophies of the fight

9
Page 12 from *Collier's Weekly*, August 27, 1904. New-York Historical Society.

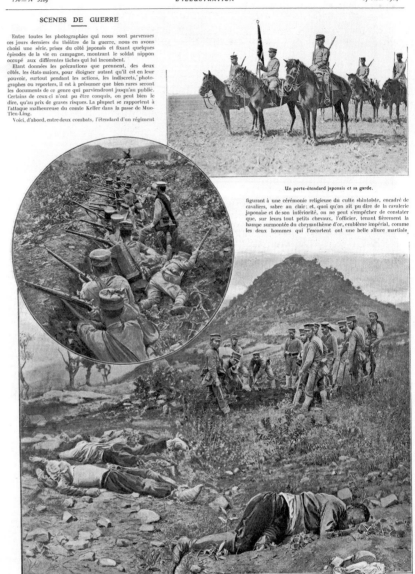

SCENES DE GUERRE

Entre toutes les photographies qui nous sont parvenues ces jours derniers du théâtre de la guerre, nous en avons choisi une série, prises du côté japonais et fixant quelques épisodes de la vie en campagne, montrant le soldat nippon occupé aux différentes tâches qui lui incombent.

Étant données les précautions que prennent, des deux côtés, les états-majors, pour éloigner autant qu'il est en leur pouvoir, surtout pendant les actions, les indiscrets, photographes ou reporters, il est à présumer que bien rares seront les documents de ce genre qui parviendront jusqu'au public. Certains de ceux-ci n'ont pu être conquis, on peut bien le dire, qu'au prix de graves risques. La plupart se rapportent à l'attaque malheureuse du comte Keller dans la passe de Muo-Tien-Ling.

Voici, d'abord, entre deux combats, l'étendard d'un régiment

Un porte-étendard japonais et sa garde.

figurant à une cérémonie religieuse du culte shintoïste, encadré de cavaliers, sabre au clair; et, quoi qu'on ait pu dire de la cavalerie japonaise et de son infériorité, on ne peut s'empêcher de constater que, sur leurs tout petits chevaux, l'officier, tenant fièrement la hampe surmontée du chrysanthème d'or, emblème impérial, comme les deux hommes qui l'escortent ont une belle allure martiale

L'attaque de la passe de Muo-Tien-Ling : une compagnie de tirailleurs arrêtant l'élan des Russes. — L'assaut repoussé : les devoirs funèbres rendus aux vaincus.
Phot. Hare. — Copyright for U. S. A. by Collier's Weekly.

10
Pages 136–37 from *L'Illustration*, August 17, 1904. Ryerson Image Centre, Toronto.

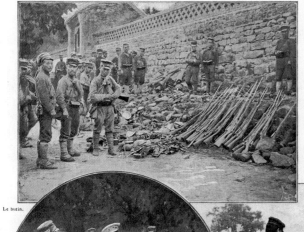

Le butin.

Prisonnier !

La critique des "opérations"
par le major Takakusangi.

même dans cette circonstance pacifique.
Mais, maintenant, les Japonais sont au
feu. Couchés dans la tranchée, pendant
un assaut de l'ennemi, les fantassins de
la première ligne, celle qui soutient tout
d'abord le choc de l'assaillant, sont atten-
tifs, l'arme au poing, le doigt à la détente,
prêts à tirer, au premier signal, aussitôt
que le but humain sera à « bonne portée ».
Ce but, qui court à la mort, un officier,
debout, le guette, plus exposé lui seul
que tous les autres aux balles russes qui
ont déjà abattu plus d'un défenseur de la
position.

Puis ce sont quelques clichés saisis
après la bataille : ici, une équipe de sol-
dats japonais préparant une tombe aux
morts, qui gisent de place en place sur
la terre nue, l'un, au premier plan,
tombé à côté de sa « boule de son », au
moment, sans doute, où, afin de se donner
des forces pour combattre, il prenait un
suprême et maigre repas ; là, la moisson
des fusils enlevés à l'ennemi, rangés en
gerbes, contre les murailles du temple de
Kouan-Tu, pêle-mêle avec des débris de
fourniment, des munitions, tout un
fatras bizarre ; plus loin, un officier japo-
nais, le major Takakusangi, faisant à des
camarades la critique du combat, à deux
pas de pauvres cadavres encore sans sé-
pulture, refroidis à peine ; puis des blessés
par las, les mourants exhalant leurs der-
niers râles près de leurs compagnons
légèrement atteints, sous l'œil des vain-
queurs, sans doute émus malgré eux
devant ces adversaires de tout à l'heure,
maintenant réduits à l'impuissance et
captifs.

Enfin, un tableau presque reposant,
après ces visions pénibles : celui de deux
petits soldats japonais qui, chargés de la
conduite d'un lamentable Russe, griève-
ment blessé, le cou traversé d'une balle
et se traînant cependant, mais incapable
de porter son équipement, l'ont débar-
rassé de ce faix pour lui rendre la mar-
che moins pénible.

Et, au moment où, de part et d'autre,
on se reproche violemment, d'inutiles,
d'atroces cruautés, il est consolant de
penser que la férocité n'est, ni dans une
armée ni dans l'autre, la règle sans
exceptions.

L'attaque de la passe de Muo-Tien-Ling : les blessés et les morts avant l'arrivée des civières.
Phot. Hare. — Copyright for U. S. A. by Collier's Weekly.

THE GREATEST BATTLE SINCE GETTYSBURG

Photographs by James H. Hare, Collier's Special War Photographer with the Japanese First Army. Copyright 1904 by Collier's Weekly

JAPANESE ENTERING LIAO-YANG THROUGH A BREACH IN THE OLD CITY WALL WHICH THE RUSSIANS MADE TO FACILITATE THEIR RETREAT

PILES OF WHEAT, FIRED BY THE RUSSIANS BEFORE THEY EVACUATED LIAO-YANG, BURNING IN THE ...

FOUR CANET GUNS CAPTURED BY THE JAPANESE AT NANSHAN HILL, AND DRAGGED 150 MILES BY HAND, IN ACTION AGAINST THE RUSSIANS AT LIAO-...

SOLDIERS OF KUROKI'S ARMY BUILDING A FUNERAL PYRE PREPARATORY TO BURNING TH...

outside his photography tent (figs. 7 and 8). Beside it, the American magazine placed a portrait of journalist Frederick Palmer surrounded by Korean villagers. Set at the top of the page, the two images formed a visual preamble to the clashes on the Yalu River, as experienced and recounted by Palmer. In *L'Illustration*, the photograph of Hare was the only illustration on the page and the subject of an article titled "Photography at War," which described the difficulties and dangers facing the photographer in the field and warned readers of the effect of these conditions on the quality of the images: "Not to speak of the serious risks run by a war correspondent, photographer, or journalist, when we know the circumstances behind these results—the rudimentary facilities, the delicacy of handling required by the art of

photography—we can only express surprise and would not dream of stinting on our respect and admiration for our bold, inventive contributors. . . . Think of all the courage this represents . . . and do not be too severe if from time to time we show you an image that is slightly less than perfect."[20] This attentiveness is to be seen in the treatment of the image: where the American magazine crops the photograph slightly so as to enhance its content in small-format reproduction, L'Illustration takes its brush to the foreground and background, heightening the contrasts and softening the edges of the image so that it merges into the page.

Thus the French weekly brought special care to photographic layout and greater freedom to graphics and image orchestration generally. Ten days apart, the two magazines recounted the clashes in the Muo-Tienling Pass and chose the same photograph of a Russian soldier wounded in the throat. In a long text spread over three columns, Collier's Weekly described in the first person the different phases of the battle as observed by the journalist, stressing the strategic skill of the Japanese officers and the "stupidity" of the Russian military (fig. 9). The picture of the wounded Russian soldier appears here as an illustration of the article, placed at the bottom left of the page and separated from the text by a thick black border. The narrative, which makes no direct reference to the photograph, and the layout, which clearly separates text and image, offer the reader two distinct approaches, which coexist on the page rather than actually coming together as an account of the events.[21] Things are done differently in L'Illustration, which leaves less space for the text and offers a complex layout that plays with the shape of the images, using silhouetting to generate visual effects and overlaying to interconnect the pictures (fig. 10). The text itself is not an eyewitness account but a description of the images: "From among all the photographs we have received these last few days, we have chosen a series, taken on the Japanese side."[22] The French editorial team, which usually called on its illustrators to create the images it needed, now had to find a way of dealing with the photographs that were coming in, and resort to a series provided a solution that enabled use of Jimmy Hare's snapshots. The result was a visual account with a beginning and an end, and graphic effects—silhouetting, overlays—whose visual rhetoric was at once narrative and eye-catching.

The publication of Hare's photographs of the encounter between the two armies at Liao-Yang in the late summer of 1904 underscores this difference in the treatment of news images. In the United States,

1. — Le généralissime japonais,
maréchal Oyama, devant sa tente;
le maréchal a laissé pousser sa barbe.

2. — Les attachés militaires étrangers assistant
au combat, du point qui leur a été assigné.
Au premier plan un cerf-volant.

3. — Vue générale de

6, 7 et 8. — Le photographe, M. Hare, s'avançant vers la ligne du feu, prend successivem
Pendant ce temps, l'infanterie japonaise attaque la position russe et la pre

11. — Dans les

9. — Soldats au repos, endormis après le combat. 10. — Ruines du temple en partie détruit par les obus.

13. — Une des cours du temple transformée en ambulance.

14. — Morts et mourants

UNE JOURNÉE DE COMBAT ENTRE YEN-TA
Photographies J.-H.

12
Pages 412–13 from *L'Illustration*, December
10, 1904. Ryerson Image Centre, Toronto.

, centre de l'action.

4. — Troupes de réserve abritées
derrière un talus.

Général anglais Hamilton. Général Kuroki.

5. — Le général Kuroki suivant les opérations
de ses troupes.

-dessus des batteries japonaises tirant sur la colline du Temple occupée par les Russes.
Hare gagne aussitôt la position conquise et y prend les clichés ci-dessous :

anc de la colline.

12. — Cadavres russes et japonais au sommet de la colline.

mbat fut le plus acharné.

15. — M. Hare s'arrête de photographier pour donner ses soins aux blessés.

HA-HO PHOTOGRAPHIÉE HEURE PAR HEURE

lier's Weekly.

97 Shifting Images

Collier's Weekly devoted seven pages of its November 5 issue to an account of the battle. Images played a prominent part but revolved around an article by Frederick Palmer titled "The Greatest Battle since Gettysburg."[23] The article opened with a large picture on the left-hand page, while another image served as a frontispiece and a third was placed like an illumination, introducing the text. The remaining images were rectangular, sometimes interacting symmetrically but without any actual link between them. The last double page was entirely given over to illustrations beneath the title of the article: four photographs taken after the battle, simply laid out, all of the same format, and each accompanied by a one-line caption (fig. 11). Hare's photographs also went to *L'Illustration*, which devoted its center spread to the story in the December 10 issue. Usually allotted to large drawings by leading illustrators, this very special spot offered readers a series of small photographs[24]—sixteen in all—under the heading "A Day's Fighting between Yen Tai and the Cha Ho, Photographed Hour by Hour" (fig. 12). Laid out in four lines, the images were carefully sequenced: beginning at the Japanese headquarters, they follow the photographer as he advanced toward the "line of fire." To ensure that the reader could accompany him through the battle, the editors numbered the images, indicating their order in relation to the unfolding of the action. This layout provided a visual account independent of the articles and the rest of the issue, and gave the reader/spectator the impression of having direct access to the conflict. On this double page, it was no longer a matter of *representing* a battle scene, but of *presenting* the actual battle, "hour by hour."

Thus an examination of the circulation of Jimmy Hare's photographs from one continent and one magazine to another reveals the editorial teams' work of mediation. While the task had hitherto been that of the illustrators, halftone reproduction of photographs brought with it a new editorial post, that of the art director whose task was to choose the images and organize their layout so as to give them meaning and visual appeal. The same Jimmy Hare photographs were laid out differently, in response to differing journalistic aspirations and the specific expectations of the readership of each magazine. The pictures of the Russo-Japanese War published in *Collier's Weekly* followed the illustrative habits developed for engravings, the intention being to complement the journalist's personalized narrative. By contrast, *L'Illustration* covered the same events with an anonymous text based on images whose organization on the page suggested both narrative and spectacle. More extended and systematic study of such differences

Thierry Gervais

might enable larger interpretations, concerning, for instance, the role of differing national and professional traditions; for our present purposes, it is enough to stress the editorial process of circulation and multiple publication as it fashioned the historical apparition of Jimmy Hare's photographs—and their different aesthetic treatments as illustrations.

Men on the Move

This study of the treatment of images and the readily observable differences between two magazines' coverage of the same events raises the question of the movements of the men who carried out the work of editorial mediation. The interwar years saw many Europeans flee Nazism and go into exile in North America, among them German pressmen who began fresh careers in the New World. The launch of *Life* magazine by Time Inc. in New York in November 1936, together with the coming of the photographic essay concept, throws interesting light on this migration and points up the influences at work in defining an editorial line and a visual identity.[25]

Only a few weeks after Adolf Hitler came to power in 1933, Ullstein, publisher of the illustrated magazines *Berliner Illustrirte Zeitung* (*BIZ*), *UHU*, and *Die Dame*, began losing control of its publications; and between 1933 and 1935, most of its leading figures, among them Kurt Korff, Kurt Safranski, Martin Munkácsi, Felix H. Man, and Alfred Eisenstaedt, left Germany. The majority went to North America, where they began anew in the illustrated press.[26] In New York, then, European inspiration among press publishers was not just rhetorical effect to attract readers but a thoroughgoing intercontinental transfer of skills.

In New York in December 1934, Time Inc.'s Henry Luce (1898–1967) and Daniel Longwell met with Kurt Korff (1876–1938) and Kurt Safranski (1890–1964) to share their experiences as publishers. As, respectively, former editor in chief of *BIZ* and former manager of Ullstein's magazine division, the two had played a considerable part in the success of *BIZ*, which in 1931 had a circulation of 1.9 million.[27] This success was founded on serials written by such renowned authors as Vicki Baum and scrupulous attention to the choice of photographs.[28] On the agenda at the Time Inc. meeting was a plan for a general news magazine—those attending were shown a mock-up prepared by Safranski[29]—and how to get it running in North America. From then on, the two German émigrés went their separate but complementary ways: Korff worked as a consultant for Time Inc.

RICH AND POOR, OLD AND YOUNG, JAPANESE LOVE MOVIES, RADIO, SENSATIONAL JOURNALISM AND PHONOGRAPHS EVEN MORE THAN WESTERNERS DO

THE JAPANESE: THE WORLD'S MOST CONVENTIONAL PEOPLE

As late as 600 A.D., the Japanese were about as barbarous as the tribes of North Europe. But when they looked about for a civilization to copy, the nearest to hand was the magnificent culture of great China and they borrowed it almost intact—laws, sciences, trades, alphabet, art, clothes and religion. They did such a fine job of adapting that today they look down on the Chinese as an anarchic, crude and undisciplined people that has left its great past far behind. The great Japanese virtues of today are the old Chinese virtues of Confucius—sincerity, loyalty and decorum.

Japan has built a singularly effective civilization on its Chinese models. Loyalty and decorum are virtues primarily useful, not to oneself but to other people. Every Japanese inherits at birth a mass of loyalties and proprieties. His whole life is stylized for him by elaborate social, moral and legal codes, written and unwritten, that cover every situation he can possibly get into. He is taught to act always by the rules. Hence he is never embarrassed because he always knows that he is doing the "right thing." His politeness, so impressive to foreigners, is merely conventionality. He is taught not to take seriously any individualistic impulse that occurs to him and to trust those whom God has put above him. He feels himself more of a man when he disciplines himself than when he "expresses" himself. And he is happiest in a swarming crowd. The result is that the Japanese is not much good by himself (Japan has produced almost no great writers, artists or scientists) but superb in the mass.

The Japanese relax naturally into a squat for curbside conversations. The head falls forward and leans on the hand. The woman's old-fashioned kimono is suitable for squatting but the press in the man's modern trousers is being ruined. In this position the people of Japan are now pondering war with China.

13
Pages 40–41 from "The Japanese: The World's Most Conventional People," *Life*, August 30, 1937.
Ryerson Image Centre, Toronto.

This man's trade is to lower fire risks by brandishing his apparatus in front of an uninsured house. This relic of Shintoism still has a multitude of Japanese believers.

A store-float elephant celebrates the landing of U. S. Commodore Perry at Shimoda in 1853. The baskets advertise *saké* liquor and soya sauce: the blanket, the store's rice.

Religious minstrels play bamboo flutes for their supper before a restaurant. They hide their faces with baskets which are also used to conceal arrested persons on trial.

Ancestors of the whole Buddhist congregation at Tsurumi-Soji-ji are memorialized in this battalion of wooden tablets on the temple altar. The names are not their real ones but the Buddhist names given after death. The Buddhist religion long ago edged out Japan's native, primitive Shintoism.

Pilgrim beggars of the Buddhist Hokké sect are drumming for their supper (*above*). Japan is full of pious itinerants. A Japanese juggler by instinct, the balancing bicyclist (*at right*) is delivering bowls of *soba*, a low-priced kind of wheat vermicelli largely eaten in offices by busy workers.

CONTINUED ON NEXT PAGE

101 Shifting Images

in the experimental department directed by Longwell.[30] He met regularly with members of the team, had lengthy discussions with Longwell, sent out numerous memoranda, and wrote a document titled "Essential Outline for a New Illustrated Magazine,"[31] whose suggestions included covering cultural news, never using the same subject twice in the same issue, and a meticulous choice of images. The strategies underlying *BIZ*'s success and reputation—among them negotiation of exclusive rights and good rates for photographers—were also brought on board, guaranteeing the quality of the images used. Thus Korff shared his experience in illustration, insisting on the best ways of obtaining, selecting, and editorially enhancing images.

It was in December 1935, after more than a year working in the American press, that Safranski, realizing what was needed in the way of images and what his own skills were worth, got together with Ernest Mayer and Kurt Kornfeld to set up the Black Star photography agency.[32] Mayer had founded the Mauritius agency in Germany in 1929, and he drew on its established network to meet Longwell in 1936 and offer him Black Star's services. The upshot of the meeting was that for a fee of $5,000 Time Inc. was given a year's special access to all images taken by Black Star's photographers and all those the agency acquired overseas. Time Inc. was thus securing the services of experienced, innovative picture editors. Mayer even took credit for convincing the American publishers of the value of the photographic series.[33] Obviously claims like these are hard to verify, but long photographic series began appearing with the first number of *Life* on November 23, 1936.[34] The editorial board even came up with a definition of these series as a journalistic practice in their own right: the photographic essay. Henceforth the definition extended to all series or groups of images covering the same subject on one or more pages. But before becoming this vague concept, the photographic essay had already been defined in a specific historical situation that reveals just how European ideas had been adjusted to suit the North American context.

In discussions about the journalism profession, Luce's position was clear-cut: any notion of objectivity was illusory. He urged his editorial teams to take sides and express a point of view. The task was no longer to reflect what was happening but to make it the stuff of an editorial line.[35] In April 1937, the *Life* editors published the short article "The Camera as Essayist," sticking closely to Luce's editorial policy, defining the photographic essay concept, and assigning a specific role to photography: "When people think of the camera in

journalism they think of it as a reporter—the best of reporters: the most accurate of reporters: the most convincing of reporters. Actually, as *Life* has learned in its first few months, the camera is not merely a reporter. It can also be a commentator. It can comment as it reports. It can interpret as it presents. It can picture the world as a seventeenth-century essayist or a twentieth-century columnist would picture it."[36]

So where the standard rhetoric justifying the use of photography in the general news press had so far opted for emphasizing the medium's mechanical character, *Life* took a contrary stance in presenting the camera not as an incontrovertible recording tool but as a means of recounting, providing evidence, mediatizing, and giving a point of view. The photograph was no longer put forward as a window onto the world but as a representation shaped by the photographer. Thus, the men at *Life* retained their European colleagues' attachment to the snapshot, taken without the subject's knowledge and masking the presence of the photographer, as well as to the impact of the series; but at the same time, they presented the photographer, armed with his camera, as the prism through which news was filtered before being handed on.

Some months later, this clear, uncompromising stance gave rise to the formal addition of the Photographic Essay to *Life*'s table of contents. A count of the reports published and the photographs reproduced under this heading provides some interesting statistics and an indication of how the editorial discourse was actually put into practice in the magazine. Between 1937 and 1962, 1,292 photographic essays were published, and in 769 cases the section contained only one essay.

14
Yonosuke Natori,
*Japanese War, Army
Recruits and Training*
(reverse), ca. 1940.
Gelatin silver print,
8 × 10 in. (20.3 × 25.4 cm).
Ryerson Image Centre,
Toronto. The Black
Star Collection,
BS.2005.074394/45-222.

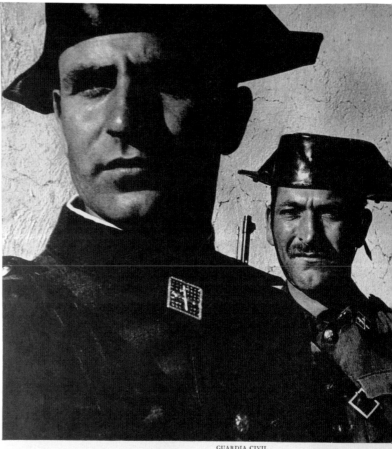

GUARDIA CIVIL

These stern men, enforcers of national law, are Franco's rural police. They patrol countryside, are feared by people in villages, which also have local police.

VILLAGE SCHOOL

Girls are taught in separate classes from the boys. Four rooms and four lay teachers handle all pupils, as many as 300 in winter, between the ages of 6 and 14.

◄ **FAMILY DINNER**

The Curiels eat thick bean and potato soup from common pot on dirt floor of their kitchen. The father, mother and four children all share the one bedroom.

126

15
Pages 126–27 from "Spanish Village: Photographed for *Life* by
W. Eugene Smith," *Life*, April 9, 1951. Ryerson Image Centre, Toronto.

A CHRISTENING

While his godfather holds him over a font, the priest Don Manuel dries the head
of month-old Buenaventura Jimenez Morena after his baptism at village church.

THE THREAD MAKER

A peasant woman moistens the fibers of locally grown flax as she joins them in a
long strand which is spun tight by the spindle (right), then wrapped around it.

CONTINUED ON NEXT PAGE 127

Among these long essays, only 418 were the work of a single photographer:[37] in other words, a substantial number of *Life's* photographic essays were put together by members of the editorial team. Picture editors like Wilson Hicks—but also art directors like Bernard Quint (who laid out W. Eugene Smith's 1951 "Spanish Village" essay)—chose and arranged the news pictures, with the series ultimately subject to the approval of the managing editor.[38] Thus the photographers were theoretically promoted to the rank of essayists, but in practice the weekly kept a firm hand on its visual content.

A qualitative analysis also shows that the editors allowed themselves interpretative discretion. The first essay to appear under the new rubric was published on August 30, 1937, with the ambiguous title "The Japanese: The World's Most Conventional People" (fig. 13).[39] For this set of thirty photographs, the editors drew on nine different sources, among them freelance photographers (Masao Horino) and agencies (Associated Press, Wide World, Keystone, Pix, and Black Star). At the time, Black Star represented Fritz Henle and, most notably, Yonosuke Natori (1910–1962), thirteen of whose photographs were included. A number of Natori's original prints are now in the Ryerson Image Centre collection in Toronto, and several of them have been stamped on the back, "Natori—Photographs should not be used for anti-Japanese purposes" (fig. 14).[40] And so, contrary to his express wishes, Natori's images make up a substantial part of an exercise in racist propaganda. A photographer's style could also explain why his photographic series did not appear under the Photographic Essay heading. With its saturated blacks and tight framing, "Spanish Village" by W. Eugene Smith (1918–1978) was stylistically very distinctive, and included compositional references to such biblical scenes as the Lamentation of Christ (fig. 15); it appeared not in the Photographic Essay section, but under the new Pictorial Essay heading (fig. 16) (introduced in 1947), designed by the editors for "the work of the men who both create and record the culture of their times: the artists."[41]

A notable outcome, then, of this movement of pressmen from one continent to another was the circulation of their ideas regarding news photography, together with the implementation of those ideas and their necessary adaptation to the North American context. German illustrational practices played a large part in shaping the photographic essay concept as developed in *Life* between 1937 and 1962, with the aesthetics of the snapshot and the serialization of images becoming standard features of the rhetoric of information. It was in this American setting, too, that the concept of authorship evolved,

LIFE

Vol. 30, No. 15 REG. U.S. PAT. OFF. **April 9, 1951**

CONTENTS

16
Table of contents
from *Life* (detail),
April 9, 1951.
Ryerson Image
Centre, Toronto.

meeting photojournalists' need for recognition but at the same time causing them all sorts of frustration in practice.[42]

The study of the reproduction of images in magazines and the people behind this publication process underscores the ubiquity of photographs that has characterized modern press illustration. These photographs passed from hand to hand and were sufficiently malleable to enable faster and more ample news illustration while also serving the purposes of different discourses. This is why journalistic stances and statements of intent such as the one concerning the photographic essay are indisputable sources of historical information; but their true worth can only be appreciated in light of the actual use to which photographs were put. The study of the pragmatics of visual information also requires an appreciation of the aesthetic character of press images whose history can only dispense with analysis at the risk of

considering them mere windows opening onto the world,[43] rather than the representations that they are. Brought to light by the examination of their different modes of circulation, the adjustments photographs have undergone and the evolution of their layout over time indicate that the effectiveness of press photographs depends not solely on the conditions of their production but also on their formal aspects, their presentation, and their publication contexts. This means that we must be ready to see these news images not only as vehicles for information, but equally—or maybe above all—as triggers for collective emotion. Published photographs, which enjoyed a wider dissemination than the photographic images by themselves, appear then as inescapable "visual" counterparts to the more consecrated works of the fine-arts tradition.[44]

1 Tim Gidal, *Modern Photojournalism: Origin and Evolution, 1910–1933* (New York: Collier Books, 1973); Gisèle Freund, *Photography & Society* (Boston: D. R. Godine, 1980).

2 Bodo von Dewitz and Robert Lebeck, *Kiosk: A History of Photojournalism* (Göttingen, Ger.: Steidl, 2001); Mary Panzer and Christian Caujolle, *Things as They Are: Photojournalism in Context since 1955* (New York: Aperture Foundation/World Press Photo, 2005); Thierry Gervais and André Gunthert, eds., "La Trame des images: Histoires de l'illustration photographique," special issue, *Études photographiques* 20 (June 2007); Christian Delage, Thierry Gervais, and Vanessa Schwartz, eds., "Caught in the Act: Re-thinking the History of Photojournalism," special issue, *Études photographiques* 26 (Nov. 2006); Vincent Lavoie, *Photojournalismes: Revoir les canons de l'image de presse* (Vanves, Fr.: Hazan, 2010); Jason Hill and Vanessa R. Schwartz, eds., *Getting the Picture: The Visual Culture of the News* (London: Bloomsbury, 2015).

3 Geoffrey Batchen, "Double Displacement: Photography and Dissemination," in *The "Public" Life of Photographs*, ed. Thierry Gervais (Toronto: RIC Books; Cambridge, MA: MIT Press, 2016), 73.

4 Gaëlle Morel, "A Formal Paradigm for Contemporary Art," in Hill and Schwartz, *Getting the Picture*, 266-71 (quotation on 266).

5 Dominique de Font-Réaulx, *Painting and Photography, 1839–1914* (Paris: Flammarion, 2012).

6 *L'Illustration*, Aug. 26, 1843, 404.

7 Regarding the first uses of photographs in the press, see Kevin Barnhurst and John Nerone, "Civic Picturing vs. Realist Photojournalism: The Regime of Illustrated News, 1856–1901," *Design Issues* 16 (Spring 2000): 59–79; Thierry Gervais, "D'après photographie: Premiers usages de la photographie dans le journal *L'Illustration*," *Études photographiques* 13 (July 2003): 56–85

8 John Tebbel, *The Magazine in America, 1741–1990* (New York: Oxford University Press, 1991), 18–23.

9 *WAR/PHOTOGRAPHY: Images of Armed Conflict and Its Aftermath* (Houston, TX: Museum of Fine Arts, Houston; New Haven, CT: Yale University Press, 2012); Jeff L. Rosenheim, *Photography and the American Civil War* (New York: Metropolitan Museum of Art, 2013).

10 The inventory of *Harper's Weekly* spans January 1861 to December 1865, and the inventory of *Leslie's Illustrated Newspaper* spans December 1860 to September 1865. They were produced by the author, with the help of Stephanie Hofner, for the exhibition *Dispatch: War Photographs in Print, 1854–2008* (Sept. 17–Dec. 7, 2014, Ryerson Image Centre, Toronto).

11 Beaumont Newhall, *The History of Photography: From 1839 to the Present* (New York: Museum of Modern Art, 1982), 250.

12 Ibid., 249

13 Rosenheim, "Barnard and His Views of Sherman's Campaign," in *Photography and the American Civil War*, 195–219.

14 Copies of this print exist in the Metropolitan Museum of Art, New York, and in the J. Paul Getty Museum, Los Angeles. The one analyzed for this paper is part of the National Gallery of Canada, Ottawa (reference number 20711.1).

15 Kate Addleman-Fraenkel, "Photographic Engravings during the American Civil War," in *Dispatch: War Photographs in Print, 1854–2008*, ed. Thierry Gervais (Toronto: Ryerson Image Centre, 2014), 65–73.

16 Richard Benson, "Photography in Ink: Relief and Itaglio Printing," in *The Printed Picture* (New York: The Museum of Modern Art, 2008), 210–239.

17 Thierry Gervais, "On Either Side of the 'Gatekeeper': Technical Experimentation with Photography in *L'Illustration* (1880–1900)," *Études photographiques* 23 (May 2009): 51–63.

18 Cecil Carnes, *Jimmy Hare: News Photographer, Half a Century with a Camera* (New York: Macmillan, 1940); Lewis L. Gould and Richard Greffe, *Photojournalist: The Career of Jimmy Hare* (Austin: University of Texas Press, 1977).

19 Thierry Gervais, "'The Greatest of War Photographers': Jimmy Hare, a Photoreporter at the

Turn of the Twentieth Century," *Études photographiques* 26 (Nov. 2010): 35-49, from which I am reproducing a few paragraphs here.

20 "La photographie à la guerre," *L'Illustration*, June 25, 1904, 22–23.

21 *Collier's Weekly*, Aug. 27, 1904, 12.

22 *L'Illustration*, Aug. 17, 1904, 136.

23 Frederick Palmer, "The Greatest Battle since Gettysburg," *Collier's Weekly*, Nov. 5, 1904, 10–16.

24 Tom Gretton, "Différence et compétition: L'imitation et la reproduction des oeuvres d'art dans un journal illustrée du XIXe siècle," in *Majeur ou mineur? Les hiérarchies en art*, ed. Georges Roque (Nîmes, Fr.: Jacqueline Chambon, 2000), 105–43. See also Tom Gretton, "The Pragmatics of Page Design in Nine-teenth-Century General-Interest Weekly Illustrated News Magazines in London and Paris," *Art History* 4 (Sept. 2010): 680–709.

25 Wendy Kozol, Life's America (Philadelphia: Temple University Press, 1994); Erika Doss, ed., *Looking at* Life *Magazine* (Washington, DC: Smithsonian Institution Press, 2001); Chris Vials, "The Popular Front in the American Century: *Life* Magazine, Margaret Bourke-White, and Consumer Realism, 1936–1941," *American Periodicals* 16, 1 (2006): 74–102; Jason Hill, "On the Efficacy of Artifice: *PM*, Radiophoto, and the Journalistic Discourse of Photographic Objectivity," *Études photographiques* 26 (Nov. 2010): 50–70.

26 Cynthia Zoe Smith, "Émigré Photography in America: Contribution of German Photojournalism from Black Star Picture Agency to *Life* Magazine, 1933–1938" (PhD diss. University of Iowa, 1983); Hanno Hardt, "Pictures for the Masses: Photography and the Rise of Popular Magazines in Weimar Germany," *Journal of Communication Inquiry* 13, 1 (Jan. 1989): 7–29; Daniel H. Magilow, *The Photography of Crisis: The Photo Essays of Weimar Germany* (University Park: Pennsylvania State University Press, 2012).

27 Winfried Lerg, "Media Culture of the Weimar Republic: A Historical Overview," *Journal of Communi-cation Inquiry* 13, 1 (Jan. 1989): 94–110.

28 Kurt Korff, "Die Berliner Illustrirte," in *50 Jahre Ullstein, 1877–1927*, ed. Max Osborn (Berlin: Ullstein Verlag, 1927), read in French transl. in Olivier Lugon, *La photographie en Allemagne: Anthologie de textes, 1919–1939* (Nîmes, Fr.: Jacqueline Chambon, 1997), 249–50.

29 Henry Luce to Kurt Safranski, Dec. 5, 1956, private collection.

30 Robert T. Elson, *Time Inc.: The Intimate History of a Publishing Enterprise, 1923–1941* (New York: Atheneum, 1968), 272–73.

31 Kurt Korff, "Essential Outline for a New Illustrated Magazine," 1935, Time Inc. Archives, quoted in Smith, "Émigré Photography in America," 245–47.

32 Hendrik Neubauer, *Black Star: 60 Years of Photojournalism* (Cologne, Ger.: Könemann, 1997).

33 C. Zoe Smith, "Black Star Picture Agency: *Life*'s European Connection," *Journalism History* 13, 1 (Spring 1986): 19–25.

34 See photographs by Margaret Bourke-White published in "Franklin Roosevelt's Wild West," *Life*, Nov. 23, 1936, 9–17.

35 See Michael Schudson, *Discovering the News: A Social History of American Newspapers* (New York: Basic Books, 1978); Elson, *Time Inc.*; Loudon Wainwright, *The Great American Magazine: An Inside History of* Life (New York: Knopf, 1986); James L. Baughman, *Henry R. Luce and the Rise of the American News Media* (Baltimore, MD: Johns Hopkins University Press, 2001).

36 "The Camera as Essayist," *Life*, Apr. 26, 1937, 62.

37 Statistics realized with the help of Elisa Gilmour and Paige Lindsay.

38 Wilson Hicks worked for *Life* between 1937 and 1950; "Spanish Village: Photographed for *Life* by W. Eugene Smith," *Life*, Apr. 9, 1951, 120–29.

39 "The Japanese: The World's Most Conventional People," *Life*, Aug. 30, 1937, 40–50.

40 See, for example, print BS.2005.071917/43-1887, Ryerson Image Centre, Ryerson University, Toronto, Canada

41 "The History of Western Culture," *Life*, Mar. 3, 1947, 69.

42 Thierry Gervais, with the collaboration of Gaëlle Morel, "Le modèle *Life*: La standardisation des magazines d'actualité (1936–1976)," in *La fabrique de l'information visuelle: Photographies et magazines d'actualité* (Paris: Textuel, 2015), 143–210.

43 "Photographs opened a window, as it were," wrote Gisèle Freund in *Photography & Society*, 103.

44 Hartwig Fischer, ed., *Covering the Real: Kunst und Pressebild, von Warhol bis Tillman* (Cologne, Ger.: DuMont Literatur und Kunst Verlag, 2005); Gaëlle Morel, ed. *Photojournalisme et art contemporain: Les derniers tableaux* (Paris: Éditions des archives contemporaines, 2008).

REMAINDER

JAMES McNEILL WHISTLER

Hélène Valance

Rematriating James McNeill Whistler: *The Circulation of* Arrangement in Grey and Black No. 1: Portrait of the Artist's Mother

Walter Greaves,
*Whistler and
His Mother* (detail,
see fig. 2).

Late in the month of October 1871, Maggie, a model for James McNeill Whistler (1834–1903), fell ill and told the artist she could not sit for the portrait he intended to make of her. The weather being too bad for him to continue working outdoors on the Thames landscapes project he had recently started, Whistler, who was then living in Chelsea with his mother, asked her to pose for him.[1] Anna McNeill Whistler (1804–1881) later recounted the experience in a letter to her sister: "I so interested stood as a statue! but realized it to be too great an effort so my dear patient Artist (for he is greatly patient as he is never wearying in his perseverance) concluding to paint me sitting perfectly at my ease, but I must introduce the lesson experience taught us, that disappointments are often the Lord's means of blessing, if the youthful Maggie had not failed Jemie . . . he would have had no time for my Portrait."[2] Here, while she appeared aware of the way anecdotal circumstances shaped the painting, Anna McNeill Whistler also expressed confidence in its artistic value. The exceptional destiny of the painting proved her right: *Arrangement in Grey and Black No. 1: Portrait of the Artist's Mother* (1871) (fig. 1) came to be, to quote a recent review, "one of the world's best-known masterpieces," one audiences are so familiar

114

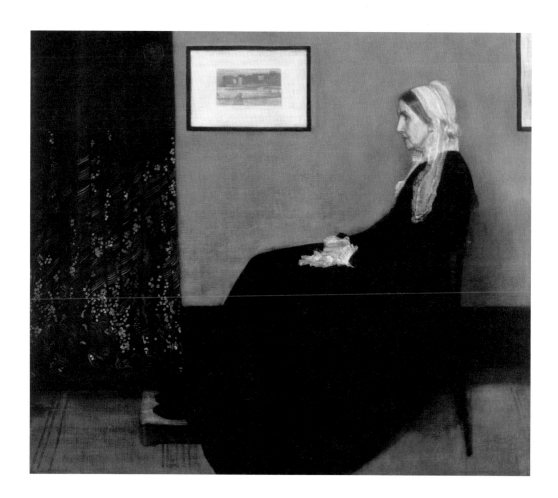

1
James McNeill Whistler,
*Arrangement in Grey
and Black No. 1: Portrait
of the Artist's Mother*,
1871. Oil on canvas,
56¼× 63⅞ in. (144.3 ×
162.5 cm). Musée
d'Orsay, Paris, RF699.

with they could "probably draw it, from memory, at least its outlines, and which way the artist's mother faces in her chair and the square of the painting on the wall."[3] Many Americans would indeed instantly identify the portrait's spare composition and the unusual position of the old woman seated in profile, looking away from the viewer, her feet resting on a footstool.

The work was already so well known in 1917 that Walter Greaves (1846–1930), who had been a student and friend of Whistler's, felt compelled to celebrate its creation in a painting he entitled *Whistler and His Mother* (fig. 2). Greaves's canvas works almost as a mise en abyme of Whistler's portrait. Greaves imitated the sober tonalities of Whistler's painting, barely altered the flatness of the sitter's figure, and simply enlarged the scope of the scene, taking a step back from the first vision, in a move that parallels that of the artist pausing to consider his arrangement of elements. Early twentieth-century viewers would

Hélène Valance

have been familiar enough with Whistler's work to recognize Greaves's few additions—the profile of the painter, mirroring that of his mother, the accumulation of frames on the wall, and the delicate flowers in their Japanese vases—as so many allusions to Whistler saturating the canvas's meaning. They could also mentally cut out the original canvas from the larger composition, encouraged to do so by Whistler's own gesture, tracing an imaginary frame around his sitter with the tip of his maulstick. Greaves's homage to Whistler's work stood as a sort of pictorial making-of, referring simultaneously to the finished form of the painting and to its genesis.

But if Greaves's tribute to Whistler acted as a narrative reiteration, it also operated a significant shift. In *Whistler and His Mother*, Greaves reintroduced not only the figure of the painter but also that of his actual mother, insisting on the relationship that united them. In his reinterpretation of Whistler's painting, Greaves put the emphasis on the personal dimension of the portrait, giving the biographical content of the work at least as much weight as its original formal qualities. The comparison between *Arrangement in Grey and Black No.1: Portrait of the Artist's Mother* and *Whistler and His Mother* raises a number of questions that are still relevant to the celebrity of Whistler's work today. What happened in the few decades that separated the creation of these two works resulted in the change of perspective visible in Greaves's

2
Walter Greaves, *Whistler and His Mother*, 1917. Oil on canvas, 24 ¾ × 29 ¾ in. (62.9 × 75.6 cm). Harvard Art Museums/ Fogg Museum, Cambridge, Massachusetts. Gift of Mr. and Mrs. Stuart P. Feld, 1975.75.

work, a transformation that to some extent affected the way *Arrangement in Grey and Black* was circulated and received, and even shaped later understandings of the portrait.

Only decades after its creation, then, *Arrangement in Grey and Black* had already become what Whistler scholar Margaret MacDonald calls "an American icon." MacDonald states that today "it is an image as familiar as Leonardo's *Mona Lisa* and Grant Wood's *American Gothic*, joining Michelangelo's *David*, Botticelli's *Flora*, Munch's *Scream*, as cultural commodities familiar throughout the Western world."[4] Indeed, the painting still has a significant presence in contemporary popular culture. One of the remarkable paradoxes in the painting's trajectory is the very popularity of "Whistler's Mother," given the artist's outspoken execration of popular taste and culture. Whistler, who feared nothing more than seeing "the gentle circle of Art swarm[ed] with the intoxi-cated mob of mediocrity,"[5] distanced himself ostensibly from the masses. The artist loved to be hated, and liked to quote his friend Oscar Wilde (1854–1900), who once said that "popularity is the only insult that has not yet been offered to Mr. Whistler."[6] But while throughout his life Whistler tried, through elitist attitudes and sophisticated aesthetics, to set himself apart from the crowds of "Philistines," his portrait of his mother has suffered the fate of all the extremely famous works of art MacDonald cites. Like them, it has undergone many reuses in popular culture, ranging from homage to parody.

In a strange conflation of the "high" and "low," Whistler's Mother can now be found on a hoard of everyday objects such as mouse pads, coffee mugs, key chains, umbrellas, ties, T-shirts, and hats, artifacts that surely would have caused the dismay of the artist had he had the chance to encounter them. In the age of digital images and Internet spoofs, Whistler's portrait of his mother, perhaps precisely because it represents a severe-looking old woman in a stark composition, has offered a fertile terrain for parodists and satirists. Internet users have introduced cats, dogs, televisions sets, laptops, music instruments, and laser swords into the old woman's room, adapted her dress to contemporary styles, and reemployed the portrait to convey sarcastic comments on popular culture or on political events—for example, deriding Angelina Jolie's dress at the Academy Awards in 2012, and commenting on the "pepper spray incident" during student protests at UC Davis in 2011. Whistler's mother's face has been replaced by that of other major characters of popular culture such as Minnie Mouse and Marge Simpson, and was completely erased and redrawn by the comically awkward Rowan Atkinson in the 1997 movie *Bean*.

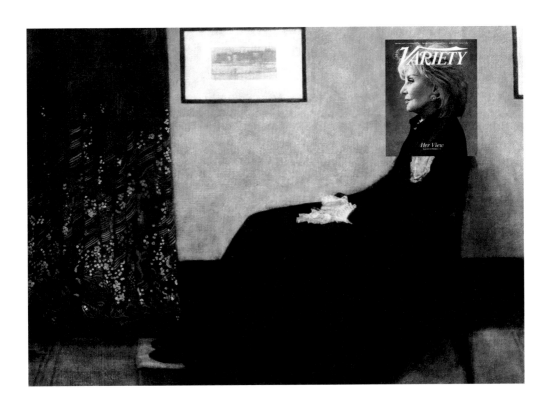

3
Eisen Bernardo,
The View of
Whistler's Mother,
2014. Digital image.

More than a famous artwork, Whistler's portrait of his mother has turned into an icon of old age in women: one of the latest examples of these parodies, part of the *Mag+Art* project by Eisen Bernardo (b. 1985) (fig. 3), superposes the face of Barbara Walters, the eighty-five-year-old American television personality, onto Anna McNeill Whistler's body. This rearrangement of the portrait attests at once to the painting's value in the public eye as a remarkable work of art and to its main character's status as one of the most famous figurations of mature women in American culture. Similarly, MacDonald acknowledged Anna McNeill Whistler's significance in the American imagination by publishing her cookbook, explicitly presenting her as a model of domesticity.[7] Despite its appearance of extreme rigidity, *Arrangement in Grey and Black* actually proved particularly plastic: the image of Whistler's mother has become, symbolically, that of every American mother.

Yet this diffusion, and the recycling and reinterpretation it implies in every instance, demonstrates the wide gap between the artwork and its circulated image. The metamorphosis of *Arrangement in Grey and Black* into one of the most celebrated images of popular culture has relied on dynamics that ran counter to Whistler's proclaimed aesthetic

Rematriating James McNeill Whistler

beliefs. This essay confronts the artist's intentionality, and the work's autonomy, with its context and reception—issues particularly relevant here, given both Whistler's artistic convictions and the work's remarkable career. The essay explores the construction of the painting as an American icon through time, underlining the contradictions involved in this canonization. First, as Jonathan Weinberg has noted, writing for an American audience, "It is bizarre that a work that was painted in England, by an artist who spent most of his mature life in Europe, and that was purchased by the French government should figure so large in our consciousness."[8] And beyond the issue of the painting's national identification, the process of popularization itself appears problematic: What, in the history of the painting's reception, allowed it to become such a symbol, and one that strayed so far from Whistler's own convictions? Paradoxically, although it has been evaluated one of the best-known works of American art, *Arrangement in Grey and Black*'s reception stems from displacement, both literal and figurative. Reactions to the painting cannot be understood, for instance, outside the complex network of influences and competition between American and European artistic identities, which Whistler navigated with a skillful ambivalence. While the artist showed, on occasion, some reluctance to share it beyond his private circle, the painting moved into the very public domain of national icons only decades after its creation. And whereas it was intended to remain in the high spheres of culture, its innumerable reiterations in popular culture made it the perfect emblem of kitsch. *Arrangement in Grey and Black* exemplifies many aspects of circulation, as it has moved with an extreme flexibility across time and geographic borders, but also sociocultural categories and medias, acquiring new meanings through these multiple transfers.

The definition of the painting as an "American" icon is, first, quite surprising, given the cosmopolitan character of Whistler's life and career. The artist left the United States at age twenty-one, spending the rest of his life in London, Venice, and Paris. Although he talked about visiting his native country, he never returned there. The European dimension of Whistler's career is reflected in the painting's own history, starting with its creation in England. On the wall behind the elderly woman, Whistler included a copy of *Black Lion Wharf*, a view of the banks of the Thames he created in 1859. The etching, published the same year Whistler painted the portrait of his mother in a series he entitled *The Thames Set*,[9] situates this interior scene within the larger environment of late nineteenth-century London. For decades, the painting's home was indeed definitely on the European side of

the Atlantic, and although Whistler sent the portrait to his native country for an extended time in the hope that he would be able to sell it, he never managed to do so. In 1881, the artist showed *Arrangement in Grey and Black* at the Pennsylvania Academy of Fine Arts and exhibited it a few months later in New York. The artist's biographer Jerome Eddy (1859–1920) reported, "It is said on good authority that the painting was offered for sale in New York for twelve hundred dollars but found no buyer."[10] The painting went back to England, where Whistler, then in debt, had to leave it with one of his creditors.[11] Eventually in 1891, twenty years after its creation, a group of friends and supporters of the artist's in Paris lobbied to have the French government acquire the work.[12] The painting went to the Musée du Luxembourg in Paris, then to the Musée d'Orsay. After his death, Whistler's biographer Sadakichi Hartmann (1867–1944) clearly identified Whistler and his work as European: "It was France who gave him that final great recognition of his genius when it purchased 'The Artist's Mother' portrait for the Luxembourg, and made him an officer of the Legion of Honor. In England, on the other hand, he fought the great battles of his life for social as well as artistic recognition. In England he married, and was for many years one of the most conspicuous characters of London art and social life." Hartmann continued: "America really did nothing for him, and he did nothing for America."[13]

Until the 1890s, Whistler had mostly been regarded with distrust by his compatriots. The artist had an exceptional presence in the public sphere, and was, as Sarah Burns has demonstrated, one of the first artists to expertly craft the construction of his persona by actively engaging with the press. Long before the portrait of his mother became a popular icon, Whistler already marketed his own image: "Whistler attracted and held the spotlight of celebrity just when celebrity — a public, consumable image — was in the process of becoming a cultural commodity in America's emergent consumer economy."[14] Burns has shown how Whistler's reception in the American press, hostile reviews included, was eventually crucial in his radical transformation from "old maverick" to "Old Master." In Burns's view, while critics stereotypically resorted to a rhetoric dissociating Whistler's turbulent personality from his appeasing *Nocturnes* and *Harmonies*, the discrepancy between these two apparent extremes was bridged in a discourse recasting the artist as a high-strung genius unable to fit in a vulgar and materialistic society. Burns's argument, although it does not consider *Arrangement in Grey and Black* in detail, is in part relevant to the

reception of the painting. Whistler's portrait of his mother acted as the pivot of the dialectical dynamics that transformed the artist into a canonical American painter. Its exceptional destiny, combined with its attractive subject matter, opened it to its reinterpretation as the work of a misunderstood genius—and, ironically, to a type of reading Whistler had always vigorously resisted.

Before the painting was acquired by the French government, Whistler's reputation in the United States amounted to little more than a succès de scandale. The painter was more easily perceived as a Bohemian womanizer, an eccentric provocateur, a "buffoon,"[15] and a "mountebank"[16] than as a respectable artist. This perception grew out of his particularly pugnacious attitude with his critics, starting in 1877 with the infamous *Whistler vs. Ruskin* trial: after John Ruskin (1819–1900) had severely reviewed Whistler's quasi-abstract *Nocturne in Black and Gold: The Falling Rocket* (1874) and accused him of being an impostor flying a "pot of paint in the face of the public," Whistler took him to court, turning the dispute into a show.[17] The lawsuit raised an enormous interest at the time, with the press and public following with enthusiasm the exchange of repartees between this young and extravagant expatriate and the lawyers of the much-respected Ruskin he had dared to challenge. Whistler repeatedly resorted to these conflicts to attract attention, publishing sarcastic accounts of his various court litigations as well as mordant remarks on the critiques his works and ideas received in books, articles, and lectures, among which the most prominent remain *The Gentle Art of Making Enemies* (1890) and *Ten O'Clock*, a lecture he delivered in 1885 and first published in 1888. These reveal a strong personality, showing at once how wary Whistler was of what he saw as misreadings of his work and how much he enjoyed playing the provocateur.

To his compatriots, this skillful yet aggressive manipulation of celebrity made him, at best, a fascinating source of amusing anecdotes. *McClure's Magazine*, for instance, published a five-page article on the artist entitled "Whistler, Painter and Comedian," which practically never discussed his art, focusing instead on his queer appearance and ferocious humor.[18] However delighted they were to read about Whistler's whims and quips, most Americans did not recognize him as one of their own. *The Collector* thus published a letter from a San Francisco woman claiming to be the artist's cousin, narrating her visit

to her parent in London: "I stayed with my cousin, James Whistler, the artist, when I was in London last summer . . . and I must say that he is a most curious individual. . . . His house at Chelsea is called 'the White House,' and is painted in the most abominable colors. It is really an eyesore, but Cousin James thinks it is very artistic. You would never imagine that he was an American. He and his brothers are all thorough Johnnie Bulls."[19]

According to Whistler biographer Jerome Eddy, the artist resented bitterly his fellow countrymen's attitude, allegedly complaining that "the papers in America seem content to publish second-hand whatever they find about me in English journals that is mean and vindictive or that savors of ridicule." Whistler reproached Americans for their lack of solidarity with their compatriot, alleging that the American press "leans to the side of the bully" and badly chooses its allies in an international war on artistic taste:

> One would think the American people would back a countryman—right or wrong—who is fighting against odds; but for thirty years they laughed when the English laughed, sneered when they sneered, scoffed when they scoffed, lied when they lied, until,—well, until it has been necessary to reduce both nations to submission. . . .
>
> But when France—in all things discerning— proclaimed the truth, America—still blind—hastened to shout that she, too, saw the light, and poured forth adulation ad nauseam.[20]

Indeed, after *Arrangement in Grey and Black* was purchased by the French government, Whistler's reputation in America changed dramatically. In the eyes of the American public, this success in the artist's career almost acted as an antidote to the Ruskin trial. The prestige of the institutions made up for the eccentricities of the painter: the portrait entered the national collection of living artists in the Musée du Luxembourg and was sure to join the Louvre's collections after his death. Whistler himself was aware of the advantageous publicity this would offer him. The sale to the French government had quickly followed the acquisition of *Arrangement in Grey and Black No. 2: Portrait of Thomas Carlyle* (1872–1873) by the National Gallery of Scotland, and Whistler, with more self-confidence than ever, explained to one of his patrons that he preferred not to see too many of his works go into private hands: "When a picture is purchased by the Louvre or

the National Gallery, all can come and see it on the walls but when a painting is bought by a private gentleman, it is, so to speak, withdrawn from circulation, and for public fame is missing from the story of the painter's reputation."[21] In 1892, the French government added to Whistler's triumph by making him an officer of the Legion of Honor.

Such honors bestowed on an American artist immediately awoke interest in the United States. The diffidence Whistler had inspired in the 1870s in the press gave way to praise, with journalists taking an immense pleasure in detailing the marks of distinction conferred on the artist:

> [The Luxembourg] is admittedly the ante-chamber of the
> Louvre. It contains the flower and ripe fruit of French
> art of the period; the gems of the Salons for many years past.
> It is into this select and admirable company that
> Mr. Whistler has been admitted—nay, invited, since the
> proposal came direct and unsolicited from the govern-
> ment. The highest honor that can be conferred on any artist
> by that government has been conferred upon him.[22]

In this slightly exaggerated account (the journalist obviously omitted the lobbying that preceded the "invitation" of the French government), Whistler was reclaimed as an American: "He is our countryman, and though art may not have a country, artists have. Mr. Whistler, I am certain, would claim no favour because he is an American. But are we Americans to be silent when a great distinction is bestowed upon an American artist?"[23]

The thorny question of Whistler's nationality gave way to awkward discussions where Americans were chastised for their indifference to the artist and at the same time authors saw his triumph in France as a vindication over the English. One journalist accused his fellow Americans of having treated Whistler "with even more ignorance and coldness than England; this, of course, coming from the desire of the Anglomaniac to out-English the English."[24] Whistler's own opportunistic exploitation of this triangular competition complicated the situation, as he chose to exhibit alternately in British and American sections of international exhibitions,[25] and derided the English as "Pecksniffs and Podsnaps"[26] as soon as *Arrangement in Grey and Black* was acquired by France.

Yet increasingly, reviewers tried to reassert Whistler as "an American of Americans."[27] In 1892, the *New York Daily Tribune*

detailed the debates around a commission for a painting by Whistler that would "beat the Luxembourg affair" and be displayed at the World's Columbian Exposition the following year.[28] The journalist admitted that some regarded Whistler as a "bizarre Austrian or French master," but insisted it was a good idea to bring back "erratic Jimmy" in the city where his own grandfather was born. Commentators strove to reconcile Whistler's lifelong exile with his American identity: "Despite his long residence abroad, in person and speech Whistler was a typical American. . . . No one who knew him failed to perceive that he was always a lover of his native country," asserted one journalist after the artist's death.[29] Whistler's friend and biographer Joseph Pennell (1857–1926) even went further, making his exile the very proof of his attachment to America: "It is rare in America to find so patriotic an American as James McNeill Whistler, and the mere fact that he lived his own life in his own way as an American in the heart of England proved that he had a courage and determination far beyond the conception of detractors."[30] Many writers, like Pennell, shifted the focus on Whistler's nationality to make it an intimate matter, and at the same time affirmed that this interiorized national identification was a superior kind of Americanness, calling Whistler "the most intensely American of Americans."[31]

Whistler thus emerged as a member of the American pantheon: after his death in 1903, a monumental "Whistler memorial" exhibition was organized in Boston, accompanied by dozens of biographies of the artist, which celebrated him as a national hero. In 1912, Ezra Pound placed the first issue of his *Poetry* magazine under the tutelage of the painter, with a dedicative poem entitled "To Whistler, American," where he put the painter on an equal footing with Abraham Lincoln himself.[32]

The painting that won Whistler such popularity—*Arrangement in Grey and Black*—became an object of national worship, acclaimed by journalists as "the most unquestioned and unquestionable master-pieces of the last half of the nineteenth century."[33] As early as 1913, its influence among the younger generation of American artists was such that Sadakichi Hartmann wrote: "No modern painting has been more talked about and more frequently imitated than this one."[34] Whistler's imitators self-consciously copied the composition of the painting and its characteristic dark tones, simultaneously exhibiting their admiration for Whistler and their ambition to emulate him in his international success. Among these imitations, one can think of, for instance, *Les derniers jours d'enfance* (1883–1885) (fig. 4) by Cecilia

Beaux (1855–1942) and *Portrait of the Artist's Mother* (1897) (fig. 5) by Henry Ossawa Tanner (1859–1937).[35] Tanner, an African American expatriate painter who lived most of his life in Paris, saw, like Whistler, one of his own works, *The Raising of Lazarus* (1896), bought by the French government in 1897.[36] For Tanner, painting the portrait of his own mother in the style of Whistler was a way to align himself with his predecessor, to inscribe himself and his art in a Franco-American success story, and perhaps also to show that his own mother, who had been born a slave, could be portrayed with the same dignity as the genteel Anna McNeill Whistler.[37]

Outside artistic circles, too, the painting seems to have functioned as a national icon very soon after its purchase. Whistler's portrait of his mother was among the pictures that were most often reproduced in the press, and as early as the 1900s, one can find evidence of its familiarity in popular culture. Although the rather dark picture did not always translate well on the printed page, Whistler's Mother regularly appeared in magazine illustrations, typically on Mother's Day, when readers were encouraged to buy reproductions of the painting as gifts for their own mothers.[38] Before 1920, the portrait was so popular that the J. Walter Thompson advertising company published it as an example of the "universal emotional appeal" of images in advertisement. The sentimental attachment to Whistler's Mother served business but also national goals, as it later fueled the patriotic rhetoric of World War I posters.

The popularity of the work increased even more when the director of the Museum of Modern Art (MoMA) Alfred Barr organized a tour for the painting across the country from 1932 to 1934. After a few months as one of the key pieces in an exhibition of American art at MoMA, the painting traveled to eighteen cities and was seen by over two million people, breaking attendance records in many institutions. As the press release from MoMA underlined, "No painting, and very few living personalities, have ever received such nation-wide ovation."[39] Press releases stressed the unprecedented efforts made to keep this treasure safe: "armed guards, a heavy rail, and a hidden alarm which sets off a loud gong if the picture is moved the fraction of an inch," as well as a high-tech night surveillance system complete with photoelectric cells.[40] Reviewers showed they were aware of the painting's complicated history with the United States: the *New York Times* printed an article triumphantly titled "'Whistler's Mother' Comes Home Again; Once Rejected Here, the Portrait, Now a Symbol, Returns to Us on Loan."[41] The occasion was marked by a strong emphasis on the national pride attached to the painting, but also by its assimilation into popular

4
Cecilia Beaux, *Les derniers jours d'enfance*, 1883–1885. Oil on canvas, 45¾ × 54 in. (116.205 × 137.16 cm). Pennsylvania Academy of the Fine Arts, Philadelphia. Gift of Cecilia Drinker Stantonstall, 1989.21.

5
Henry Ossawa Tanner, *Portrait of the Artist's Mother*, 1897. Oil on canvas, 29¼ × 39½ in. (74.3 × 100.3 cm). Philadelphia Museum of Art. Partial gift of Dr. Rae Alexander-Minter and purchased with the W. P. Wilstach Fund, the George W. Elkins Fund, the Edward and Althea Budd Fund, and with funds contributed by The Dietrich Foundation, 1993, EW1993-61-1.

Rematriating James McNeill Whistler

culture: for instance, Cole Porter's song "You're the Top" listed "Whistler's mama" as one of the wonders of the world his lover could be compared to, along with Camembert, Mona Lisa, and Mickey Mouse.[42] As the tour was nearing its end, the painting made a last stop in "Whistler's native state, Massachusetts," Boston having the "privilege of showing it on Mother's Day."[43] This focus on motherhood blended with national politics as Franklin Delano Roosevelt's mother was invited to preside over the final ceremonies before the portrait sailed back to France.[44]

The 1930s tour was such a landmark in exhibition history that in 2015 it was repeated on a smaller scale, with the painting visiting two museums: the Norton Simon in California and the Clark Art Institute in Massachusetts. The exhibition organizers displayed the same bravado as their predecessors: the press release on the Clark Art Institute's website announced, "Independence Day brings an American icon to the Clark Art Institute with the arrival of *Arrangement in Grey and Black No. 1 (Portrait of the Artist's Mother)* (1871) by James McNeill Whistler."[45] Mimicking MoMA's words from more than seventy years ago, the *Boston Globe* found it appropriate that the painting would "return" to Massachusetts, "the state in which Whistler was born."[46] Briefly reclaiming the painting as a national emblem thus permitted commentators to reintroduce Whistler, this lifelong exile, into the American cultural landscape.

The 1932–1934 tour, however, was marred by a controversy that pitted cultural readings associating the painting with the theme of Americanness and motherhood against more strictly aesthetic considerations. That year, the portrait was adapted into a national postage stamp printed on the occasion of Mother's Day (fig. 6). The designer of the stamp altered the artwork's original composition, letting the old woman's glance fall on a bunch of flowers decorating the lower-left angle of the stamp, the new image suggesting contemplation rather than meditation. On the upper-left background, illuminated as though through a high window in the style of Dutch painting, the original *Black Lion Warf* etching had disappeared, making room for words picked by Franklin Delano Roosevelt himself: "In memory and in honor of the mothers of America."[47] With these small alterations, *Arrangement in Grey and Back* was completely recast into an image calling to simple familial and national feelings and meant to elicit collective adhesion at a moment of national crisis. Yet some voiced concern for the integrity of the portrait: the American Artists Professional League protested these changes and called them a

"mutilation" and a "serious transgression of professional ethics."[48] Barr, willing to offer suggestions from an "impartial art institution," explained in an official letter to Postmaster General James A. Farley how much Whistler took aesthetic matters to heart, and that "if he were alive today he would have been enraged by the adulteration of his design."[49] Barr advocated a spare design he saw as more faithful to the identity of Whistler's painting, and which, incidentally, also aligned with his own formalist reading of the artist as a precursor of modernism who bore comparison with twentieth-century artists such as to Piet Mondrian. Barr's protests and suggestions were not, however, taken into account and the stamp remained the same: the painting's more popular reading effaced the expert view of artists and curators from elitist institutions.

This controversy is symptomatic of the ambiguities inherent to the reception of the painting. From the early twentieth-century onward, the reception of Whistler's portrait of his mother often involved overlooking some of Whistler's most important aesthetic commitments. Bringing Whistler and his mother back into American culture proved a complicated, contradictory process. First, the painting's iconic status in the United States seems to have overshadowed the reality of its career, in which apart from the 1932–1934 episode, the painting did not physically circulate. If, for instance, the press release of the Norton Simon Museum in February 2015 acknowledged Whistler's portrait of his mother as "the single most recognizable image in the history of American painting," it also admitted that "the fact that *Arrangement in Grey and Black No. 1* resides not in the United States but in France may come as a surprise," a detail repeatedly underlined by wide-audience articles discussing the painting.[50]

6
United States postage
stamp, 1934. Collection
of the author.

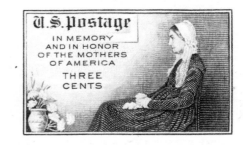

Inversely, the painting remains relatively unknown to French audiences, who often are only familiar with the portrait's apparition — and, ironically, its defacement — in the 1997 comedy *Bean*. The traffic statistics of the popular online encyclopedia *Wikipedia* show that the English article on the painting, entitled "*Whistler's Mother,*" was visited over 104,000 times in 2015, while the very short article in French, "*Arrangement en gris et noir no 1,*" counts just under 4,000 visits during the same time period.[51] Even considering the respective sizes of Internet audiences in each country, this remains a significant difference. The disparity in these results certainly originates in the difference in titles, but this variation can itself be understood as a reflection of the unequal popularity of the work, which, while referenced under its original title in French, has acquired a more familiar moniker in American culture. As a journalist from the *Los Angeles Times* conceded, most of her readers "might know the painting by its more famous unofficial name: 'Whistler's Mother,'"[52] and, tellingly, the vast majority of references made to *Arrangement in Grey and Black* in the mainstream media are followed by a similar elucidation.

The intriguing double title of the painting reflects the divergence between Whistler's artistic statements and the reception the artwork received. The "arrangement" elaborated by Whistler was, from the first time he exhibited the painting, a source of confusion among the public, and the point it made still escapes most of the painting's viewers. *Arrangement in Grey and Black* is the first example of Whistler's use of the word in his titles. This unusual choice drew the curiosity of lawyers, reporters, and their audiences during Whistler's lawsuit against Ruskin. The debates, centered on Whistler's unusual art for art's sake aesthetics and his attachment to a decorative formalism inspired by Japanese art, elicited both laughter and perplexity. The public found it difficult to understand Whistler's claims that art was simply a matter of decoration and suggestiveness, which he clearly set apart from real-life considerations and preoccupations.

Whistler was asked to justify his use of nondescriptive titles such as "harmonies," "symphonies," and "arrangements." About one of his portraits, one jury member asked Whistler, "Why do you call Mr. Irving 'an arrangement in black'?" Upon which one of Whistler's defenders specified: "It is the *picture* and not Mr. Irving that is the arrangement."[53] Whistler then explained what he meant by the term: "an arrangement of line and form and color" where all that mattered was the harmonious ensemble that resulted from the careful selection of the artist, not the painting's subject matter or what it could possibly

represent. In 1878, in a highly sarcastic letter to the journal *The World*, Whistler asked: "Why should not I call my works 'symphonies,' 'arrangements,' 'harmonies,' and 'nocturnes'? I know that many good people think my nomenclature funny and myself 'eccentric.'" But this, in Whistler's view, came from a deep misunderstanding of what art should be. Whistler denounced the constant need of his audiences to associate the artwork with preoccupations that did not belong to the realm of art: "The vast majority of English folk cannot and will not consider a picture as a picture, apart from any story which it may be supposed to tell." On the contrary, Whistler reaffirmed the autonomy of the work of art, convinced that "art should be independent of all clap-trap—should stand alone, and appeal to the artistic sense of eye or ear, without confounding this with emotions entirely foreign to it, as devotion, pity, love, patriotism, and the like."[54] In *Ten O'Clock*, Whistler denied that his work could be the reflection of any time and place, claiming that "there never was an artistic period. There never was an Art-loving nation," and that "the master stands in no relation to the moment at which he occurs," being in "no more the product of civilisation than is the scientific truth asserted dependent upon the wisdom of a period."[55] Whistler even specifically addressed the case of *Arrangement in Grey and Black*: "Take the picture of my mother, exhibited at the Royal Academy as an 'Arrangement in Grey and Black.' Now that is what it is. To me it is interesting as a picture of my mother; but what can or ought the public to care about the identity of the portrait?"[56]

However vocal Whistler was in the assertion of these principles, the critics, writers, and journalists writing on *Arrangement in Grey and Black* have ignored them time and again. Since the painting's acquisition by the French government, commentators have repeatedly transgressed Whistler's interdictions, persistently conferring values such as "love, patriotism, and the like" to the portrait. A few years after Whistler's death, the critic John Van Dyke (1856–1932), who, ironically, also wrote a book entitled *Art for Art's Sake* (1893),[57] openly rejected Whistler's claim for national neutrality, asserting that "quite apart from *Ten O'Clock* and other painter extravagances, art is still believed to be in some way an expression of a time, a place, and a people."[58] From very early on, most of Whistler's American contemporaries bluntly rejected his commitment to art for art's sake principles, considering it as nothing else than another of his eccentricities. "The Whistlerian theory of art is not new," commented a critic in 1889, "nor do we believe it necessary for him to set it forth in this country." The

journalist added, with magnanimous pragmatism: "We are willing to judge him by his pictures, without discussing his theories."[59] This is precisely what commentators did with *Arrangement in Grey and Black*, using the portrait as the key example that would allow them to dismiss Whistler's aesthetics as "quite unsound philosophy."[60] The consistency of Whistler's purely decorative ideals had already been questioned by Algernon Swinburne (1837–1909) in his response to the artist's *Ten O'Clock*: "It would be quite useless for Mr. Whistler to protest . . . that he never meant to put . . . intense pathos of significance and tender depth of expression into the portrait of his own venerable mother. The scandalous fact remains, that he has done so; and in so doing has explicitly violated and implicitly abjured the creed and the canons, the counsels and the catechism of Japan."[61] Swinburne's interpretation of Whistler's art fueled a bitter dispute that ended the long friendship between the two artists.[62] Whistler publicly denounced this abusive reading of *Arrangement in Grey and Black* as "an apostasy," outraged to see that the poet "also misunderstands, and is capable of saying so, with vehemence and repetition," "in the face of a ribald world."[63]

Despite Whistler's protests, American commentators rushed to follow Swinburne, insisting that Whistler was "as it were in spite of himself, a most able interpreter of human emotion,"[64] and that he had "infringed [his theories] flagrantly by expressing, in his portrait of his mother a tenderly filial piety which transcends the facts of an arrangement in black and gray."[65] Journalists and critics typically read the portrait as a testimony of filial affection and interpreted this alleged sentimentality as the one link between the artist and his native country. In the eyes of Seymour Eaton (1859–1916), who later contributed to sentimentalizing Theodore Roosevelt's image with his *Roosevelt Bears* (1905–1908) series, Whistler's portrait of his mother was "a work of impressive simplicity, sincerity, sympathy and subtilty, which of itself instantly and forever disposes of the theory of art for art's sake."[66] Even today, the agreement is that *Arrangement in Grey and Black* betrays the artist's inability to maintain his work in a strictly decorative, nonreferential sphere: "Whistler's dream, in line with his burgeoning view of himself as a dandy, was to elevate a quivering hothouse aestheticism over psychology, history, politics, and virtually all else. His mother's presence somehow harnessed this unrealistic reverie, pulling it back toward the grit and the grip of specific truth."[67]

Thus even though Whistler "denied a thousand times our right to interest ourselves in his mother's personality"[68] and thoroughly rejected anecdotal readings of his work, the sitter's identity and her

intimate connection to Whistler became the focus of a widespread fascination once the painting entered the Luxembourg collections. Reviewing the painting after it was first shown in New York in 1881, a critic from the *New-York Daily Tribune*, in fact, found it lacking in personality and called it "dull" and "empty": "The head of the subject, for instance, surely ought, in a professional portrait, to stand for something. But it is the least significant point. It is flat, it is lifeless, it is destitute of all modelling, and the eye keeps running away from it to the well painted etching or engraving in its narrow black frame and white mat that hangs on the wall."[69] Compare this review with Hartmann's lyrical description of the painting two decades later:

> *Whistler attempted in his "Mother" to give us the whole atmosphere that surrounds a personality. . . . The artist does not merely represent his old mother. He endowed the old woman, sitting pensively in a grey interior, with one of the noblest and mightiest emotions the human soul is capable of — the reverence and calm we feel in the presence of our own aging mother. And with this large and mighty feeling, in which all discords of mannerisms are dissolved, and, by the tonic values of two ordinary dull colours he succeeded in writing an epic, a symphonia domestica, of superb breadth and beauty — a symbol of the mother of all ages and all lands, slowly aging as she sits pensively amidst the monotonous colours of modern life.*[70]

The consecration of Whistler's work explains this dramatic change of perception: whereas the first critic was only commenting on *Arrangement in Grey and Black* as a portrait and, in this reading, as a sophisticated but confounding combination of forms, lines, and tonalities, Hartmann, like many of his fellow Americans at the time, desired to inscribe the painting into a larger narrative that would allow him to claim the painter's success as a national achievement. The subject matter of the painting proved central to this reinterpretation on two counts: First, the theme of motherhood helped reattach Whistler to his native country and to compensate for both the artist's and the painting's residence abroad. Second, it also inscribed his work within a larger body of values that were particularly significant in turn-of-the-century America, where artistic representations of women predominantly idealized them as emblems of purity and motherhood.[71]

The painting's real title sank into oblivion as "Whistler's Mother" became synonymous with domesticity and maternal feeling. The visual reinterpretations of the painting illustrate this shift. Beaux's *Les derniers jours d'enfance* (see fig. 4) imitated the structure of Whistler's portrait, but injected sentimentality and even nostalgia into the composition. The wording of the title—in French, probably as a means to situate Beaux as a cosmopolitan painter circulating in the same prestigious artistic environment as Whistler—also accounted for the young mother's wistful look. Whereas Anna McNeill Whistler's absorption remained hermetic to viewers, here Beaux suggested a narration that extends beyond the borders of the canvas and that appeals to an almost universal sentiment. Greaves's *Whistler and His Mother* (see fig. 2) gave its viewers a glimpse of the artist's studio as a domestic interior. The vase of flowers in the 1934 stamp design (see fig. 6), while recalling Whistler's *japonisme*, also helped complement the rather stark furnishings of the room as it appeared in *Arrangement in Grey and Black*. Today, viewers facing the canvas for the first time often find it larger than they expected, that is, "on a scale to match its domestic subject."[72] This indicates that their perception of the painting belongs to a popular imagery of motherhood dominated by a sense of intimacy and modesty, while, on the contrary, the ambitious size of the canvas rather suggests that Whistler meant to showcase his artistic abilities and bolster his position in the professional and public spheres.

The details of Whistler's relation to his mother form an important part of the discussions surrounding the painting, as though commentators, like visual artists paying homage to the work, felt the need to reinforce the private, anecdotal dimension its severe design represses. Jonathan Weinberg has commented on what he sees as "the central paradox of Whistler's picture: its ability to raise sentimental associations of motherhood and to negate them."[73] The major part of his chapter on *Arrangement in Grey and Black* explores Whistler's relationship with his mother using psychoanalytical models. I would like to approach the issue from a different perspective, considering that if sentiment needs to be taken into account here, its public expression—and the manipulations this involved—is more pertinent to the work's circulation than the reality of Whistler's and his mother's intimate lives. There is no doubt that Whistler nourished tender feelings for his mother: he shared her house for years, wrote her frequently when he was away from her, and, after her death in January 1881, started using her last name in his signature. Yet the artist, who

fathered a child outside of wedlock after an infidelity to his mistress, could hardly be seen as fitting Victorian standards of respectability and family values.[74]

As with his national identity, Whistler sometimes instrumentalized his connection to his mother when it could be profitable for his career and status. His attitude was, for instance, rather ambivalent when the question of selling *Arrangement in Grey and Black* came up. Although he had offered it for sale in the United States and elsewhere, in 1884 he protested vehemently against the idea, telling an exhibition organizer that "certainly I should never dream of disposing of it."[75] Beyond filial attachment, Whistler's rejection of the offer might have reflected his disapproval of the price proposed, or of the buyer's identity. The painting's acquisition by a prestigious public collection must have been a good compromise for the painter, granting him artistic recognition and at the same time avoiding the appearance of an indelicate, frankly monetary transaction. When learning about the purchase of *Arrangement in Grey and Black*, for instance, Whistler's

7
James McNeill Whistler, *Cameo No. 1 (Mother and Child)*, 1891–1895. Etching on paper, 6⅞ × 5 in. (17.5 × 12.7 cm). Freer Gallery of Art, Smithsonian Institution, Washington, DC. Gift of Charles Lang Freer, F1906.108.

Rematriating James McNeill Whistler

friend Thomas Lamont allegedly expressed surprise at his having painted his mother's portrait, or even at his having a mother at all. Whistler replied, with his characteristic effrontery: "Yes indeed I have a mother, and a very pretty bit of color she is, I can tell you."[76] If Lamont was trying to give the conversation a personal turn, the artist's slightly irreverent playfulness deflated his expectations, instead reasserting that the image Whistler wanted to convey was not that of domesticity and motherhood but a purely formal, aesthetic conception.

Around 1891–1895, the artist returned to images of motherhood in at least five etchings (fig. 7).[77] Depicting a young mother in bed with her toddler, these display far more sentimentality than the 1871 portrait of elderly Anna McNeill Whistler. Whistler's engagement with maternal tenderness in these pictures might reveal a wistful memory of his own mother, or simply the softened outlook of an aged man. But the fact that the artist created these works at the time he was monitoring the acquisition of *Arrangement in Grey and Black* by the French government might also indicate the artist was willing to exploit the theme and to cater to his patrons' interest in a more emotional approach. Additionally, whereas up until the publication of *The Gentle Art of Making Enemies* in 1890, Whistler reacted violently against the interference of personal and anecdotal elements in the interpretation of his work, after *Arrangement in Grey and Black* was purchased by France, he did not protest the innumerable sentimentalizing interpretations of the American press. From the moment he painted the portrait until after its purchase, then, Whistler adopted an ambivalent, fluctuating attitude, oscillating between the strict rejection of "claptrap" anecdotal and narrative readings and a tacit acceptance that the public could and should "care about the identity of the portrait."

Anna McNeill Whistler also drew a lot of attention because of the contrast between her personality and that of her son, a contrast that proved central in the shift of perception surrounding the painting. Anna McNeill Whistler was notorious for her piety: she did not receive guests on Sundays, nor did she allow anyone to open any other book than the Bible in her house on that day. She even invested her son's art with her own spirituality. In a letter to her sister, she described the creation of the painting in quite religious terms: to her, "it was a Mother's unceasing prayer while being the painter's model gave the expression which makes the attractive charm."[78] Commenting on Anna McNeill Whistler's portrait in a posthumous account of Whistler's life and art, Christian Brinton subsumed the painter's aesthetics to moral ideals and qualities:

*It was not through gifts wholly esthetic that Whistler was
able to conceive the "Mother" and the "Carlyle," but
also by grace of qualities distinctly intellectual and moral.
In all matters he was essentially a purist. . . . Art was his
religion, and for his artistic creed he was ready to make
any sacrifice. You cannot gaze at these two canvases
without feeling that they represent the sovereign force of
pure mentality as well as finely attuned sensibilities. The
abstract reasoning of his engineer-mathematician father
and the exalted piety of his mother were curiously blended
in Whistler's making. The "Mother," seated in that
subdued room, fixed intently upon the world invisible,
seems the incarnation of Puritanism.*[79]

Anna McNeill Whistler's piety is called upon, here, to moderate
the stark formalism of the painting, while the hermetic art beliefs of
Whistler are turned into a more familiar kind of invisible world. In
Brinton's eyes, Whistler's personal genealogy, the anecdotal dimension
of not only his but his parents' lives, is expressed on the canvas,
understood as a perfect balance between the gendered qualities of
mental abstraction and sentiment. Through this reconstructed
personal history, Whistler could be considered a true American,
despite the eccentricities of his cosmopolitan life.

In the words of another of Whistler's biographers, Whistler was
a puritan and an American malgré lui:

*The Puritan element which is to be found in every American
achievement, whether in war, in art, or in literature,
though often deeply hidden, is conspicuous in Whistler's
work, though he himself would probably have been the
first to deny it; and it is this element of sobriety, of stead-
fastness, of undeviating adherence to convictions and
ideals that constitutes the firm foundation of his art, of his
many brilliant and beautiful superstructures of fancy.*

*Only a Puritan at heart could have exhibited as he
did in everything he touched those infinitely precious
qualities of reserve, of delicacy, of refinement, which are
the conspicuous characteristics of his work.*[80]

Recasting *Arrangement in Grey and Black* as "Whistler's Mother,"
commentators transformed the artist's elitist aesthetics into an

expression of puritanical values, which they considered part of Whistler's "artistic nationality" and "temperament."[81] Whistler's search for pure art was reinterpreted as a form of puritanism he had inherited from his mother and that aligned him with American cultural values. Critics praised the sobriety of the interior and of the sitter's outfit, imbuing the restricted tonalities of Whistler's arrangement with a religious feeling the artist probably did not want to confer to his work. Whistler's own formulation of art in quasi-religious terms might have, in part, misled his commentators. If he called art "a goddess of dainty thought" in *Ten O'Clock*, however, he certainly did not mean to give his art the accepted moral or religious sense many of his viewers expected to see in it. He complained, on the contrary, that too often "humanity takes the place of Art" and that "beauty is confounded with virtue."[82]

Whistler's religion of art was a ritual meant to distinguish him from the rest of his contemporaries, but his provocative avant-garde art beliefs, rewritten as "reserve," "delicacy," and "refinement," were made more palatable to American audiences. Van Dyke, in a 1904 article featured in the *Ladies Home Journal*, tried to make intelligible the reasons why there was "all this talk about Whistler" after the painter's death. Unsurprisingly, the example he gave the longest consideration was the portrait of the artist's mother, probably because he estimated his readers would be more sensitive to its theme. Trying to explain Whistler's aesthetics, Van Dyke reinterpreted the painting's sobriety as a mark of simplicity and straightforwardness. Separating the two parts of the title, Van Dyke struggled to reconcile its two facets: "As narration it is the portrait of his mother; as decoration it is an 'Arrangement in Black and Gray,'" painstakingly adding, "that is to say, black and gray are the predominant notes. The dress is black and white, the floor and wall gray, the curtain and floor-board black." After celebrating the painting as "the most human and personal document [Whistler] ever produced" with respect to its subject matter, Van Dyke reinvested the other dimension of the painting, its strikingly spare formalism, with a moral value: "Nothing could be simpler than such a scheme of color. And this, perhaps the most celebrated picture by the painter, is characteristic of all his work in its simplicity, its directness, its infallible good taste." Ultimately, Van Dyke used the painting as the final absolution of the artist's excesses, dissolving his apparent pretentiousness into a simple truth: "There is no pose about it, though he has been called the grand poseur; no affectation in it, though he was counted a bundle of pretense; no trickery in it, though he was written

down the prince of mountebanks. Where in all art have you seen so unpretentious a picture? That figure in a plain black gown, seated in a straight-backed chair, with the feet on a stool, with only a wall, a curtain and a picture in for a background, is almost bare in its simplicity."[83]

Van Dyke's remarks hint at one possible explanation for the prodigious reversal in the reception of the painting. The "emptiness" of this abstract composition, once a reproach, was later exploited by commentators who could conveniently project their own interpretation onto it. They could thus contrast their perception and the apparently hermetic surface of the canvas, claiming they had only transcribed a "deeply hidden" truth. The very abstraction and open-endedness of the painting allowed for commentators to project onto it a variety of readings that contradicted Whistler's expressed views on art. Indeed, in the end, it may be precisely because it resisted interpretation so much that the painting's meanings could be asserted with so much confidence by its commentators. Van Dyke, for instance, felt no hesitation: "It is quite impossible to miss the painter's point of view—quite impossible to misunderstand this picture. It is the portrait of a noble mother by a loving son."[84]

Arrangement in Grey and Black stands as the ultimate paradox: a popular icon created by one of the most elitist painters of its time, it was made American by entering a French institution; a manifesto of art for art's sake, it has been read as the epitome of sentimentality, as a moral statement, and as a confession of patriotic attachment. Whistler's mother, turned into a familiar character of American imagination, the stern elderly puritan, has thus helped to symbolically repatriate "erratic Jimmy" in spite of himself. Wilde once prophetically told Whistler: "Be warned in time, James; and remain, as I do, incomprehensible. To be great is to be misunderstood."[85] This advice, compared to the circulation of Whistler's painting, resonates as one last irony. If, to quote Brunet's introductory essay, there can be "no representation without circulation," the case of Whistler's *Arrangement in Grey and Black*'s endless recycling begs a further question: Can there be a circulation without misrepresentation?

1 Margaret MacDonald, "The Painting of Whistler's Mother," in *Whistler's Mother: An American Icon*, ed. Margaret MacDonald (Burlington, VT: Lund Humphries, 2003), 29–58.

2 Anna McNeill Whistler to Catherine Jane Palmer, Nov. 3–4, 1871, Library of Congress, Manuscript Division, Pennell-Whistler Collection, PWC 34/67-68 and 75-76.

3 Alysia Gray Painter, "Iconic Painting Visits Pasadena," NBC Los Angeles, Mar. 25, 2015, http://www.nbclosangeles.com/entertainment/the-scene/Whistlers-Mother-Iconic-Painting-Visits-Pasadena-297589941.html.

4 Margaret MacDonald, introduction to MacDonald, *Whistler's Mother*, 9.

5 James McNeill Whistler, "Ten O'Clock" [lecture], reprinted in Whistler, *The Gentle Art of Making Enemies* (London: W. Heineman, 1890), 152.

6 Oscar Wilde, quoted in Whistler, *Gentle Art of Making Enemies*, 99.

7 Margaret MacDonald and Anna McNeill Whistler, *Whistler's Mother's Cook Book* (New York: Putnam, 1979).

8 Jonathan Weinberg, "Origins: The Artist's Mother," in *Ambition and Love in American Art* (New Haven, CT: Yale University Press, 2001), 6.

9 James McNeill Whistler, *A Series of Sixteen Etchings of Scenes on the Thames (The Thames Set)* (London: Ellis and Green, 1871).

10 Arthur Jerome Eddy, *Recollections and Impressions of James A. McNeill Whistler* (Philadelphia: J. B. Lippincott, 1903), 54.

11 Algernon Graves to James McNeill Whistler, Sept. 9, 1878, Glasgow University Library, MS Whistler G163; and Algernon Graves to James McNeill Whistler, June 10, 1882, Glasgow University Library, MS Whistler G173.

12 Margaret F. Macdonald and Joy Newton, "The Selling of Whistler's Mother" *American Legion of Honor Magazine* 49, 2 (1978): 97–120.

13 Sadakichi Hartmann, *The Whistler Book* (Boston: L. C. Page, 1910), 234–35.

14 Sarah Burns, "Old Maverick to Old Master: Whistler in the Public Eye in Turn-of-the-Century America," *American Art Journal* 22, 1 (Spring 1990): 30.

15 "London Pictures and London Plays," *Atlantic Monthly* 50, 298 (Aug. 1882): 257–58.

16 Edmund H. Wuerpel, "My Friend Whistler," *The Independent* 56, 2877 (Jan. 21, 1904): 136.

17 For details on the controversy and trial, see Linda Merrill, *A Pot of Paint: Aesthetics on Trial in Whistler vs. Ruskin* (Washington, DC: Smithsonian Institution Press, 1992).

18 "Whistler, Painter and Comedian," *McClure's Magazine*, no. 7 (Sept. 1896): 374–78. See also Frank A. Hadley, "Whistler, the Man, as Told in Anecdote," in "Special Whistler Number," special issue, *Brush and Pencil* 12, 5 (Aug. 1903): 334–38, 341–48, 351–56, 359–67.

19 "A San Francisco lady," quoted in "The Drift of the Day," *The Collector* 3, 9 (Mar. 1, 1892): 134–35.

20 James McNeill Whistler, quoted in Eddy, *Recollections and Impressions*, 15–16.

21 James McNeill Whistler to Henry Studdy Theobald, Apr. 25, 1888, British Museum, London, Department of Prints and Drawings, Alexander volume 59-11-14-6.

22 "Mr. Whistler, Mr. Smalley and Mr. Ruskin," *The Critic: A Weekly Review of Literature and the Arts* 17, 520 (Feb. 6, 1892): 91.

23 Ibid.

24 N.N., "Mr. Whistler's Triumph," *The Nation* 5, 1398 (Apr, 14, 1892): 280–81.

25 Daniel Sutherland, *Whistler: A Life for Art's Sake* (New Haven, CT: Yale University Press, 2014), 102, 273, 318–20.

26 James McNeill Whistler to William McNeill Whistler, Feb. 1–14, 1892, Glasgow University Library, MS Whistler W995.

27 Ibid.

28 "Whistler and Chicago," *New-York Daily Tribune*, Feb. 20, 1892.

29 "Art Notes," *New York Times*, July 21, 1903.

30 "Matters of Art," *New York Tribune*, Dec. 27, 1908.

31 Frederic Keppel, "Whistler as Etcher," *The Outlook* 85, 16 (Apr. 27, 1907): 963–77.

32 "To Whistler, American," *Poetry: A Magazine of Verse* 1, 1 (Oct. 1912): 8.

33 *New York Evening Transcript*, quoted in "Some Newspaper Estimates of Whistler," *Literary Digest*, no. 27 (Aug. 1, 1903): 132.

34 Hartmann, *The Whistler Book*, 145

35 Linda Merrill, *After Whistler: The Artist and His Influence on American Painting* (New Haven, CT: Yale University Press, 2003), 138–41, 226–27.

36 Tanner's *The Raising of Lazarus* is housed at the Musée d'Orsay.

37 Darrel Sewel suggested the appropriation of Whistler's painting could have been read as a "gentle intellectual joke" by Tanner's family. Dewey F. Mosby, Darrel Sewell, and Rae Alexander-Minter, *Henry Ossawa Tanner* (Philadelphia: Philadelphia Museum of Art, 1991), 42.

38 See, for instance, "Their Portraits of Their Mothers: The Best Works of Famous Artists," *Chicago Daily Tribune*, May 5, 1905; "Mother's Day" *Washington Herald*, May 9, 1913.

39 Museum of Modern Art, press release, May 9, 1934, Museum of Modern Art Archives, New York.

40 Museum of Modern Art, press release, Apr. 3, 1934, Museum of Modern Art Archives, New York.

41 H. I. Brock, "'Whistler's Mother' Comes Home Again; Once Rejected Here, the Portrait, Now a Symbol, Returns to Us on Loan," *New York Times*, Oct. 23, 1932.

42 Cole Porter, "You're the Top," *Anything Goes*, 1934.

43 Museum of Modern Art, press release, Apr. 3, 1934, Museum of Modern Art Archives, New York.

44 Museum of Modern Art, press release, May 9, 1934, Museum of Modern Art Archives, New York.

45 Clark Art Institute, "Iconic Painting 'Whistler's Mother' Arrives July 4 at the Clark Art Institute" [press release], May 14, 2015, http://www.clarkart.edu/About/Press-Room/Press-Releases/2015/Whistler-s-Mother#sthash.5RXDHyke.dpuf.

46 Sebastian Smee, "'Whistler's Mother' to Visit Clark Art Institute in July," *Boston Globe*, Mar. 19, 2015, https://www.bostonglobe.com/arts/theater-art/2015/03/19/whistler-mother-visit-clark-art-museum-july/dstm9bFU8xXgyF6c46QLAJ/story.html.

47 Cheryl Ganz, Daniel Piazza, and M. T. Sheahan, *Delivering Hope: FDR and Stamps of the Great Depression* (Washington, DC: Smithsonian National Postal Museum, 2009), 7, https://repository.si.edu/bitstream/handle/10088/21718/npm_ganz_and_piazza_delivering_hope_2009.pdf?sequence=1&isAllowed=y.

48 "Whistler Stamp Scored by Artists," *New York Times*, May 5, 1934.

49 Alfred H. Barr to Postmaster General James A. Farley, May 9, 1934, reproduced in Museum of Modern Art, press release, May 9, 1934, Museum of Modern Art Archives, New York.

50 Norton Simon Museum, "The Norton Simon Museum Presents *Tête-à-tête: Three Masterpieces from the Musée d'Orsay*, March 27–June 22, 2015" [press release], Feb. 2015, accessed Sept. 5, 2015, http://www.nortonsimon.org/assets/Uploads/Tete-a-Tete-Press-ReleaseFeb-2015.pdf.

51 The statistics are from the Langviews Analysis tool. See https://tools.wmflabs.org/langviews/?project=en.wikipedia.org&platform=all-access&agent=user&range=last-year&sort=views&direction=1&view=list&page=Whistler%27s_Mother.

52 Jessica Gelt, "At Norton Simon, a Delicate 'Tête-à-Tête with Whistler, Other Masters,"

Rematriating James McNeill Whistler

Los Angeles Times, Mar. 27, 2015, http://www.
latimes.com/entertainment/arts/la-et-cm-norton-
simon-20150327-story.html#page=1.

53 Whistler defender, quoted in Joseph Pennell,
The Life of James McNeill Whistler (Philadelphia:
Lippincott Library, 1911), 170.

54 James McNeill Whistler, "'The Red Rag' Letter
to *The World*" [May 22, 1878], reprinted in Whistler,
Gentle Art of Making Enemies, 127.

55 Whistler, "Ten O'Clock," 139, 154–55.

56 Whistler, "'The Red Rag' Letter," 128.

57 John Van Dyke, *Art for Art's Sake* (1893;
New York: Charles Scribner's Sons, 1896).

58 John Van Dyke, *American Painting and Its
Tradition* (New York: Charles Scribner's Sons, 1919), 17.

59 "Mister Whistler's 'Notes,' 'Harmonies,'
'Nocturnes,' and Epigrams," *Boston Evening Transcript*,
Mar. 9, 1889.

60 Bernard Sickert, *Whistler* (London: Duckworth;
New York: E. P. Dutton, 1908), 20.

61 Algernon C. Swinburne, "Mr. Whistler's Lecture
on Art," *Fortnightly Review*, no. 49 (June 1888),
reprinted in Whistler, *Gentle Art of Making Enemies*,
250–58.

62 For a detailed account of their friendship
and of the controversy, see Robin Spencer, "Whistler,
Swinburne, and Art for Art's Sake," in *After the
Pre-Raphaelites: Art and Aestheticism in Victorian
England*, ed. Elizabeth Prettejohn (New Brunswick, NJ:
Rutgers University Press, 1999), 59–89.

63 James McNeill Whistler, "Et Tu, Brute," in
Whistler, *Gentle Art of Making Enemies*, 259.

64 Mrs. Arthur Bell [N. D'Anvers], *James McNeill
Whistler* (London: G. Bell, 1904), 27.

65 "Some English Criticisms of Whistler's Art,"
Literary Digest 27, 9 (Aug. 29, 1903): 250–64.

66 Seymour Eaton, "The Louvre and Luxembourg
Galleries," *San Francisco Call*, July 11, 1900.

67 Smee, "'Whistler's Mother' to Visit Clark Art
Institute in July."

68 Royal Cortissoz, "Whistler," *Atlantic Monthly* 92,
150 (Dec. 1903): 826–37.

69 "General Notes," *New-York Daily Tribune*,
Nov. 25, 1881.

70 Hartmann, *The Whistler Book*, 145–46.

71 Martha Banta, *Imaging American Women: Idea
and Ideals in Cultural History* (New York: Columbia
University Press, 1987); Bailey Van Hook, *Angels of Art:
Women and Art in American Society, 1876–1914*
(University Park: Pennsylvania State University Press,
1996).

72 Caitlin Silberman, "Portrait of the Artist's Mother
as an Old Woman," *Getty Iris*, May 13, 2015, http://blogs.
getty.edu/iris/the-portrait-of-the-artists-mother-as-an-
old-woman/.

73 Weinberg, "Origins: The Artist's Mother," 8.

74 Sutherland, *Whistler*, 116–17.

75 James McNeill Whistler to William Booth
Pearsall, Dec. 4–11, 1884, Library of Congress,
Manuscript Division, Pennell-Whistler Collection,
PWC 2/40/5.

76 Lucy Margaret Lamont, *Thomas Armstrong, C.B.:
A Memoir, 1832–1911* (London: Martin Secker, 1912), 193.

77 *Mother and Child, No. 1, Mother and Child—
The Pearl, Cameo, No. 1 (Mother and Child),
Mother and Child, No. 4*, and *Cameo, No. 2*, 1891–1895,
Freer Gallery of Art and Arthur M. Sackler Gallery.

78 Anna McNeill Whistler to Catherine Jane Palmer,
Nov. 3–4, 1871, Library of Congress, Manuscript
Division, Pennell-Whistler Collection, PWC 34/67–68
and 75–76.

79 Christian Brinton, "Whistler from Within,"
Munsey's Magazine 36, 1 (Oct. 1906): 3–20.

80 Eddy, *Recollections and Impressions*, 48–49.

81 Mrs. Schuyler Van Rensselaer, *American Etchers*
(New York: Frederic Keppel, 1896), 15.

82 Whistler, "Ten O'Clock," 137. See Kathleen Pyne,
"James McNeill Whistler and the Religion of Art," in
*Art and the Higher Life: Painting and Evolutionary
Thought in Late Nineteenth Century America* (Austin:
University of Texas Press, 1996), 84–134.

83 John Van Dyke, "What Is All This Talk about
Whistler?," *Ladies Home Journal* 21, 4 (Mar. 1904): 10.

84 Ibid.

85 Oscar Wilde to James McNeill Whistler, Feb. 22–23,
1885, Glasgow University Library, MS Whistler W1046.

CIRCULATION AND TRANS-

FORMATION OF CINEMA

Tom Gunning

Circulation and Transformation of Cinema; *or, Did the French Invent the American Cinema?*

Circulating the Cinema: International Distribution

As an art of moving images, cinema depends on circulation, movement. This is both literal—even mechanical, as the filmstrip moves through camera first and then the projector—and metaphorical. Films transport us as viewers; they take us through space and time virtually. But circulation in cinema has another literal dimension: the movement of actual films from place to place and across borders— the branch of the film industry known as distribution, as essential to it as production and exhibition, even if generally less evident to the moviegoer. During the nineteenth century, national and even global transportation and circulation of what had once been local commodities became technologically possible. As canning and eventually refrigeration allowed distant transportation of perishable foodstuffs, modern technology also transformed the circulation of popular entertainment.

Entertainers had always traveled; their wandering nature defined their identities as exotic beings outside the routines of settled living. But in the late nineteenth century, the circulation of popular entertainment became rationalized and integrated with modern technology such as the railway. Under P. T. Barnum and his post–Civil War rivals such as the Ringling brothers, the circus became a model of efficient and rapid transportation with huge tents, equipment, animals, and entertainers moving along strictly calculated routes.[1] Even the massive,

Adrien Barrère, "À la conquête du monde" (detail, see fig. 1).

146

industrially manufactured panoramas popular at the time were designed to be rolled up and transported across land by rail (or across oceans by steamer). Vaudeville shows became organized in "wheels" of rail-connected theaters, while "roadshows" of Broadway hits complete with casts and sets traveled between major cities.[2] But the cinema truly revolutionized circulating entertainment, by providing a program that could be packaged and shipped with remarkable ease. Films were referred to as "canned vaudeville," which highlighted not only the way film "preserved" performances but also the ease of their circulation. While the circus and the panorama gained massive audiences through their new systems of circulation, mechanical reproduction allowed the cinema to become a new form of mass entertainment.

As the twentieth century progressed, cinema served as the exemplar, whether for praise or blame, of modern machine art. Cinema not only was produced and exhibited by machines (the camera, the projector), but was itself a mass-produced object (reels of film) that embodied mechanical reproduction's most revolutionary aspects. Universal circulation, a new sort of transcendental homelessness, seemed to beset cinema, even as it strove for national identity by producing national historical epics (e.g., *The Birth of a Nation*, 1915; *Napoleon*, 1929). Hollywood became less a southern California location than an international brand of entertainment, crossing borders as few previous art forms could have. Just as national magazines could present the same issue across the nation, the cinema as an art of mechanical reproduction allowed the same exact show to be shown across the nation or around the world. Cinema emerged as an art whose nature was partly determined by its possibilities of circulation. From its origins, cinema distribution was conceived of as global. This world vision began primarily in France.

The Movies Come from . . . France

The idea that the cinema came from France contradicts the way we usually think about the movies. In 1937, Gilbert Seldes, former editor of the modernist journal *The Dial* and one of the first American critics to take the popular (or as he called them, "the lively") arts—movies, comic strips, vaudeville, and especially jazz—seriously, published a book entitled *The Movies Come from America*.[3] Seldes was stating what was an acknowledged fact in 1937: movies came from Hollywood and then circled the globe, especially its urban centers. In the thirties, not only were Hollywood films seen in Delhi, Tokyo, Shanghai,

Johannesburg, Buenos Aires, Mexico City, Berlin, and Paris, but the fashions, music, lifestyles, and even jokes seen in the movies affected urban culture around the world, resulting in what Miriam Hansen has described as a "vernacular modernism," a new view of modern life as seen on the screen.[4] Further, the plots and situations from Hollywood films were absorbed and transformed by indigenous film-makers from China to India to Japan and Mexico in films that were less remakes than cannibalizations of Hollywood topoi. The movies may have come from America, but they were watched and reinter-preted around the world.

However, if Seldes had been writing three decades earlier, say in 1907, about ten years after the apparatus of cinema was launched on its global career (by 1896 films were projected in nearly every interna-tional urban center, including all those mentioned above), his study would have been titled *The Cinema Comes from France*. This claim does not rest simply on invention. France has consistently claimed that local heroes Louis Lumière (1864–1948) and Auguste Lumière (1862–1954) "invented" cinema, and certainly their apparatus, the Cinémato-graphe, gave the new medium one of its most enduring names. But the national provenance of inventions is always disputed. The United States promotes Thomas Edison and Francis Jenkins as "inventors" of cinema; Germany, the Skladnowsky brothers; and Great Britain, William Friese-Greene and (more credibly) French immigrant Louis Le Prince. The Lumières' claim to preeminence makes sense espe-cially in terms of projected motion pictures and reliable performance (Edison's initial motion-picture invention, the Kinetoscope, was a peep show device limited to a single viewer at a time). As a product of a major international photographic supply company, the Lumières' new invention had a major impact in Europe.

Unlike the other pioneers, the Lumières almost immediately conceived of their invention in global terms. Although the first films produced by the Lyon-based Lumière Company were essentially local views of its hometown (workers leaving the Lumière factory, the arrival of a train at a local station, people milling about town squares, a family breakfast in the garden of Auguste Lumière), by 1896 the company launched a worldwide strategy. Lumière cameramen criss-crossed the globe projecting films and filming new ones in Mexico, Indo-China, Egypt, the United States, England, Sweden, and Japan, among other countries. The Lumière Company set a pattern for early cinema by defining the attraction of the new medium as not only capturing motion but transporting viewers around the world. The

modern identity of cinema depended on this ease of circulation. The Lumière Cinématographe had a premiere in New York and across the United States in 1896, and it was generally greeted as one of the finest new motion-picture devices, although it had competitors in the Vitascope and some months later the Biograph.[5] Despite the positive reception of the Cinématographe on its premiere in the United States, American cinema interests headed by Edison managed to curtail its American career. This was the first foray in a battle that would last over the next two decades as American film companies strove to keep the French producers out of the United States. Initially the Americans failed.

If the Lumière Company did not manage to dominate the public projections of motion pictures in the United States, the near colonization of America's cinemas by the French was achieved—at least for a while—by the French film company Pathé Frères. The Lumière Cinématographe was received very favorably in 1896, but left no lasting impact. Some years later the popularity of the trick films of Georges Méliès (1861–1938), especially *The Trip to the Moon* from 1902, deeply impressed the entrepreneurs of American vaudeville theaters. American film production companies not only imitated Méliès's films (as in Edwin Porter's *Jack and the Beanstalk* [1902] for the Edison Company)[6] but also rushed to dupe their own copies of the French films, which they often sold as their own productions in this era before films had established copyright. By 1903, the Lumière Company had abandoned film production, and Méliès's Star Film Company remained stuck with an artisan mode of production in which almost all tasks were under the control of the company head, Georges Méliès. It was Charles Pathé (1863–1957) who, in the words of André Gaudreault, "institutionalized" the cinema by industrializing film production.[7] The Pathé studio from 1905 on instituted a program of maximum efficiency in production with multiple directors filming individual films simultaneously, greatly increasing output. Further, the market Pathé envisioned was global rather than national with branch offices across the globe and subsidiary production companies in several countries. Although a global conception of the cinema had existed from the Lumières on, Pathé was in a position to actually make it work as a modern model of circulation.

As Richard Abel's meticulous research has shown, Pathé Frères had a fundamental influence on the emerging American film industry. While the major players in American film production, the Edison Company and the Biograph Company, were mired in a patent war

1
Adrien Barrère, illustrator, "À la conquête du monde," satirical drawing, 1906. Poster. Collection Julien Anton.

over their rival apparatuses, Pathé released a great number of films to American exhibitors and the independent film exchanges that handled national distribution. While the American system of production remained underdeveloped, the popularity of the movies with an expanding audience stimulated the growth of both film theaters and independent exchanges that distributed films. These factions of the industry (rather than the producers) led the way to the emergence of movies as a form of mass entertainment, an event known as the "nickelodeon boom." Movie theaters sprang up by the hundreds and exchanges could deliver product nationwide, but where were the films coming from? As Abel demonstrates in his book *The Red Rooster Scare* (1999), it was the output of Pathé, films imported from France, that fueled and enabled the American nickelodeon boom of 1904–1908.[8]

The nickelodeon boom was almost more important to the history of American cinema than the "invention" of cinema ten years earlier. From 1896 to about 1904, movies played primarily in vaudeville houses to middle-class audiences along with a bill of live acts. By the early twentieth century, film had almost worn out its popularity as a technological novelty or living newspaper presenting current events. The nickelodeon boom redefined film as something more than a vaudeville act or source of news and sought a broader audience than vaudeville patrons. The movies were born. The proliferation of cheap movie theaters (admission one nickel, hence the name "nickelodeon") that primarily showed films rather than live acts defined film as a form of mass entertainment that initially appealed to working-class patrons and eventually was embraced by all classes. Further, during this period the main attraction of cinema moved from actualities and technical novelties to the story film. The nickelodeon boom was literally an explosion, unanticipated by most film manufacturers, as first hundreds and then thousands of nickel theaters popped up in American cities and small towns. They attracted a new audience paying cheap prices who gathered informally to catch a show. City officials and "guardians of culture" were often alarmed at this primarily proletarian audience, including recent immigrants, women, and children, without benefit of tradition and apparently without supervision. These thousands of new movie theaters, which tended to change bills several times a week, demanded large quantities of films, which the laggard American producers could not supply.

Pathé filled this vacuum as the industrially organized studio was uniquely positioned to supply a volume of films American producers could not dream of offering. As Abel has shown, up till 1907 Edison

and Biograph were only producing about two films a week, while Pathé could offer eight to twelve new films every week.[9] Therefore, from about 1905 to 1908, American nickelodeons primarily showed French films produced by Pathé (although Pathé's chief French competitor, Gaumont, also contributed to the nickelodeon programs of the United States). Pathé had realized early on the key role the United States would play within its global strategy. The enormous US population (85.5 million in 1906, more than twice the population of France the same year) and its high standard of living marked the United States as the most promising of markets. Pathé had opened a business office in New York in 1904, and then another in Chicago (the center of the film exchanges). In 1909, it opened a plant in New Jersey for manufacturing prints, cutting the expense of importing each individual print from France.

Pathé was known for quality as well as quantity. Its trademark, the red rooster, became to American audiences synonymous with the best in cinema. What did quality mean in this era before film stars or auteurs? Clarity of photography and detailed sets were often cited. But, as Abel stresses, Pathé's use of color gave it a competitive edge against American films.[10] Pathé used a variety of techniques, including tinting and toning, to make its films colorful, but its stenciled multicolored process was probably the most outstanding. Its fairy-tale films, filled with cinema tricks and bright colors, were immensely popular in the United States. Pathé's mastery of narrative techniques (the studio was a pioneer in the use of both parallel editing and close-ups) allowed it to lead the way in the newly popular story films. The three or four years of French dominance of American screens may not seem long-lasting, but these few years represented perhaps the greatest transformation of American cinema.

A conscious industrial nationalism followed by the global cataclysm of World War I reversed French dominance of American theaters. American film producers were slow to respond to the nickelodeon boom, but by 1907 they realized that their internecine fighting had to be resolved. American producers, especially Edison and Biograph, had two goals after they realized that the nickelodeon boom had caught them off guard: First, they wanted to assert dominance over the other factions of the film industry, including the nickelodeons and the film exchanges (which had gained control over distribution). Secondly, they wanted to limit the share foreign films (read French) had taken of American screens. From 1907 through 1908, the leading producers jockeyed for prominence, threatening legal actions with their various patents. They realized that only a policy of combination and patent pooling could give

them the leverage they desired over the industry and foreign rivals. Their efforts culminated in the late 1908 announcement of the Motion Picture Patents Company (MPPC), which subordinated all the major US production companies to a licensing agreement that recognized the preeminence of the patents of Edison and Biograph. Pathé was admitted to this organization after a great deal of negotiation.[11] The MPPC brought order to the American film industry, establishing regular release dates for films sufficient to supply the voracious nickelodeons. American producers, including Edison and Biograph, committed to increasing both the quality and quantity of their production (it was often noted that Biograph and its new director D. W. Griffith had begun following Pathé's lead in terms of acting and narrative clarity). Although Pathé found a secure place within the new organization and remained a major supplier of films, the new release schedule actually reduced the number of films it placed on the American market. The reign of Pathé over American nickelodeons was ended.

Economic collusion (the MPPC was broken up by US antitrust laws in 1914) primarily dethroned the Pathé cock in the United States. But, as Abel has detailed, economic organization was accompanied by an ideological campaign, sowing suspicion of "foreign" films while calling for a virile, healthy, and clean American cinema.[12] Whereas French provenance had previously carried connotations of refinement and culture, American cinema trade journals now associated France with decadence and loose morals. The MPPC had vowed to clean up American films, to make them suitable for middle-class tastes, and to shed the carnival trappings the cinema had previously displayed. Calls for censorship were met by a board of censorship adopted by the MPPC, which criticized certain Pathé films for their Grand Guignol gruesomeness and piquant portrayal of situations of adultery. Whether Pathé films were any more obscene or suggestive than other films could be debated, but moral outrage merged into a jingoistic call for "American subjects." As Abel has shown, American filmmakers responded by increasing production of action-dominated films of national subjects, especially westerns.

Pathé opted to join rather than defy its American competitors, not only by becoming part of the MPPC and accepting its restrictions, but by trying to adapt to the newly nationalistic American market. Pathé had already established production subsidiaries in a number of European countries (Spain, Italy, Russia), and in 1910 it opened a studio in the United States specifically to produce films with an

American flavor and targeted at native audiences but likely to have worldwide popularity (westerns soon showed international appeal and paved the way for increased exports of American film throughout the world). The first Pathé American production was, not surprisingly, a western, *The Girl from Arizona* (1910). Pathé hired James Young Deer a Native American actor and director to produce western films, and in 1911 the company established a studio in California, following the migration west of other American production companies, partly motivated by the search for authentic western landscapes.

By 1913, the landscape of American cinema had been transformed. Storefront nickelodeons gave way to purpose-built neighborhood theaters, while downtown shopping areas saw the creation of picture palaces with elaborate façades, comfortable seating, and uniformed attendants. The variety-based nickelodeon program of a number of one-reel (fifteen-minute) films of differing genres was replaced by an evening's entertainment dominated by a feature film sometimes lasting two hours or more. Stars, like Mary Pickford, replaced the trademark of studios (such as Pathé's cock) as the guarantee of quality and the focus of audience desire. The MPPC broke apart and ceded prominence to the "independent" studios that became Universal and Paramount. From the entertainment of the working class, movies became the pastime of all classes, and middle-class standards of taste and comfort became the norm.[13] Pathé continued to have a presence in American theaters, but mainly for its American productions and stars, such as the 1914 serial drama *The Perils of Pauline* starring Pearl White and its popular newsreel (which continued to show the Pathé rooster crowing on American screens until the 1950s, although the Pathé Film Exchange was bought by Americans in 1921). Imported French film became specialized fare shown in urban art theaters in the 1920s and never regained the broad popularity it once, if briefly, held.

If the international and especially the American market for Pathé films had shrunk by 1913, the outburst of World War I in 1914 seriously curtailed the export of French films to the United States. Soon the war stalled film production in France. Since the United States did not enter the war until 1917, this period allowed the newly transformed American film industry to cohere and consolidate. The stability of the business, the elimination of foreign competition, and the formulation of feature-length American genres and stars not only guaranteed the domestic market but poised American cinema to launch a project of American hegemony over movie theaters worldwide. After World War I, the movies did indeed "come from America."[14]

Recoil and Redefinition: Another Phase of Circulation

Pathé instituted a basic transformation not only in French film distribution and export but also in film production after World War I. Unlike his early rival Georges Méliès, whose filmmaking career had ended by World War I (following a brief stint working for Pathé), Charles Pathé was less a filmmaker than a businessman. It became clear to him, as the 1920s approached, that the money in filmmaking was more likely to come from film distribution and exhibition than the production of films for a restricted domestic market instead of an expanding global one. In 1918, Pathé Frères announced that it would no longer produce films but would serve exclusively as a film distributor and exhibitor, especially of the newly popular films imported from the United States.[15]

French film production no longer dominated worldwide distribution. But here the focus of my essay shifts from economic circulation to the circuit of ideas. In this area, French film culture after World War I truly comes into its own, and I would claim (admittedly retrospectively) that this culture inaugurated not only a new serious understanding of the nature of cinema but also a definition of American cinema. At the same time, and emerging out of the same culture of serious discussion of film, a small group of French filmmakers, known now as the "Impressionists" and including Louis Delluc (1890–1824), Germaine Dulac (1882–1942), Marcel L'Herbier (1888–1979), Jean Epstein (1897–1953), and René Clair (1898–1981), fashioned an alternative film culture based in pursuing artistic goals more than commercial success. Together and in a dialogue between critics and filmmakers (most of these figures both wrote criticism and made films), this group undertook to define cinema as an area of aesthetic practice equal to, and different from, the other arts. Critical discussions in new film journals that were more than trade publications or fan magazines and lectures in the newly formed noncommercial ciné-clubs approached cinema as a new modern art form.[16] But if these discussions were aesthetic rather than economic, they nonetheless depended on and articulated the international circulation of films, offering a uniquely French reception of American movies

Of course film remained primarily a commercial business and even the work of these avant-garde filmmakers existed within the orbit of commercial filmmaking. All of them made films that were in some degree commercial, and of course their output constituted a small proportion of French filmmaking in the twenties. But I am claiming that this film culture represented a form of the circulation of film

based in critical reception and discourse. After World War I, France moved from an exporter of films to the United States to an importer of American movies, but its reception of American cinema was far from passive. The film culture that emerged in France not only viewed American cinema but redefined it discursively. The movies may have come from America, but France (re)defined them. Although the full American reception of French film culture was probably accomplished with the rise of film studies in the 1970s, already by the twenties French critics discussed American films with a seriousness surpassing their reception in their native land. The French were fascinated, attracted, and occasionally a bit repelled by the American cinema. They undertook discussing and finally defining what the American cinema was. It is in this sense that we could claim (with conscious irony) that France invented "the American cinema."

In contrast to the in-depth research by early cinema scholars, especially the redoubtable Richard Abel, that formed the basis of the first section of this essay, this section remains a bit speculative and launches a thesis rather than summarizing a history. The influence of French critics and theorists on film studies is well known, and the impact of French criticism on the understanding of American cinema has long been recognized. But its history remains to be thoroughly researched and written. I restrict myself here to the founding moment of this history, following directly on the worldwide expansion of American movies.

One could focus this discussion on the French reception of Charlie Chaplin (1889–1977), a love affair that was enthusiastic to the point of mania and lasted as long as Chaplin's career (see the wonderful later essays André Bazin devoted to Chaplin in the 1950s embracing not only the most famous silent film but his later films, such as *Monsieur Verdoux* [1947] and *Limelight* [1952]).[17] But Chaplin, with his British roots and his final exile from a red-baiting America, seems to float above nationalism and become the closest thing cinema has produced to a truly international or transnational filmmaker. Further, enthusiasm for Chaplin was an international phenomenon from Europe to Asia, even if the French probably articulated it better than any other nation.[18] But Chaplin was less appreciated by the figures of French film culture than he was adopted and absorbed by them, as his rebaptism as the Gallic "Charlot" indicates. But the figures of post-World War I film culture also discovered and celebrated the American cinema qua American and contrasted it to the (as they saw it) old-fashioned and unimaginative French cinema.

Even as perceptive a historian as Richard Abel has defined this alternative French film culture of the post-World War I era in opposition to Hollywood—following a sort of critical reflex of the post-1970s film study in which the avant-garde was understood more as a critical conception than a historical phenomenon.[19] Certainly the filmmaking of the Impressionist directors opposed key aspects of modes of film production that have become associated with what film historians David Bordwell, Kristin Thompson, and Janet Staiger have defined as the "classical Hollywood cinema": studio production, narrative structure determining film style, and the central role of the star. One could also claim that the Impressionist films with their emphasis on poetic imagery; loose, elliptical, and even ambiguous narrative structures; and embrace of visual abstraction were the opposite of the action-driven Hollywood narratives based in clearly volitional and well-defined characters with narrative resolution and closure.[20]

But the French reception of the American cinema beginning after World War I poses a paradox in need of decoding. Rather than scorning Hollywood, proponents of this alternative cinema culture often looked to the fast-paced, action-oriented, genre-driven American movies as a model for what modern cinema could accomplish, beginning with their admiration of Cecil B. DeMille's 1915 film *The Cheat*. This early French film culture understood American cinema in a very different way from the imperialist, highly capitalized, narrative-driven leviathan that was constructed by film studies in the seventies. I am not claiming that this interpretation of American cinema is more historically accurate. Indeed, accuracy is not the issue here. Rather the French film culture after World War I selectively reconfigured American cinema and highlighted those aspects it found new and exciting and useful for fashioning a new sense of cinematic possibilities. This involved seeing America as a unique modern culture that possessed an energy that could unmoor the static traditions and devotion to the traditional arts of theater and literature that the French avant-garde felt had ossified their native cinema. This enthusiasm for American movies can be seen as an aspect of the "Americanism" evident in much of the European avant-garde of the 1920s, perhaps most vividly in the embrace of American jazz and dance.

I am dealing with an international phenomenon that embraced many aspects of American culture, especially the lively arts, celebrated by Gilbert Seldes, of jazz, comic strips, slapstick comedy, and vaudeville. Film historian Yuri Tsivian has written brilliantly on what was called "Americanitis"—an obsessive fascination with things American—

in relation to early Soviet culture, and far from shying away from its contradictions, he addresses them head-on in a manner that helps me resolve the paradox of the importance of American cinema for early French alternative cinema culture.[21] It perhaps seems even more paradoxical that Hollywood cinema provided a model for a socialist revolutionary cinema. Although post-World War I modernism has many facets, admiration for the machine remains central to it. The machine functioned for modernist aesthetics as the nude had in post-Renaissance painting, providing not only an image of beauty and a model of visual form but also a guide to artistic practice. As opposed to the organic unity and sense of luminous surface that the nude provided, the machine represented form as an assemblage of separate elements joined by a functional logic.

In the Soviet Union, the machine carried multiple significances: an emblem of reason, an actual tool of industrial development and progress, the companion of productive proletariats rather than luxury-seeking bourgeois. The cinema was a machine-art directed at the masses, a scientific-based medium capable of instructing its audience, all of which made Lenin proclaim it the most important of the arts for the new socialist state.[22] The ideology of the new Soviet cinema may be directly opposed to that of Hollywood, but Hollywood (like the other American industries from which the Soviet Union sought advisers and models) also showed a knowledge of this machine art that was radically different from that of traditional arts. The American cinema embraced industrial processes as opposed to the European cinema (read French), which had tried to adapt cinema to the practices of theater. Compared to French films, not to mention prerevolutionary Russian films, American films aggressively placed the camera closer to its subjects and cut from place to place and scene to scene quickly, building a sense of intensity and tempo through editing. The young Soviet filmmakers embraced these radical aspects of the American cinema.[23] Therefore the early Hollywood cinema per- formed for the Soviets one of the essential roles of the avant-garde: destroying previous norms and traditions borrowed from the older arts. Tsivian accents, as other historians have, two particular aspects of fragmentation in American cinema: closer framing (the close-up being its most radical form) and rapid cutting (editing, which the French and Russians called "montage").

Hollywood cinema employs these techniques of fragmentation and tempo at the service of the story. This is the mantra not only of Bordwell, Thompson, and Staiger, but also of the Hollywood industry

itself. Fragmentation becomes subordinated to a purpose, constructing a narrative that makes these elements cohere. This subordination of editing and framing to a consistency of narrative space and time and cause and effect has been christened the continuity system. While I feel that its absolute rule over all periods and genres of American cinema can be questioned, its general dominance cannot be denied. Tsivian sees the legacy of American movies to the Soviet cinema as split: the Soviets took the meat but not necessarily the potatoes. As Tsivian puts it, "It may sound paradoxical, but the montage theory in the Soviet sense descends directly from the Hollywood continuity techniques minus the very thing it served: the fluent and unobtrusive rendering of the film story."[24]

I cannot agree more wholeheartedly with Tsivian's analysis or applaud more heartily his research and argument. However, I want to stress two modifications, perhaps implicit in his account, but perhaps not. The first is that the Hollywood calculation of the way elements of fragmentation serve to drive the story seems to me very consistent with the admiration the Soviets had for rational construction. The continuity system understood as the coordination of disparate elements corresponds to a mechanical model of the Constructivist sort. The purpose-driven use of fragmentation, while problematic for the Formalist critics that Tsivian quotes who celebrated an awareness of form for its own sake, was very acceptable to the later Soviet Constructivists who applied Formalist techniques for the purpose of integrating art into the new Soviet state. My other modification has to do with claiming that the function of cinematic technique in "classical Hollywood cinema" lies primarily in narrative clarity, in other words, serving a cognitive process. This role cannot be denied, but the close-up was never only a means of clarification; it served as an intensification of emotional affect, as much as it served narrative efficiency. The Soviets learned from American movies, as Eisenstein makes especially clear, the means to affect the viewer, to control and direct his or her emotions. Lev Kuleshov, praising American cinema in his 1922 essay "Americanitis," declared, "The public especially 'feels' American films."[25] Of course in contrast to the petty bourgeois emotions that the American cinema seemed to aim at, Soviet cinema evoked horror, anger, and sympathy in order to foster a revolutionary consciousness.

Viewing the reception of American silent film by French critics and filmmakers as a part of the dynamic of cinema's international circulation, I hope to stress its transformative nature, its role in (re)defining American cinema. There are numerous differences between the Soviet reception of Hollywood film in the era after the Bolshevik revolution

and the French situation after World War I, but the similarities in the use made of American movies are also striking. Politics plays a less essential role in the alternative film culture the French intellectuals were fashioning, and an interest in a scientifically rational and efficient Constructivist form of cinema was not as important. But I would claim that two essential aspects of a transformative reception were common to the Soviet and French receptions of American movies: the sense that the new very modern pace and fragmentation of the American cinema would help cinema overcome its ties to theater; and the decoupling of the formal devices of closer framing and rapid editing from strictly expository or narratively driven tasks. I explore both of these in the French context but also indicate some aspects that give this remediation of American cinema a uniquely French accent.

The Critic's Role in Circulation

Let me begin with Louis Delluc, the critic who in his writings introduced in the late 1910s many of the principles of the alternative French film culture, including its key word *photogénie*. Delluc was also a pioneer in setting up *ciné-clubs*, noncommercial sites where films were shown and accompanied by discussions and lectures, which not only supplied alternative exhibition sites but embedded cinema in serious discourse. Editor from 1917 on of the film magazine *Le Film* and later of other film journals and author of a regular film column in *Paris-Midi*, Delluc became the major voice defining the new art of cinema in France, arguing for a very particular view of what cinema was and should be. He was particularly excited by the beauty of natural landscapes in cinema and praised along with American westerns the new Swedish films of Victor Sjostrom and Maurice Stiller. He saw the movie star as a cinematic physiognomy as much as a personality. These two highly visual mappings, the landscape and the face, reveal what the somewhat vague term *photogénie* meant to Delluc. *Photogénie* referred not only to photography's ability to capture the world and its objects through a technological process but to the unexpected aspects of beauty that photography revealed. Often briefly defined as the qualities that the photographic process brings to the world, *photogénie* was not simply a theory of distortion or stylization (such as the Russian Formalists offered) but rather a claim, almost mystical, that a deeper layer of reality became visible through photography. *Photogénie* offered an essentially modern beauty, the product of a mechanical process, but also the product of a new experience of instantaneity that photography introduced, profoundly related to what Baudelaire half

a century earlier had described as the smack of the instant of modernity.[26] Delluc, like Baudelaire, saw this as a somewhat paradoxical "impression of evanescent eternal beauty," precisely the "beauty of the passing moment."[27] Later French theorists, especially Jean Epstein, would extend and expand the concept of *photogénie*, especially the dimensions opened up by movement, seeing it as a source of the magical animism of the film image, as the primitive and the modern blended in the visual fascination cinema could offer.

For Delluc, American cinema offered a vivid demonstration of these cinematic qualities. He became, as Abel puts it, "the leading French advocate of American film."[28] Delluc dubbed Hollywood "the factory of American beauty."[29] The American movie star had a quality not found in the actors of French cinema who came primarily from theater. Delluc articulated the French fascination with three American stars in particular: Chaplin, Sessue Hayakawa (1889–1973), and William S. Hart (1864–1946). In a discussion of Hayakawa, Delluc stressed that when he praised the movie star he was not talking about "talent" (presumably the quality of the traditional theatrical actor), but rather referred to his "face as a poetic work." Chaplin, likewise for Delluc, went "beyond the actor's art."[30] William S. Hart, the cowboy actor known in France as "Rio Jim," was for Delluc the "tragedian of the cinema . . . the synthesis of that plastic beauty which marks the schematic and almost stylized Far West."[31] The faces of these movie stars were "forces of nature," beyond the traditional theatrical values of artifice or talent. Delluc claimed, "The true dramatic film was born one day when someone realized that the translation of theater actors and their telegraphic gestures to the screen had to give way to nature." By "nature," Delluc did not mean "naturalism," a more realistic style of acting, but rather an intense shift in focus from the actor to the surrounding world: "Vegetation or everyday objects, exteriors or interiors, physical details, anything material, in the end, offers a new dimension to the dramatic theme."[32] These domains of nature and physiognomy are not simply conveyed by the cinema: they become revealed through *photogénie*, as surely as a microscope or telescope reveals new worlds of scale. Cinema provided a new art form, based in a modern technological vision of the natural world.

"It is to the Americans that we owe this miracle," Delluc announced, referring to cinema's revelation of the drama of material nature. "In their Far West films . . . they got us interested as much in the cowboy's horse as in the cowboy himself."[33] Perhaps the essence of the American cinema as the French discovered and celebrated it after the First

2
William S. Hart in Two-Gun Bill pose, ca. 1920. Photograph. William S. Hart Collection, Los Angeles County Museum of Natural History, P-75-H-3509.

Circulation and Transformation of Cinema

World War lies in William S. Hart's genre, the western. Ironically, the production of westerns by American production companies in the early 1910s had served to establish a nativist cinema and thus aided in wresting the American movie audience from French films. As mentioned above, Pathé opened its American studio in 1910 partly to produce authentic-seeming westerns. Now with the battle over and the American audience lost, the western became perhaps the most popular American genre internationally. In the post-World War I reception of the American cinema, the French appreciation of the western as both quintessentially cinematic and American offered a bold interpretation of the genre.

As I hope is clear to anyone who knows later French reception of American cinema, this earlier reception established patterns that would endure for decades. The French love for, and especially their understanding of, the western extends beyond Louis Delluc and his generation, at least until the seventies, as writings by André Bazin, Jean-Luc Godard, Raymond Bellour, and others testify.[34] But the western played a specific role in the early French reception of American cinema. It embodied that modern synthesis of nature (the landscapes of the Far West) and technology (the cinema itself, but also the drama of the railway and the six-shooter) that so attracted this earlier generation to film. The Wild West provided an energy that early French cinephiles hoped would inoculate the cinema against the ossifying effects of the older arts. For instance, Blaise Cendrars (1887–1961), an early devotee to the modern possibilities of the cinema, collaborator with director Abel Gance (1881–1981), and major figure in modernist poetry, bitterly denounced the 1920 import from Germany *The Cabinet of Dr. Caligari*, claiming it was "not cinema": "It is theatrical. . . . All effects are obtained with the help of means belonging to painting, music, literature, etc. Nowhere does one see the camera." Expressing his judgment against such artistic hybridity, he proclaimed in a parenthesis as a healthy alternative, "Long live cowboys!"[35]

The western embodied the freshness and openness, the tempo and action that the French avant-garde celebrated in American films. Delluc often referred to the major effect of American cinema as "santé" (health), declaring, "The children who shout with joy or blush deliciously watching the harmonious and adventurous health of Douglas Fairbanks are not wasting their time."[36] Delluc claimed that the western seemed to renew (and presumably replace) the traditional art of tragedy. He described Rio Jim "as simple as Orestes, he moves through an eternal tragedy free of psychological snare." He felt the

same way about Hart's leading ladies: "Doesn't the terrible bitch played by Louise Glaum possess the fatal splendor of Clytemnestra? Doesn't Bessie Love evoke the chaste, savage energy of Electra?"[37] Delluc was fascinated by the French title for one of Hart's westerns, *The Man from Nowhere* (1915) (he later reformulated it for one of the films he directed, which he titled *The Woman from Nowhere* [1922]). His description of Rio Jim not only succinctly describes the western hero from Hart to Clint Eastwood but conveys a particularly French grasp of the genre (existential avant la lettre): "We never know where Rio Jim comes from. He just passes through. He crosses the West—and the West is so huge. He arrives on horseback. He leaps down onto the ground where other men live. Generally the time that he remains there is devoted to suffering, that is, loving. When his forehead has been ravaged enough, his fingers tortured, and all his cigarettes crushed out, he refuses to continue to suffer on earth or in an enclosed room—he mounts his horse again, and that done, disappears."[38] But the western as exemplar of American cinema went beyond the mythic and archetypal qualities of its hero and action; its cinematic quality lay in its setting: "All that *photogénie* is so satisfying. Gray plains void of obstacles, high mountains shining like white screens, horses and men full of animal vitality and the ready intensity of a simple life that affords rhythm, dimension, beauty, and provides a burst of incomparable humanity to the simplest feelings—love, duty, vengeance—which loom there."[39] I know of no American writing on the western this early (Delluc's review of *The Cold Deck* appeared in 1919, and his essay comparing Rio Jim to Orestes comes from 1921) that so deeply grasps the unique nature of this American genre.

The seriousness with which the western was taken by Delluc and others marks one of the extraordinary aspects of the circuit between French cineasts and the American films: an ability to take the most popular American movies seriously. Delluc's comparison of westerns to Greek tragedy would have many offspring; in the United States such similes often smack of irony, but the French indicate thereby a profound respect for the genre. Invoking Greek tragedy or the epic tradition (as when Delluc compared Hart to "Hector, Achilles, Orestes, Renaud or Roland")[40] does not simply provide the western with a cultural pedigree but rediscovers through this comparison the primitive energies of Greek ritual and fatality. I would go so far as to claim, that, as in the case Edgar Allan Poe's reception by Baudelaire, the French ultimately taught Americans what was valuable about their own cinema.

A French Tradition: American Subjects

As influential as Delluc was, his views of American cinema were by
no means unique among this post-World War I group of French cine-
philes. The great art historian Élie Faure (1873–1937) in his important
essay "The Art of Cineplastics" from 1923 declared: "The French
film is only a bastard form of a degenerate theater and seems for that
reason to be destined to poverty and death if it does not take a new turn.
The American film, on the other hand, is a new art, full of immense
perspective, full of promise of a great future. . . . For the Americans
are primitive and at the same time barbarous, which accounts for the
strength and vitality which they infuse into the cinema." This vitality
manifested itself in an intuitive visual quality, the cinematic dynamics
Faure named "cineplastics": "The interpenetration, the crossing,
and the association of movements and cadences already give us the
impression that even the most mediocre films unroll in musical
space."[41] The American cinema for Delluc and Faure used dramatic
action to create a new art of space, time, and rhythm, delivering a
powerful visual effect directly to the viewer.

Hollywood's classical continuity signified for certain French
avant-garde critics and filmmakers a specific cinematic modernity
rather than a conservative classicism. This does not mean that they
entirely ignored those aspects of the American cinema that could
be associated with a sort of classicism: a clarity of image, a vectorization
of editing in terms of action, an address focused on the emotions
and physical sensations of the viewer. Indeed these formal elements
often occurred in violent narratives set within a natural landscape
of barren hostility that recalled for them the stark fatality of Greek
tragedy. But this classical reference evoked for these critics an archaic
and Dionysian primitive energy, not simply a rule-bound model
of harmony and repose. American cinema offered a dynamic, if
sometimes contradictory, model of cinema to these filmmakers and
critics: simultaneously primitive, classical, and modern.

But as the twenties progressed, this paradoxical and dynamic
model resolved itself into separate aspects. A consciously experimental
filmmaker and theorist such as Jean Epstein clearly articulated the
move that Tsivian attributes to the Soviets: separating the formal
aspects of the American cinema from their narrative purposes. Epstein
began the section of his 1921 book *Bonjour cinéma* (which was illus-
trated with images of Hayakawa, Fairbanks, Chaplin, and other
American stars) entitled "Magnification" with these words: "I will
never find a way to say how much I love American close-ups. Point

3
Illustration by Claude
Dalbanne, from Jean
Epstein, *Bonjour
cinéma* (Paris: Éditions
de la Sirène, 1921),
n.p. Cinémathèque
française, Paris.

blank. A head suddenly appears on screen and drama, now face to face, seems to address me personally and swells with an extraordinary intensity. I am hypnotized. Now tragedy is anatomical. The décor of the fifth act is this corner of a cheek torn by a smile. Waiting for the moment when 1,000 meters of intrigue converge in a muscular denouement satisfies me more than the rest of the film."[42] Epstein values the enlargement and fragmentation of the American close-up more for its startling discontinuity than for its role in clarifying the story. But rather than seeing Epstein's focus on the formal aspect of the close-up as a willful modernist imposition on a classical mode of narration, we need to recognize the revelatory intention of such criticism. Epstein does not see the close-up simply as a formal move, which he isolates from its context, but as a dynamic and direct way to address to the viewer a gesture intent on a physiological affect. As a move in the French reception of American cinema I have been summarizing, Epstein performs an act of creative redefinition—a transformation, certainly—but also a discovery.

Epstein's slightly later comment on the close-up in his 1924 essay "On Certain Characteristics of Photogenie" reveals how, instead of clarifying narrative action, the close-up can render a moment in a film resonantly mysterious. Narrative impulses are not evacuated here, but rather lifted from a causal chain to expose an energy made more powerful by its abstraction from context, evoking a primitive animism: "And a close-up of a revolver is no longer a revolver, it is a revolver-character, in other words the impulse toward or remorse for crime, failure, suicide. It is as dark as the temptations of the night, bright as the gleam of gold lusted after, taciturn as passion, squat, brutal, heavy, cold, wary, menacing. It has a temperament, habits, memories, a will, a soul."[43] For Epstein, the power of the cinematic image does not lie in what it signifies, in how it conveys narrative information, but in what it makes him dream of, the associations it engenders. We enter here into a new phase of the French avant-garde reception of American cinema, which we could call Surrealist, especially if we think in terms of Surrealism's more flexible, pre-manifesto and pre-Breton forms, which, as Christopher Wall-Romana has shown, Epstein played a crucial role in formulating.[44]

A French Avant-Garde Cinema

Around 1923, a newly self-conscious and confident French avant-garde film culture asserted itself. The films of L'Herbier, Delluc, Abel Gance, and Germaine Dulac began to appear in the late 1910s and early 1920s,

but 1923 saw the masterpieces of *La souriante Madame Beudet* (Dulac), *Cœur fidèle* (Epstein), and especially (in terms of impact) Gance's *La roue*. Gance's film showed the influence of American cinema with its action-filled melodramatic plot and its invocation of the mechanical rhythms of the railway, but it pushed the rapid editing of Griffith and Sennett further than anything to be seen before the Soviets. Epstein and Dulac reveled in close-ups, but in service of narratives far removed from American action genres: psychological, deeply interior, and elliptical. The French cinema had steeped itself in the lessons of American cinema in order to purge itself of a "degenerate theater," but it now emerged as something entirely different from its model, a truly alternative cinema, not simply modern but self-consciously modernist.

Likewise around 1923, critics associated with the alternative French film culture began to display a historical perspective and to view their discovery of American cinema in the late 1910s with a sort of nostalgia (in 1921, Delluc had celebrated a Parisian revival screening of Hart's 1916 *The Aryan* by wistfully recalling the earlier films of Hayakawa, Hart, and Fairbanks as a memory).[45] Delluc's praise of American movies for their visual presentation of faces and landscapes, or movement and rhythm, rather than their stories, had opened a fissure that widened from 1923 on. One of the most talented filmmakers and theorists of the era, Germaine Dulac, in an essay from 1926, located the power of cinema in its control of movement rather than its scenario and explained the French enthusiasm for American cinema after the war as an early stage in rediscovering cinema's true path as the art of motion: "At that time the Americans were kings. Little by little, after a detour, a sense of life, if not of movement, was recovered. One still worried about a plot, but the images were decanted so that they were no longer burdened with useless gestures and superfluous details. They were balanced in harmonious juxtaposition." But even as Dulac celebrated the clarity, energy, and—dare we say—classicism of American movies, she felt they had led cinema away from its true path toward "literary dramatic and decorative conceptions." Dulac saw the future paths of cinema leading elsewhere, toward a truly avant-garde conception quite different from the American films that had provided inspiration: "To divest the cinema of all elements not particular to it, to seek its true essence in the consciousness of movement and of visual rhythms that is the new aesthetic appearing in the light of the coming dawn."[46] This concept of "pure cinema" would define a radically alternative avant-garde cinema for which American cinema could only serve as prelude or a nostalgic memory.

The stakes of this bifurcation in film culture between a narrative cinema and a pure cinema based on visual rhythms is beautifully articulated in an imaginary dialogue written by Henri Fescourt (1880–1966) and Jean-Louis Bouquet (1898–1978) in 1925. Recalling the power of the American close-ups, in contrast to Epstein, the authors emphasized narrative tasks more than abstraction: "With a new technique, the Americans pursued a previously agreed-on aim: they told stories. Their films had no other purpose." But they also recognized that narrative purpose had not initially drawn critics like Delluc to American films: "From his first contact with American films, Delluc was dazzled, enthusiastic. Was it by the intrigue? No, it was by the 'atmosphere,' by the detail that cropped up, by the picturesqueness of the décor."[47] Criticizing the new avant-garde ideal of visual rhythm, these authors, declared that narrative form need not imply an out-moded theatricality. Their implication is that French films, rather than following the avant-garde path outlined by Dulac, could learn something by paying closer attention the narrative form of American cinema without regressing to the older theatrical model.

But this simple dichotomy between a pure cinema based in visual form and a narrative cinema whose formal aspects serve the purpose of story remains too static. What we could call a Surrealist reception of American cinema detoured around this dilemma. It was indifferent if not hostile to the abstract *cinéma pur* that appeared in the late twenties, but it did not celebrate American movies for their narrative form. Epstein's celebration of the American close-up lies at antipodes from Fescourt and Bouquet's analysis, but it sounds the keynote of a Surrealist reception, valuing fragmentation not simply as an abstract formal technique but as a critical method that lifted moments and images out of narrative context. André Breton described the essence of such a method in his description of his discovery of cinema during wartime, when, accompanied by Jacques Vaché, he would attend a movie without looking at its starting time, entering at an arbitrary point in the narrative, becoming fascinated by ambiguous images—and leaving as soon as the images coalesced into a story, moving on to another nearby cinema and repeating the process.[48]

A number of writers associated with the Surrealist movement wrote about the cinema before the movement's founding manifesto was issued in 1924. In 1918, an incisive essay by Louis Aragon (1897–1982) on the role of "décor in cinema" (which Delluc had solicited for his journal *Le Film*)[49] sketched a path from Delluc's appreciation of the energy of American movies to the Surrealist discovery of their

mystery and ambiguity. Picking up the antitheatrical theme, he praised "those American films that enable a screen poetry to be redeemed from the farrago of theatrical adaptations." But in praising the "modern beauty" of the cinema, its poetry formed from the common objects of everyday life, Aragon anticipates Epstein's invocation of the aura that the close-up gives to things, its intensification of an undefined significance that goes beyond mere formal beauty: "All our emotions exist for those dear old American adventure films that speak of daily life and manage to raise to a dramatic level a banknote on which our attention is riveted, a table with a revolver on it, a bottle that on occasion becomes a weapon, a handkerchief that reveals a crime, a typewriter that's the horizon of a desk, the terrible unfolding telegraphic tape with magic ciphers that enrich or ruin bankers."[50] This aura of mystery comes from a cinematically heightened intensity and focused attention. These techniques may clarify narrative information, but the Surrealists found in them an energy that exceeded any possibility of a fixed significance.

Perhaps most beautifully, writing in 1923, Philippe Soupault (1897–1990) (who continued to write on film even after he left the Surrealist movement), invoked (again with a slightly nostalgic tone) the moment of discovering American movies in the late 1910s:

> We lived swiftly, passionately. It was a beautiful period.
> Without doubt, many other elements contributed to its
> beauty, but the American movie was one of its fairest
> graces. I have kept my memories of these films, which even
> today I find delightful to recall. . . . There were long rides
> on horseback without a word being spoken, without a
> useless gesture, sensational abductions. There were films
> of Douglas Fairbanks, of Rio Jim and of Tom Mix. . . .
> This novel beauty, discovered so easily, so naturally,
> was accompanied by a technical perfection hitherto
> unknown. The directors in America understand
> all the drama that is hidden in a keyhole, in a hand,
> in a drop of water.[51]

By 1929, Surrealist poet Robert Desnos would explicitly attack what he termed "avant-garde cinema" in favor of the American films of Erich von Stroheim and the performances of George Bancroft and Betty Compson, stars of Joseph von Sternberg's *The Docks of New York* (1927).[52]

Conclusion: A Hermeneutics of Transnational Circulation

I cannot claim that my survey of the reception of the American cinema by an alternative French film culture is anything other than selective. As even this limited survey reveals, there were variations in the reception of American movies in France. Especially toward the end of the twenties, separate camps were forming within the culture of cinephiles. But I do want to abstract from this rich and evocative critical language a number of principles, which hopefully raise issues of the circulation of art in the modern era that have implications beyond the reception of the films of one nation by another. These in effect form the conclusion of my essay.

First, and most broadly, I claim that, even granting the often-drastic effects of the hegemony of American cinema from the 1910s on, we must also allow for the creative and transformative role critical reception of films by different cultures plays. The enormous economic expansion of American cinema around the world during and after World War I must be understood not only in terms of economic imperialism, but in cultural terms as part of the vernacular modernism that Miriam Hansen has described in which American cinema appeared as a vehicle of cultural transformations that various cultures digested in different manners. To understand the circulation of American cinema beyond its borders, critical reception plays an essential and even transforming role. The international brand that became known as Hollywood, even in everyday language, refers not simply to a national product, but to a way of representing and imaging. This does not belie American economic or ideological hegemony, but it does indicate that the mode of circulation, as it is transformed materially, takes radical new form and possesses new effects in an era of mechanical reproduction.

My next point stresses this transformative aspect, and not simply one of hegemonic imposition. Critical reception is never a passive act but rather affects what it receives. Within a hermeneutic tradition (following Gadamer, Jauss, and Ricoeur), the process of reading and interpretation is invited by aesthetic works that remain incomplete without this process.[53] Thus circulation between cultures becomes a creative act, but far from a merely willful imposition of alien meaning. Between texts and viewers a process akin to pollination and blossoming takes place. Thus, as I indicated in my discussion of Delluc's understanding of the American western, the French did to some degree "invent" the American cinema, defining its qualities and possibilities. More research is needed to see to what degree these early French readings of American cinema influenced US film culture. In this essay, I have only discussed the first phase of the French reception of

American cinema. Later, after another world war, American cinema again arrived in Paris after a long absence and triggered another round of discovery and interpretation. The writings on American cinema by André Bazin, Edgar Morin, and then the critics of *Cahiers du cinéma* and *Positif* share many elements with the earlier reception I have described in this essay. But in this later case, the rebound of French ideas about American cinema onto American film culture and filmmaking appears unmistakable. The fact that key terms used in understanding American cinema, such as the *auteur theory*, *mise-en-scène*, and *film noir*, are taken from French indicates the enormous debt American cinema owes to post-World War II French discourse. Film studies in America would not exist, I would claim, without a series of crucial French texts.

My third point becomes more specific: I believe aspects of the first French reception of American cinema still have resonance. First, there is the determination to look at American cinema not just in narrative or thematic terms but visually and formally, trying to isolate and reflect on the devices that American movies bring to the table. The close-up, the use of natural landscapes in the western, and the power of décor and objects within mise-en-scène are primary among these. These could be treated in relation to, or separate from, their narrative roles. But to avoid the deadlock of this dichotomy, I have also stressed the importance of these devices as providing an intensification of affect, central to a modern art form based in a deep experience of movement, tempo, and excitement. Along with this dedication to a new art of intensity (perhaps best understood in terms of Miriam Hansen's reading of Walter Benjamin's concept of cinema's capacity for innervation) comes the cultural seriousness with which this critical discourse treated American films.[54] This demanded some fancy rhetorical footwork, since these writers celebrated the popular and even carnivalesque nature of the cinema but also placed movies along-side traditional artworks, partly as an act of provocation. The comparison of westerns to Greek tragedy was one such move. Rather than simply canonizing a low genre, this comparison sought to renew and defamiliarize traditional culture by bringing it into the ambit of cinema. Greek tragedy viewed in this context became primitive. Like Vachel Lindsay in the United States at the same time, these French critics praised the movies as tapping primitive energies.[55] This view, as Rachel Moore has shown, became a major motif of later cinema theory and played a key role in post-World War II French theory, including the writings of André Bazin, and, especially, Edgar Morin.[56]

American film studies as it became institutionalized in the seventies mainly imbibed later currents of academic French discourse, such as structuralism, Lacanian psychoanalysis, and Althusserian Marxism. These sources were often used to criticize the capitalist-inspired ideology of patriarchal Hollywood cinema. But currents of earlier French discourse, especially *Cahiers du cinéma* auteurism, also inflected ways American films were understood. One might look to the extraordinary television series by Jean-Luc Godard *Histoire(s) du cinéma* (1930–) to see a late descendant of this defamiliarizing and fragmenting approach to American movies (one which also includes political and psychoanalytical references). Godard provides an investigation of the intensity of the visual and aural image of American movies and of the enduring impact of an art form perhaps no longer new (and here filtered through the new media of video and television)—but always modern.

But all of this points beyond the discourses of cinema studies to a broader understanding of a new media landscape in which forms become cannibalized and translated between media, as Godard in *Histoire(s)* uses video to render cinema into a malleable form of imagery that will be carried by television and DVDs. On Godard's screens, moments from a John Ford western, a Japanese film, the paintings of Goya and Rembrandt, and newspaper photographs all meet in a video mash-up that circulates through centuries and nations in a media space that becomes the space of exchange transformation and circulation itself.

Dedicated to my old friend and colleague in the investigation of early cinema, film historian Richard Abel.

1 Janet Davis, *The Circus Age: Culture and Society under the Big Top* (Chapel Hill: University of North Carolina Press, 2002), 16–23.

2 Douglas Gilbert, *American Vaudeville: Its Life and Times* (New York: Dover, 1968), 208–42.

3 Gilbert Seldes, *The Movies Come from America* (New York: Charles Scribner's Sons, 1937).

4 Miriam Hansen, "The Mass Production of the Senses: Classical Cinema as Vernacular Modernism," in *Modernism/Modernity* 6, 2 (1999): 59–77.

5 Charles Musser, *The Emergence of Cinema: The American Screen to 1907* (New York: Charles Scribner's Sons, 1990), 135–45, 176–77.

6 Charles Musser, *Before the Nickelodeon: Edwin S. Porter and the Edison Manufacturing Company* (Berkeley: University of California Press, 1991), 209.

7 André Gaudreault, *Film and Attraction: From Kinematography to Cinema* (Urbana: University of Illinois Press, 2011), 88–91.

8 Richard Abel, *The Red Rooster Scare: Making Cinema American, 1900–1910* (Berkeley: University of California Press, 1999).

9 Ibid., 64.

10 Ibid., 40–47.

11 Besides Abel's account, Pathé's relation to American markets is discussed in Tom Gunning, *D. W. Griffith and the Origins of American Narrative Film: The Early Years at Biograph* (Urbana: University of Illinois Press, 1991); and Kristin Thompson, *Exporting Entertainment: America in the World Film Market, 1907–1934* (London: British Film Institute, 1985).

12 Abel, *Red Rooster*, 151–75.

13 See Eileen Bowser, *The Transformation of Cinema, 1907–1915* (New York: Charles Scribner's Sons, 1994), as the best synoptic account of this transformation.

14 Thompson, *Exporting Entertainment*.

15 Georges Sadoul, *Le cinéma français* (Paris: Flammarion, 1962), 23.

16 Again Richard Abel leads the way in the discussion of this aspect of French cinema with his early book *French Cinema: The First Wave, 1915–1929* (Princeton, NJ: Princeton University Press, 1987), and then in his detailed introductions in *French Film Theory and Criticism*, vol. 1, *1907–1929* (Princeton, NJ: Princeton University Press, 1988). The French *ciné-culture* is insightfully described by Christoph Gautier in his *La passion du cinéma, cinéphiles, ciné-clubs et salles spécialisées à Paris de 1920 à 1929* (Paris: Association française de recherche sur l'histoire du cinéma, 2002).

17 André Bazin, *What Is Cinema?* (Berkeley: University of California Press, 1971), 2:101–39.

18 A lively account of the French reception of Chaplin, focusing on the Surrealists, is given in Jennifer Wild, *The Parisian Avant-Garde in the Age of Cinema, 1900–1923* (Berkeley: University of California Press, 2015).

19 Abel, *French Cinema*, 241–90.

20 David Bordwell, Kristin Thompson, Janet Staiger, *The Classical Hollywood Cinema: Film Style and Mode of Production to 1960* (New York: Columbia University Press, 1985).

21 Yuri Tsivian, "Talking to Miriam: Soviet Americanitis and the Vernacular Modernism Thesis," *New German Critique* 41, 2_122 (Summer 2014): 47–65.

22 The canonical history of the Russian and Soviet cinema remains Jay Leyda, *Kino: A History of Russian and Soviet Film* (London: Allen and Unwin, 1960).

23 See especially Lev Kuleshov, "Americanitis," in *Kuleshov on Film: Writing by Lev Kuleshov*, trans. and ed. Ronald Levaco (Berkeley: University of California Press, 1974), 127–30. Also see his "The Art of the Cinema," in ibid., 49–50.

24 Tsivian, "Talking to Miriam," 65.

25 Kuleshov, "Americanitis," 127.

Circulation and Transformation of Cinema

26 Charles Baudelaire, "The Painter of Modern Life," in *The Painter of Modern Life and Other Essays*, ed. Jonathan Mayne (London: Phaidon Press, 1970), 13.

27 Louis Delluc, "Beauty in the Cinema," in Abel, *French Film Theory and Criticism*, 1:137. Delluc's film criticism is collected in two volumes: *Le cinéma et les cinéastes*, vol. 1 of *Écrits cinématographiques* (Paris: Cinémathèque française, *Cahiers du cinéma*, 1985); and *Le cinéma au quotidien*, vol. 2 of *Écrits cinématographiques* (Paris: Cinémathèque française, *Cahiers du cinéma*, 1986). For translations, I have mainly relied on Abel's anthology.

28 Richard Abel, "*Photogénie* and Company," in Abel, *French Film Theory*, 1:101.

29 Louis Delluc, "Cinema: *The Outlaw and His Wife*," in Abel, *French Film Theory*, 1:188.

30 Louis Delluc, "Beauty in the Cinema," in Abel, *French Film Theory*, 1:139.

31 Louis Delluc, "Cinema: *The Cold Deck*," in Abel, *French Film Theory*, 1:171.

32 Louis Delluc, "From Orestes to Rio Jim," in Abel, *French Film Theory*, 1:255, 256.

33 Ibid., 1:256.

34 André Bazin, "The Western or the American Film *par excellence*," in *What Is Cinema?*, 2:140–48; Jean Luc Godard, "Superman: The Man of the West," in *Godard on Godard: Critical Writings by Jean-Luc Godard*, ed. Tom Milne (New York: Da Capo, 1986), 116–22; Raymond Bellour, *Le western* (Paris: Christian Bourgois, 1966).

35 Blaise Cendrars, "On *The Cabinet of Dr. Caligari*," in Abel, *French Film Theory*, 1:271.

36 Louis Delluc, "Douglas Fairbanks dans *l'Île du Salut*," in *Le cinéma au quotidien*, 56.

37 Delluc, "From Orestes to Rio Jim," 1:257.

38 Delluc, "Cinema: *The Cold Deck*," 1:171.

39 Delluc, "From Orestes to Rio Jim," 1:257.

40 Delluc, "Rédemption de Rio Jim," in *Le cinéma au quotidien*, 53.

41 Elie Faure, "The Art of Cineplastics," in Abel, *French Film Theory*, 1:262–63, 260.

42 Jean Epstein, "Magnification," in Abel, *French Film Theory*, 1:235.

43 Jean Epstein, "On Certain Characteristics of Photogenie," in Abel, *French Film Theory*, 1:317.

44 Christopher Wall-Romana, *Jean Epstein: Corporeal Cinema and Film Philosophy* (Manchester: Manchester University Press, 2013), 171–75.

45 Louis Delluc, "Pour sauver sa race," in *Le cinéma au quotidien*, 244.

46 Germaine Dulac, "Aesthetics, Obstacles, Integral Cinégraphie," in Abel, *French Film Theory*, 1:392, 397.

47 Henri Fescourt and Jean-Louis Bouquet, "Idea and Screen: Opinions on the Cinema," in Abel, *French Film Theory*, 1:375.

48 André Breton, "As in a Wood," in *The Shadow and Its Shadow: Surrealist Writings on the Cinema*, ed. Paul Hammond (San Francisco: City Lights Books, 2000), 73.

49 Abel, "*Photogénie* and Company," 1:110.

50 Louis Aragon, "On Décor," in Abel, *French Film Theory*, 1:66–67, 166.

51 Philippe Soupault, "Cinema USA," in Hammond, *The Shadow and Its Shadow*, 56–57.

52 Robert Desnos, "Avant-Garde Cinema," in Abel, *French Film Theory*, 1:429–31.

53 See, for instance, Han-Georg Gadamer, *Truth and Method* (New York: Seabury Press, 1975); Hans Robert Jauss, *Toward an Aesthetic of Reception* (Minneapolis: University of Minnesota Press, 1982); Paul Ricœur, *Hermeneutics and the Human Sciences: Essays on Language, Action and Interpretation*, ed. and trans. John B. Thompson. (Cambridge: Cambridge University Press, 1981).

54 Miriam Hansen, *Cinema and Experience: Siegfried Kracauer, Walter Benjamin, and Theodor W.*

Adorno (Berkeley: University of California Press, 2011), esp. 132–47.

55 See my essay "Vachel Lindsay: Theory of Movie Hieroglyphics," in *Thinking in the Dark: Cinema, Theory, Practice*, ed. Murray Pomerance and R. Barton Palmer (Rutgers: Rutgers University Press, 2015).

56 Rachel O. Moore, *Savage Theory: Cinema as Modern Magic* (Durham, NC: Duke University Press, 1999). Moore does not discuss Morin whose *The Cinema, or The Imaginary Man* (Minneapolis: University of Minnesota Press, 2005) is an essential work of French film theory.

Frank Mehring

How Silhouettes Became "Black": *The Visual Rhetoric of the Harlem Renaissance*

Silhouettes confront us in our daily encounters with new digital media, advertisements, computer games, and films. They appear in the outline of company logos on smartphones and iPads, and on movie posters and advertisements in global urban environments. They remind us of the iconic Bat-Signal in the DC Comics series and the silhouetted credit sequences by Maurice Binder for the James Bond films. Silhouettes have also informed visual styles in fine art from Aaron Douglas and Winold Reiss, via Jacob Lawrence and Romare Bearden, to Kara Walker. Echoes of such precedents are perceptible in the iTunes gift cards offered in supermarkets from Berlin to Paris and New York (fig. 1). The cards use dancing silhouettes in front of monochromatic backgrounds in green, pink, and blue to gain the attention of and generate a specific affect among consumers. These silhouettes are highly recognizable all over the world. Despite the persuasive powers of silhouettes in the modern art and media world, this ancient art form and its cultural reinterpretation in different media contexts have received comparatively little attention.

In this essay, I argue that during the Harlem Renaissance[1] the allegedly obsolete art of silhouettes underwent a significant change. Many artists turned to the European art of cutouts to create a remarkable bridge between aspiring African American artists in the field of literature and white audiences. The quest for a modernist visual code that was appealing, instantly recognizable, and easily reproduced in

Winold Reiss, *African Phantasy: Awakening*, from *The New Negro: An Interpretation* (detail, see fig. 7).

1
Advertisement found in
a newspaper flyer in a
German supermarket on
May 20, 2014.

print media, and that could cross ethnic and racial boundaries, produced a striking visual rhetoric. I show that 1920s silhouettes function as a paradigmatic case for analyzing the complex process of Americanization and cultural reappropriation by way of intermedial circulation and remediation.

How can we critically map, analyze, and evaluate this process? In the United States, nineteenth-century immigration and industrialization led to challenges in communication within a culture defined by ethnic differences, intercultural confrontations, and challenges in multilingual encounters. In order to create a national culture, artists were encouraged to develop a visual rhetoric capable of addressing an extremely diverse audience.[2] In particular, cultural transmission from central Europe to the United States contributed to making silhouettes a key element for pioneering work in American modernism. Furthermore, taking a critical look at the transmission, circulation, and mediation of silhouettes in art and popular culture, I argue that there is a racial dimension encoded that continues to inform the use of silhouettes.

The visual aesthetics of silhouettes often evoke a sense of kinetic energy, rebellious attitude, and performance styles associated with African American culture. My guiding question therefore is, how could silhouettes contribute to a new visual rhetoric that both affirmed African American cultural recognition and became complicit in

racialized fantasies of modernism? Or, to frame it as an ironic paradox, how did silhouettes become black? With the term "black," I am referring both to the problematic racialized denominator of African Americans as well as the color code for silhouettes. While cutouts were most often (but not always) produced on black paper, they usually referred to white bourgeois people. Thus my aim is to trace the genealogy of an artistic form that in Western civilization traditionally referred to profiles of white people and later became more and more associated with the figuration of African Americans' culture of creative self-expression. One of the turning points in the use of silhouettes can be traced to the Harlem Renaissance, which coincided with several revolutions in mass media: the advent of radio broadcasting, the premiere of sound films such as *The Jazz Singer* (1927), the popularization of the gramophone and race records, and what could be described as an Afro-Americanization of popular music.

I trace the ambivalent use of silhouette bodies in three parts. First, I briefly evoke the emergence of silhouette cutouts in nineteenth-century Europe. Second, I trace transatlantic and inter-American processes of transmission in silhouette aesthetics, with a specific focus on the different styles of silhouettes employed by the German immigrant artist/designer Winold Reiss, the African American painter Aaron Douglas, and the Mexican caricaturist Miguel Covarrubias (1904–1957) during the Harlem Renaissance. Third, I outline a palimpsest situation in the use of silhouettes in the late twentieth and early twenty-first centuries. By turning to recent research in transatlantic transfer, my effort to reconnect the literary Harlem Renaissance with the visual communication of today's digital media brings into focus the intermediary and transnational dimension in the use of silhouette bodies in popular culture.[3]

Silhouettes in Black and White: Theoretical Premises

By focusing on the intersection of American art history, media studies, and American studies, I successively identify moments of intercultural contact in different media environments; trace specialized groups or individuals of cultural mobility, translators, and intermediaries; and map interpictorial clusters (in the sense of Udo Hebel)[4] in which silhouettes (re)emerge.[5] On the one hand, the lack of research regarding complex processes of resignification of silhouettes in American modernism and the digital age has hindered visual studies to fully recognize developments in the quest for an "American" code of communication. On the other hand, the commercial sector and marketing

industries often utilize silhouettes without an awareness of the underlying primitivist, racialized, and gendered fantasies that inform the visual discourse and processes of aesthetic empowerment.

Silhouettes offer a remarkably rich, unexplored corpus of images emerging from ancient Greece and China, transmitted via the Western culture of portraiture and twentieth-century advertising to the digital age of remediation and global image distribution processes.[6] The novel functions of silhouettes in American modernist advertisement and art create unforeseen opportunities of intercultural communication. Because of their close relationship to stereotypes, it is of central importance to also analyze how silhouettes can lead to misunderstandings and intercultural confrontations. In the first case, silhouettes signify a democratic promise of aesthetic empowerment transcending national and cultural boundaries. In the second case, silhouettes can trigger projections that rely on colonial fantasies and asymmetric gender power relations that continue to inform performance culture. How can we understand this paradoxical effect?

I turn to concepts of remediation. With "remediation," I refer to a process of translation or transformation of one medium into another. In the case of silhouettes, the remediation undergoes several developmental stages from shadow plays, illustration, and film to painting and advertisement. Depending on the medium, the transformation creates different effects and operates as a form of memory, interpretation, recontextualization, popularization, and upgrade, as well as reaffirmation of older media in the digital age. My understanding of remediation refers to a process that David Bolter and Richard Grusin describe as media "continually commenting upon, reproducing and replacing each other."[7] If we agree with Marshall McLuhan that new media often make us more self-conscious of their predecessors, we should ask in which ways silhouette artists draw on residual media (in the sense of Charles R. Acland) by reconfiguring, renewing, and recycling visual styles that have been neglected, abandoned, or thrashed over the course of time.[8]

In my analysis, I aim to understand the processes related to projective seeing. I find the concept of interpictoriality[9] useful since it puts special emphasis on visual dialogues, exchanges, and negotiations in categories such as imitation, parody, quotation, or variation— elements that are at the heart of the visual discourse in today's multivalent use of silhouettes in art and audiovisual media. While the concept shares theoretical structures with literary intertextuality, interpictoriality is not only concerned with documentation and description

of relations, influences, or sources, but rather investigates, in the words of Udo Hebel, "the semantic and semiotic implications of the frame(s) of reference and act(s) of signification added to the respective image by means of its interpictorial rhetoric."[10] There is a semantic surplus behind the image, which allows for participation, signification, transformation, and resignification.[11]

The Origins of Silhouettes in Transatlantic Contexts

At the very time when silhouettes had become seemingly obsolete at the turn of the twentieth century, E. Nevill Jackson called for a precise historical overview to bring to attention the art of silhouettes in the United States. In 1911, she argued: "Surely it is high time the art of black profile portraiture had a historian of its own and the great masters of silhouette portraiture were rescued from oblivion. Shadows are impalpable things which fade away almost before we are aware of their existence."[12] How can we describe silhouettes? The most general definition in the *Oxford English Dictionary* identifies a silhouette as a "dark outline," for example, "a shadow in profile," which appears "against a lighter background." When it comes to the representation of human beings, silhouettes refer to "a portrait obtained by tracing the outline of a profile, head, or figure by means of its shadow or in some other way, and filling in the whole with black; an outline portrait cut out of black paper; a figure or picture drawn or printed in solid black."[13] The process of cutting a silhouette can also be reversed so that the portrait is cut as a hole and then placed on dark material to bring about the profile. Sometimes we also encounter portraits that are cut on white paper and mounted on black.[14]

While the roots of silhouettes can be traced to Paleolithic times in which vases from ancient Greece show black figures in profile, Pliny the Elder connects silhouettes in his *Natural History* (AD 77–79) with the very origins of art. Pliny describes how in 600 BC Dibutades, the daughter of a Corinthian potter, traced the profile of her lover on a wall before he left on a journey. During the period of romantic classicism with its interest in the classical past, the mythical story of the first silhouette artist and the artistic practice gained particular attention. Jean-Baptiste Regnault's work entitled *The Origin of Painting* from 1785 is merely one of many artworks from the era to capture the romanticized version of shadow traces.

In Germany, silhouette art reached its climax in the second part of the eighteenth century, with its centers in Weimar, Dessau, and Berlin. In 1779, Friedrich C. Müller provided the first overview in his

book *Ausführliche Abhandlung über die Silhouetten und deren Zeich-nung, Verjüngung, Verzierung und Vervielfältigung*. With the silhouette chair and the so-called *Storchschnabel*, a technical device created by the Jesuit Christoph Schreiner in the early seventeenth century, silhou-ettes could be created in a mechanical fashion.[15] In his extremely successful book *Physiognomische Fragmente zur Beförderung der Mensch-enkenntnis und Menschenliebe*, published in 1775, Johann Caspar Lavater (1741–1801) argued that the silhouette was the most truthful and immediate reflection of a human being; in the profile, one could trace a person's character. Lavater built on the theories of the Dutch physi-cian Petrus Camper (1722–1789) who showed via changes in the profile that human beings moved away from the world of animals. Lavater's pseudoscience gained great popularity among many intellectuals. When Lavater visited Goethe in Frankfurt in 1777, the German poet was fascinated by his approach to revealing individual characteristics of a person in the tracing of his or her profile (fig. 2).

In 1794, Lavater's book was published in the United States in an abridged version with plates engraved by Samuel Hill under the title *Essays on Physiognomy*. Lavater's ideas were disseminated widely thanks to inexpensive paperback versions. Theorists such as Thomas Dobson, whose essay on physiognomy was published in the United States in his *Encyclopedia: or, Dictionary of Arts Sciences and Misc. Literature* (1790–1797), presented the classification of human features as an accepted science.

In the 1830s, the silhouette mania reached the United States because of the work of artists such as August Edouart (1789–1861), who has been hailed as the "Raphael of Shadowgraphy."[16] In the United States between the Jacksonian era and the period known as Reconstruction, the popularity of silhouettes flourished because of a specific cultural situation distinct from that of Europe. First, the ever-increasing flow of immigrants to the New World created a large market for silhouette artists.[17] Immigrants with little or no disposable income turned to the inexpensive yet accurate quality of shadow profiles as a means of communication across the Atlantic. Silhouettes were fast, cheap, and portable, and thus perfectly suited for physical transport across the Atlantic to provide a sign of life for those friends and family members who stayed behind.[18] Second, Americans embraced more enthusiastically than Europeans the new techniques of employ-ing modern machinery for the act of shadow tracing. These silhouettes acquired the quality of "authentic" snapshots representing a forward-looking new nation. The silhouette machines from the early 1800s

2
Goethe vor einem Grabmal mit weiblicher Büste (Goethe facing a grave monument), ca. 1780. Cut paper. From Hans Wahl and Anton Kippenberg, *Goethe und seine Welt* (Leipzig, Ger.: Insel-Verlag, 1932), S.92.

predate the arrival of photography and later amateur Kodak cameras by several decades. Thus, silhouettes mark the first visual media revolution in the sense of Walter Benjamin's famous thesis on "art in the age of mechanical reproduction."[19] Third, the experience of comparing silhouette profiles among Dutch, English, Irish, French, French Canadian, German, Italian, Polish, Russian, and Scandinavian immigrants made Americans particularly susceptible to the theories of physiognomy published by Lavater.

Edouart ranks among the most prolific silhouette artists in the United States, producing about six hundred cutouts per year between

1842 and 1844, and accumulating about three thousand silhouettes of the most prominent American citizens during his travels through the United States. His work includes silhouettes of upper-class members of the economic and political elite and social reform movements, but also slaves from the South. His elaborate tableau of a large middle-class family attending a magic lantern show links silhouettes with the world of shadow productions (fig. 3). At the same time, the cutouts in front of a lithography link silhouettes with popular entertainment foreshadowing the use of silhouettes in the medium of film, albeit in reverse order with the audience rather than the iconic figures on-screen appearing in silhouettes.

As a matter of fact, when a large-scale exhibition on American silhouettes was staged in New York, Edouart's work on portraits was hailed in the *New York Tribune* as offering "so complete a pictorial record of the social and political history of the time (1839–49) as probably no other nation possesses."[20] The exhibition was prominently announced. The author described silhouettes as a kind of "ghost of the modern photograph" (fig. 4). When photographs had successfully

3
August Edouart,
*The Magic Lantern
Show*, 1826–1861.
Cut paper and wash,
9 ½ × 13 ⅜ in. (24.13 ×
34 cm). The Metro-
politan Museum of Art,
New York. Bequest
of Mary Martin, 1938,
38.145.392.

Frank Mehring

4

"The Silhouette, Ghost of the Modern
Photograph, Again a Fad," *New York
Tribune*, October 26, 1913, 17.

replaced the art of silhouette cutouts, the older medium became part of a national cultural heritage for display in museums or shows. Silhouettes were now again, as the headline suggested, a "fad." However, the silhouettes shown on the newspaper cover do not so much illustrate the ethnic diversity, which Edouart allegedly captured, but instead depict prominent white intellectuals, artists, and well-known public figures such as Marie Antoinette, Mrs. George Griswold, Henry Wadsworth Longfellow, and John Quincy Adams. Meanwhile, however, an emphasis on ethnicity and race was crucial for the heated debates about immigration laws between the time of the 1882 Chinese Exclusion Act and that of the Immigration Act from 1924. Silhouette profiles played a prominent role in establishing a racialized quota system.[21]

The connection between immigration, urbanization, and changing silhouette aesthetics can be traced to the growing preoccupation of publishers with pictorial media in the early twentieth century and the rise of urbanization on both sides of the Atlantic. As Jan Baetens has argued, "Visual print culture and visual storytelling [emerged] by way of engraving."[22] The woodcuts of the early twentieth century are informed by Expressionism in the fine arts, the visual codes of Expressionist silent cinema, and the cartoons of newspapers and journals.[23] A striking example of visual storytelling in print media can be found in Europe at the beginning of the twentieth century with so-called woodcut novels. The Belgian-born artist Frans Masereel (1889–1972) coined the term *roman in beelden* (novel in pictures). Masereel created stories about modern urban dwellers surrounded by cityscapes, which seemed to promise liberation but also embody a sense of claustrophobia, violence, and self-alienation. His influential work *Mon livre d'heures: 167 images dessinées et gravées sur bois* (1919, later published under the title *My Book of Hours* in 1922 and afterward as *Passionate Journey* in 1948) traces the arrival of a young man in a prototypical European metropolis after World War I. The black-and-white images tell of moments of crisis and tragedy and the isolation of urban life. Weary of civilization, the protagonist embarks on a quest for redemption and inspiration in "primitivist cultures" (fig. 5). After his return to the city, the young man assumes a carefree attitude of complete freedom and independence. Masereel's visual style is intrinsically linked to the fine arts. It would soon be appropriated by the commercial arts in the field of advertisement. Like his preceding effort, *The Passion of Man* (1918), Masereel's work influenced a number of artists working in other media such as writing, music, and film. For example, in the United States, the German-trained woodcut artist Lynd Ward (1905–1985) appropriated

Masereel's technique to provide an iconographic visual account of American urban city life during the Great Depression in works such as *Madman's Drum* (1930) and *Wild Pilgrimage* (1932). In the latter, Ward uses the Expressionist techniques of woodcut prints to confront his protagonist with the practice of lynching, contrasting the more detailed figures of the aggressors in white with the black silhouetted body of an African American with a rope around his neck hanging from a tree.[24] Woodcut novels are thus one of the "missing links" in the circulation of images that triggered a renewed interest in the art of silhouettes to advertise the African American naissance in literature, art, and music in the United States.

In 1911, E. Nevill Jackson's *The History of Silhouettes* opened with the nostalgic remark that great pleasure comes from "the silhouette of

5
Woodcut from Frans Masereel, *Passionate Journey: A Vision in Woodcuts* (1919), n.p.

bygone days." While the first chapter offers an overview on "black profile portraiture," little did the author know that the term "black" would soon carry new meanings in the renaissance of silhouettes in the United States. Two years later, a New York exhibition by the well-known art and antiques dealer Arthur S. Vernay brought new attention to the technique of silhouette cutouts as an artistic treasure worth preserving and putting on public display. The emphasis, however, was on representing cutouts of the white upper class. New Yorkers, as an article in the *New York Tribune* suggested in 1913, "should be particularly interested, as the shades of many of their ancestors are included."[25] In the past, silhouettes could convey information on the ethnic background of the sitters. Soon, however, silhouettes gained a new function: they could convey information on racial aspirations and cultural recognition.

Interpictoral Clusters and Transatlantic Circulations

In the 1920s, silhouettes underwent a remarkable transformation. The collaboration between immigrant artists from Europe with Latin American and African American artists led to a reevaluation of silhouette aesthetics that became most prominently pronounced in works related to African American culture. The "New Negro" movement utilized silhouette figures to recodify associations of silhouettes by opening up new perspectives on African American music, literature, theater, and dance.

The "dean of African American painters" and leading visual artist of the Harlem Renaissance,[26] Aaron Douglas set out to counter stereotypical, often degrading images of African Americans with the very visual genre that is prone to stereotyping because of its radical omission of detail: silhouettes.[27] Turning to mural art and illustration, Douglas wanted to portray African American lives, dreams, and realities to provide a new sense of racial uplift, self-recognition, and general appreciation of the contributions of African Americans to modern American culture. Silhouettes played a key role in his artistic vision.

Douglas contributed significantly to American modernist art with dust jacket designs to create a bridge between readers and the poetry and fiction emerging from new aspiring artists of the Harlem Renaissance. Through the support of the white, Iowa-born writer, editor, and photographer Carl Van Vechten (1880–1964), Douglas was able to establish a fruitful relationship with the publisher Alfred A. Knopf (1892–1984). The same holds true for

6
Aaron Douglas,
illustration for dust
wrapper from Claude
McKay, *Home to
Harlem* (New York:
Harper & Brothers, 1928).
Beinecke Rare Book
and Manuscript Library,
Yale Collection of
American Literature,
New Haven, Connecticut.

Langston Hughes (1902–1967), who published his first poetry collections with Knopf. The young Miguel Covarrubias was also among the friends of Van Vechten. Knopf recognized the economic potential of publishing African American writers in the 1920s. What distinguished Knopf from other publishers was his keen interest in bringing innovative modernist design and high printing quality to the visual appearance of his books. This involved dust cover designs, book binding layouts, typeface, page design, and the selection of paper. As a member of the production department explained, Knopf insisted on being involved in all processes and called for final approval.[28] Knopf established a lasting and highly productive collaboration with

Van Vechten, Hughes, Covarrubias, and Douglas, commissioning artwork that was decorative but also significant for the perception of the contents of the product.[29]

Douglas's dust jackets for James Weldon Johnson's *Autobiography of an Ex-Coloured Man* (1927), Claude McKay's *Home to Harlem* (1928) (fig. 6) and *Banjo* (1929), André Salmon's *The Black Venus* (1929), and Langston Hughes's *Not without Laughter* (1933) employ stylized silhouettes of African Americans surrounded by abstract modern cityscapes or silhouettes in motion, often with references to music and dances. Because of the different cultural contexts on both sides of the Atlantic, the associations of silhouette figures shift from European or Orientalist contexts to African American culture and the "jazz craze." Undoubtedly, the dreamlike quality of the exotic stories represents a powerful tool to stimulate the imagination. In the works of Douglas and other African American artists such as E. Simms Campbell (1906–1971) and Richard Bruce Nugent (1906–1987), the silhouette bodies assume a double function as shadows and literal representations of the black body. The setting is not limited to a dreamlike mythical realm of the imagination. Rather, we often encounter hybrid spaces that reference both the African mythological past and the modern urban environment of American big-city life.

The silhouette figures with slit eyes became the most recognizable feature of Douglas's mural artwork. Douglas's use of flat, black silhouettes is tied to the aesthetic vision of the German immigrant artist Winold Reiss.[30] In the 1920s, when Douglas participated in Reiss's New York–based art school, he worked as an illustrator receiving commissioned work in the field of advertisement and book cover design. The artistic appropriations of Douglas are linked to the transatlantic circulation of silhouettes and wood-block prints. Reiss functioned as a mediator, teacher, and mentor who enabled Douglas to collaborate with influential intellectuals and publishers such as Paul Kellogg (1879–1958), Alain Locke (1885–1954), and Carl Van Vechten. Indeed, it was Reiss who encouraged Douglas to explore the German folk art of the *Scherenschnitte* (cutouts) in order to reflect on his own African American background.[31] Reiss had explored silhouette aesthetics since his arrival in the United States in 1913 to contribute to the lively visual culture in New York.

Reiss came to New York with an impressive portfolio. He had been educated at the Akademie der Bildenden Künste (Academy of Fine Arts) in Munich and had studied with the famous Art Nouveau painter, sculptor, engraver, and architect Franz von Stuck. He also

had attended the Kunstgewerbeschule (School of Applied Arts), learning from the influential painter, designer, and graphic artist Julius Diez. Reiss believed that he was riding on top of the "tidal wave of modernism" that had swept across the Atlantic. Envisioning himself as a transcultural mediator, he set out to "try and develop the European conception of modernism in this country."[32]

The New Negro: An Interpretation (1925), one of the founding documents of the Harlem Renaissance, marks a major breakthrough in the use of silhouettes. The title page of the book features two names in a prominent position: below the title, just above the center of the page, Alain Locke is identified as the editor of the anthology; and in the center of the page, the book decorations and portraits are attributed to the visual artist Winold Reiss. A prominent drawing in three colors

7
Winold Reiss, *African Phantasy: Awakening*, from *The New Negro: An Interpretation* (New York: A. and C. Boni, 1925). The Reiss Archives.

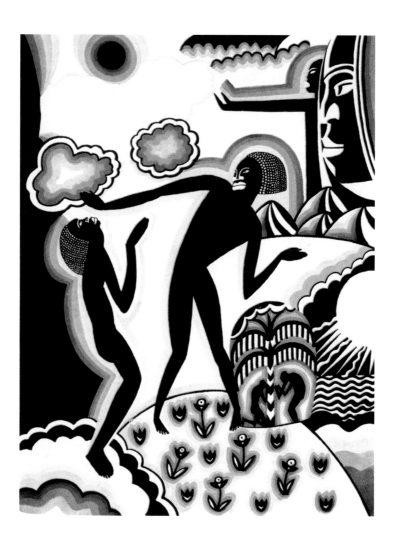

How Silhouettes Became "Black"

is his *African Phantasy: Awakening* (1925) (fig. 7). Here, we have the theme of a naissance in the sense of Locke translated into expressive silhouettes and masks. These imaginations of a new spiritual beginning combine human beings in the shape of African silhouettes in harmony with nature and the spiritual world. These images are in dialogue with an epiphany Reiss had during a two-month trip to Mexico between October and December 1920. Here, Reiss embarked on a journey driven by his disillusionment with American democracy, professional and personal challenges after World War I, and a generally hostile attitude toward all things German in the United States. After his encounter with Mexican folk art, architecture, landscapes, and the spirit of the people after the revolution, Reiss expressed his disappointment with American culture explicitly in December 1920: "And now that I am here again in America, the land of today's perhaps most extreme egotism and materialism, quite a few thoughts arise in me clearly which before had been inside me only as foreboding and longing. Contrast alone can result in deeds and works. Same here. Returning from a land that has a great, beautiful soul and has been desperately mistreated and misunderstood, I perceive America to be repellently dead and lifeless." Reiss envisioned a new path to enlightenment in which humanity is the new religion. "We ourselves are the temple," Reiss explained.[33] He saw a connection between his art of picturing the human body and the necessity to overcome selfishness and egotism in the United States. Reiss greatly empathized with Locke's project of African American cultural recognition and suggested to include, among other visual genres, silhouettes in his manifesto work on African American literature and culture.[34]

Locke explained that he selected Winold Reiss to illustrate large parts of *The New Negro* anthology based on a shared conviction: to conceive and execute a visual narrative "as a path-breaking guide and encouragement to this new foray of the younger Negro artists." Locke continued to emphasize the innovative approach that Reiss brought to the visual connection between the poetry, essays, and short stories of *The New Negro* and the audience: "In idiom, technical treatment and objective social angle, it is a bold iconoclastic break with the current traditions that have grown up about the Negro subject in American art."[35] Thus, Reiss became an intercultural mediator and teacher for Douglas who acknowledged his formal and spiritual influence: "I have seen Reiss's drawings for the *New Negro*. They are marvelous. Many colored people don't like Reiss's drawing. We are possessed, you know, with the idea that it is necessary to be white, to be beautiful. Nine

times out of ten it is just the reverse. It takes lots of training or a tremendous effort to down the idea that thin lips and straight nose is the apogée of beauty. But once free you can look back with a sigh of relief and wonder how anyone could be so deluded."[36]

For example, Douglas's silhouette drawing *Music* (1925) shows how far he appropriated the silhouette designs Winold Reiss had brought to the art scene of New York. While the silhouettes show a dancing couple with stylized musical notes in the background, it is not precisely clear what kind of dances and songs we are supposed to imagine. Given the reference to African American music, we are most likely invited to create associations with the latest dance crazes, such as the black bottom, Charleston, or shimmy, and with Harlem, the immediate neighborhood of Douglas.[37] The association is made explicit by the position in the book that the editor, Alain Locke, assigns to the silhouette drawing. The image appears above J. A. Rogers's essay "Jazz at Home." Considering the circulation of silhouette styles in the transatlantic sphere in the 1920s, it is fitting that Rogers connects the new innovative musical expressions labeled "jazz" with a style that transcends clearly defined national and racial codes: "Jazz is a marvel of paradox: too fundamentally human, at least as modern humanity goes, to be typically racial, too international to be characteristically national, too much abroad in the world to have a special home."[38]

In a similar fashion, silhouettes represented a paradox. While pointing toward the bourgeoisie of the Gilded Age, they also functioned as novel signifiers for African American cultural (self-) recognition. Rogers argues that what was commonly referred to as jazz was "more at home in Harlem than in Paris."[39] One might argue in a similar vein that silhouettes, when they emerged as a highly successful means of advertising in the 1920s, became more and more associated with a visual code for the African American cultural renaissance than with nineteenth-century bourgeois portraiture. Reiss's *Interpretation of Harlem Jazz I* (ca. 1924) (fig. 8) captures the spirit of novel dances in a modernist visual style, which Richard Powell has identified as a novel kind of "blues aesthetic" in the visual arts.[40] With a reference to an African mask in the upper-right corner, and a banjo, a key instrument of African American music, between the male dancer's feet, Reiss offers a visual staccato rhythm juxtaposing legs, bodies, and modernist layering of geographic forms.[41]

The transnational dimension of silhouettes and their connections to the "New Negro" in the arts is further heightened by the

presence of the Mexican artist Miguel Covarrubias. His caricatures on jazz combine silhouette aesthetics with more-detailed outlines of clothes and emphasize the flow of movements. The connection to dance and jazz is clearly defined via silhouettes, as his illustrations for *Vanity Fair* and Zora Neale Hurston's work illustrate, to name but a few creative outlets. In addition, the Mexican artist became friends with African American musicians such as W. C. Handy, Ethel Waters, and Florence Mills, and collaborated with Van Vechten, photographer Nickolas Muray, playwright Eugene O'Neill, and poet Langston Hughes. All these artists became involved in one way or another with Covarrubias's idiosyncratic artistry of silhouette caricatures. Alain Locke praised his particular source of imagery and contributions to the visual Harlem Renaissance, emphasizing his Mexican background:

> This typical Latin interest and tradition, with its kindly farce in which there is no hint of social offense or disparagement, no matter how broad or caricaturistic the brush, is familiar to us now in the work of Miguel Covarrubias. It may yet be an antidote for that comic art which is so responsible for the hypersensitive feelings of American Negroes and stand between them and the full appreciation of any portrayal of race types. Surely the time has come when we should have our own comic and semi-serious art, our own Cruishanks and Max Beerbohms.[42]

In addition to a number of highly influential and often reproduced caricatures in *Vanity Fair* and *The New Negro*, Covarrubias's design in stark red, black, and yellow colors for the dust cover of Langston Hughes's first publication of poems, *The Weary Blues* (1926), is highly recognizable.[43] The silhouette figure of a piano player, the light of a dull gas light, and the piano keys offer a visual translation of the first poem of the collection, which also provides the title for the book. The cover is a striking example of the advertisement industry's interest in exploiting the affective power of African American literature and music. Van Vechten offers a guide regarding how to read the poems by turning to stereotypes: "[Hughes's] verses are by no means limited to an exclusive mood; he writes caressingly of little black prostitutes in Harlem; his cabaret songs throb with the true jazz rhythm; his sea-pieces ache with a calm melancholy lyricism; he cries bitterly from the heart of his race in Cross and the Jester." This evocation of prostitutes in Harlem, authentic jazz rhythms, and the

Drawing in Two Colors *Winold Reiss*

Frank Mehring

aching feelings from the heart of the "black race" is found on the back of the dust cover, thereby inviting the reader to project these stereotypes onto the silhouetted figure by Covarrubias.

The work of Douglas on African American music resonates with the aesthetic approaches of Reiss and Covarrubias[44] but adds a new dimension. Ominous shadows serving as a reference to the African American trauma of slavery and lynching inject a disturbing subtext in the visual artwork. A prominent example is Douglas's gouache-and-pencil drawing with the somewhat innocent title *Charleston* from 1928 (fig. 9). With his signature style of slit-eyed silhouettes, he envisions a contemporary scene in a club where a jazz band plays to an audience enjoying themselves with drinks and food. The diagonal lines with slight tonal gradations and various layers of translucent geometrical forms combine modernist primitivism with popular culture and American urban imaginations, which Douglas explored in murals such as *Aspects of Negro Life: The Negro in an African Setting* (1934) and *Building More Stately Mansions* (1944). Douglas places a white silhouette of a rope with a noose at the center of the drawing. His clear reference to lynching disrupts the joyful scene of nightlife and music, adding a sense of unexpected violence and a morbid undertone. The reference ties in with what Ken Gonzales-Day calls a "landscape without memory" and the horrible practice of marketing lynching photographs, souvenir cards, and postcards.[45] Gonzales-Day refers to specific landscapes or environments in which the history of lynching has been erased from collective memory. As tens of thousands of African Americans left the South to find new opportunities in metropolitan cities in the North and Northeast of the United States in what is known as the Great Migration, the memory and images of lynching and their traumatic effects traveled with them. One could point toward media such as postcards, films such as D. W. Griffith's *Birth of a Nation* (1915) and Oscar Micheaux's *Within Our Gates* (1919), and the visualization of actions of the Ku Klux Klan. Born in Topeka, Kansas, Douglas has a close biographical link to the experience of the Great Migration. With the rope at the center of the image, Douglas forces an irrational element into the otherwise typical scene of urban nightlife in the 1920s. In addition, Douglas's *Charleston* offers another telling visual clue, which links the silhouette drawing with German Expressionist films: in the lower quarter, Douglas depicts silhouette hands frantically grasping one of the relaxed audience members enjoying the musical performance.

The work of Douglas can also be related to pictorial clusters in European art and cinema. Works such as the 1922 Expressionist horror

9
Aaron Douglas, *Charleston*, ca. 1928. Gouache and pencil on paper board, 14 ¹¹⁄₁₆ × 9 ¹³⁄₁₆ in. (37.3 × 24.9 cm). North Carolina Museum of Art, Raleigh. Purchased with funds from the North Carolina State Art Society (Robert F. Phifer Bequest) and the State of North Carolina, by exchange.

How Silhouettes Became "Black"

films by Friedrich Wilhelm Murnau (1888–1931) use shadows of the vampire and particular stylizations of his hands as a means to translate the intrusion of the irrational and horrific into our world. The ghastly hands also create an interpictorial reference to the Expressionist masterpiece *Das Cabinett des Dr. Caligari* (1919) by Robert Wiene (1873–1938) and even more explicitly to his 1924 film *Orlac's Hände* in which a concert pianist loses both hands in a train accident.[46] Thanks to a medical operation, the pianist receives new hands. After he learns that the hands are from a murderer called Vasseur, he is traumatized and becomes haunted by nightmarish visions. In the United States, the film was released under the title *The Hands of Orlac* in the very year that Douglas infused the familiar scene of jazz in a music club with the terrifying image of silhouette hands grasping the audience. Wiene uses Expressionist techniques to create a strange disconnection between the sight of hands and the pianist as a person. It is as if the hands have a life of their own and cannot be controlled any longer. In another classic of German Expressionist cinema, the shadow of hands emerges as a sign of death and the supernatural. In the horror classic *Nosferatu* (1922), Murnau plays with silhouetted hands on walls to suggest imminent destruction, death, and disease as the vampire is about to capture his victim and suck the lifeblood out of the body. Film critic Béla Balázs felt that with the vampire's silhouette (and other images of nature), the film evokes an "ice-cold breath from the beyond."[47] It is this evocation of terror from another sphere that also permeates Douglas's jazzy bar scene. The painter appropriates the psychological language of Expressionism and the uncanny to translate film silhouettes to the specter of lynching in 1920s America.

With these examples, we understand how silhouettes are racially codified to create a bridge between texts by African American writers and an audience that was for the most part made up of white, middle- or upper-class readers. When Douglas talked about the illustrations he created for the collection of poems *God's Trombones* (1927) by James Weldon Johnson (1871–1938),[48] he closely linked his silhouettes with Egyptian art. This pattern became his signature visual style: "I used the Egyptian form, that is to say, the head was in perspective in a profile flat view, the body, shoulders down to the waist turned half way, the legs were done also from the side and the feet were also done in a broad perspective. . . . The only thing that I did that was not specifically taken from the Egyptians was an eye . . . so you saw it in three dimensions. I avoided the three dimensions and that's another thing that made it sort of unique artistically."[49]

10
Aaron Douglas, *Song of the Towers*, 1966. Oil and tempera on canvas, 34 × 30 in. (86.36 × 76.2 cm). Milwaukee Art Museum, Lent by State of Wisconsin, Executive Residence, Madison, L1.2006.

Interestingly, Douglas does not use the expression silhouette here. He rather emphasizes the direct connection to African origins. The statement is in line with Romare Bearden's evaluation of African American art at the beginning of the 1930s. In his 1934 article for *Opportunity* magazine entitled "The Negro Artist and Modern Art," Bearden explained that "at the present time it is almost impossible for the Negro artist not to be influenced by the work of other men."[50] Bearden criticized particularly the filter of a white artistic tradition, which prevented African American artists from seeing "with their own eyes" and expressing themselves in a highly original fashion steeped in the tradition and environment they live in. As an example, Bearden

How Silhouettes Became "Black"

mentions the mural work of Mexican artists such as Diego Rivera and José Clemente Orozco. In his own art, Bearden repeatedly turned to the link between jazz and silhouette bodies, thereby reaffirming the frame of reference in which dark, silhouetted bodies function as signifiers for African American artistic self-expression. Thus, a creative interplay exists among the silhouette aesthetics that Winold Reiss brought to the visual Harlem Renaissance when he collaborated with Alain Locke on *The New Negro*, the illustrations of his student Aaron Douglas for African American magazines and novels, and the continuation of so-called jazz artists such as Jacob Lawrence and Romare Bearden who interlinked reduced, flat, silhouetted bodies with jazz music. Bearden, along with Harry Henderson, explicitly outlined the connection the art of silhouettes had with ancient Greek art and Cubist experiments: "Douglas's lively, flat black silhouettes impressed many publishers, editors, and artists but upset some academically trained African-American critics. Few realized that he was impressed by the classic black silhouettes on Greek vases, such as *The Return of Hephaistos*, a masterpiece by Lydos in the sixth century B.C. . . . Utilizing black silhouettes and reducing objects to their basic shapes, as in Cubist paintings, he created relationships among the flat figural groups that have a rhythmic movement similar to that in Greek vase painting. Sometimes these figures were dancing."[51]

In one of his well-known paintings, *Song of the Towers* from the series *Aspects of Negro Life* (1934) (fig. 10), Douglas condenses his distinctive style in line with his trajectory as an artist. He wanted his art to be "transcendentally material, mystically objective. Earthy. Spiritually earthy. Dynamic."[52] Douglas offers a juxtaposition of silhouetted workers and Cubist representations of skyscrapers. At the center of the image is the silhouette of an African American saxophone player and the Statue of Liberty. Concentric circles radiate from the center. With its emphasis on the centrality of African American musical expression in the United States, this image breaks with Paul Whiteman's agenda to present himself as the true "king of jazz" since he created the soundtrack of American modernism through symphonic jazz.[53] While Whiteman set out to uplift jazz from the realm of primitivism and civilize it, he actually Europeanized it, adding symphonic elements and turning down syncopated rhythms, dissonances, and elements of improvisation. He thereby streamlined the different ethnic influences on jazz and took away, as Sieglinde Lemke argued, "its original hybridity."[54] Douglas, however, Americanizes the visual codes for jazz. He incorporates a notion of playfulness

through arrangements of graphical elements and stylizations of flat silhouette figures positioned at the heart of hypermodern urban landscapes in New York. With the concentric circles, Douglas explores what he calls in an unpublished lecture "correspondences or analogies between these arts [plastic arts] and music." Douglas moves beyond the work of Cubists such as Braque and Picasso and other modernists such as Mondrian and Casotti to explore the essence of jazz forms with lines, tones, colors, and texture. At the same time, he goes back to ancient forms of visual culture to achieve an all-encompassing visualization: "The use of line in the arts of the Chinese, Japanese, Indian, and Persian peoples gives one the impression that it is always drawn with a kind of rhythmic response to the total life of the people."[55] Douglas, thus, offers a synesthetic counterstrategy to the effects of "whitening jazz" by reconnecting the new soundtrack of American modernism with African American contributions to the urban experience of leisure, work, and art.

The image resonates with a wood-block print Douglas created for Johnson's poem "Judgment Day." Johnson describes a biblical scene in which the angel Gabriel blows his silver trumpet to wake the living nations. Douglas turns this musical evocation into a visual composition, which in 1927 fit into the cultural self-recognition Alain Locke and other African Americans called for. The silhouette image referencing African masks and the signature slit eyes makes a clear connection to illustrations dedicated to jazz. In the context of the poem, African American jazz and silhouettes of the human body take on the function of calling for a renewed sense of artistic expression for racial uplift. One could argue that the silhouetted image of an African American blowing his horn in "Judgement Day" and the playing of the saxophone in *Song of the Towers* is what Romare Bearden had in mind when he envisioned a new kind of artist who "must be the medium through which humanity expresses itself. In this sense the greatest artists have faced the realities of life, and have been profoundly social."[56]

Repercussions in Black and White

The foregoing effort to critically analyze, map, and evaluate silhouette aesthetics and the recodification of the eighteenth-century European tradition of cutouts may help us answer the question whether Douglas successfully developed an art that was not "white art painted black," a problem he communicated to Langston Hughes in a letter from December 21, 1925. By going back to the origins of art, drawing on ancient Chinese art reflected through German *Scherenschnitte*, appropriating

Frank Mehring

How Silhouettes Became "Black"

Cubist experiments, and reconnecting stylized black silhouettes with African masks, Douglas strove to "bare our arms and plunge them deep, deep through laughter, through pain, through sorrow, through hope, through disappointment, into the very depths of the souls of our people and drag forth material crude, rough, neglected." In the remainder of this essay, by drawing attention to the works of Kara Walker and Apple advertisements, I briefly address the later repercussions of the visual rhetoric Douglas designed to inspire people to "sing it, dance it, write it, paint it."[57]

In contemporary art, Kara Walker (b. 1969) ranks as the artist who almost single-handedly has brought new attention to the complex frames of reference of silhouette cutouts. "The silhouette says a lot with very little information, but that's also what the stereotype does. So I saw the silhouette and the stereotype as linked," says Walker.[58] Her work highlights the potential of silhouettes to intervene in the current discourse on race, class, and gender. The appropriation of silhouette aesthetics in the murals of Walker has inspired new scholarship on negative or thoughtlessly stereotyped representations of blacks in the context of American minstrelsy.[59] In Walker's work, black silhouettes critically address the trauma of slavery. They are intrinsically linked to an American narrative of painful exploitation and what Toni Morrison has described as a white success story realized "on the backs of blacks."[60] Walker's silhouettes most often reference African American people. She builds on a cultural memory in which representations of blackness are tied to stereotypical silhouettes. This is remarkable considering that during the heyday of their popularity in the eighteenth and early nineteenth centuries, silhouettes represented the likeness of mostly white bourgeois sitters. For example, *Endless Conundrum, An African Anonymous Adventuress* (2001) (fig. 11) shows a tableau of various silhouettes, which in some form or another critically engage with issues of slavery, sexual exploitation, violence against African Americans, and deconstructing modernist aesthetics. One image shows a silhouette dancer with a particular emphasis on her breast and vagina while bananas are flying around her hips. The image clearly references the famous banana dance by Josephine Baker who became a celebrity in the Parisian art scene (and later other European metropolitan centers) in the 1920s.[61] "My works are erotically explicit, shameless. I would be happy if visitors would stand in front of my work and even feel a little ashamed because they have . . . simply believed in the project of modernism," explains Walker.[62] Hence, Walker's silhouettes are both beautifully attractive and shockingly repulsive.

11
(Previous spread)
Detail of Kara Walker,
*Endless Conundrum,
An African Anonymous
Adventuress*, 2001.
Cut paper, 180 × 420 in.
(457.2 × 1066.8 cm).
Walker Art Center,
Minneapolis.

Another revealing case study for modernist appropriations of veiled racialized fantasies behind silhouette aesthetics is the design philosophy of Apple, recently put on display in Jonathan Ive's design concepts in the exhibition *Stylectral* (2012) on the history of electro-design at the Museum für Kunst und Gewerbe Hamburg. This exhibition and the catalogue *Apple Design* refrain from investigating the link between physical products and the use of silhouettes in their marketing campaigns.[63] The iPod and the distribution of digital music files have revolutionized the way we listen to music as few other inventions since the advent of broadcasting technology in the 1920s. A crucial element in generating consumer interest in and desire to switch to digital portable playback devices and earphones drew on visual tropes that date back to ancient Chinese shadow plays. The second wave of iPod advertisements from 2003 relied on a unified, distinct campaign of silhouettes in front of brightly colored monochromatic backgrounds. The silhouettes suggest highly kinetic energy captured in dance modes. While the silhouette bodies are black, the product on display is rendered in white with a distinct emphasis on the white earphones and cables supplied by Apple. The advertisement campaign proved to be highly successful on a global scale. One might argue that what we see is a translation of pop art elements into the realm of advertisement. However, the use of silhouettes and their function within popular entertainment challenges cultural critics to ask about the desires associated with the black silhouette bodies on display. The images of the Apple commercial tap into the visual rhetoric of silhouettes to activate both conscious and unconscious associations and perhaps hidden desires associated with black silhouette bodies in motion.

In our increasingly connected world of digital information, instant dissemination, and potential manipulation of images, we can better understand the persuasive function of silhouettes in the field of advertisement by mapping, tracing, and critically evaluating response patterns to silhouettes. In the quest for an instantly recognizable and appealing visual rhetoric, silhouettes can help open up new forms of self-empowerment and de-hierarchization. Silhouette aesthetics have been particularly attractive not only for Americans but also for people outside the United States since silhouettes can express remarkably well defiant subcultural values like antiauthoritarianism, informality, immediate corporeal experience, and instant gratification. Silhouettes continue to inform a visual rhetoric intrinsically tied to the African historical experience as exemplified by the example of Kara Walker's

use of silhouettes as a critical weapon to expose racism and racialized fantasies of complicity. While the racially codified visual rhetoric continues to be influential and persuasive, other forms of silhouette usages are also visible. Silhouettes have informed the pop art revolution of the 1960s, with Andy Warhol and Roy Lichtenstein at the forefront. Street art and graffiti often employ silhouettes to draw attention to specific issues important to local communities. Hollywood films, television series, music videos, and comics regularly employ silhouette aesthetics for a specific emotional or dramatic effect. Hence, the encounter of silhouettes in our modern-day media environment is best understood as a palimpsest situation.

Conclusions

My analysis of recodification of silhouettes before, during, and after the Harlem Renaissance turns to interpictorial readings in order to trace clusters of visual communication practices. My reading reveals a veiled racialized discourse that forms an integral part of the novel visual rhetoric in the 1920s. This discourse continues to inform silhouette aesthetics. For example, the transnational silhouettes of the Apple iWorld both fulfill and exploit the promise of fusing art and life by projecting oneself into the narrative of expressive dancing to hip-hop songs such as "Hey Mama" by the Black Eyed Peas, the song that accompanied the first silhouette advertisement for the iPod in October 2003. In comparing the visual repertoire of silhouettes in European and American contexts, with a particular focus on circulation, reedification, and appropriation, the code of communication often relies on racial stereotypes. Following an aesthetics agenda of "amplification through simplification,"[64] silhouettes enable viewers to activate their own fantasies of "the black body" in modernist environments. At the same time, silhouettes trigger desires of transgression, of entering into a world that promises adventure, recognition, and seemingly unrestrained self-expression—themes that artists explored during the Harlem Renaissance with their new visual rhetoric. In the age of globalization, the iPod silhouette campaign by Apple inaugurated an aesthetic response to silhouettes that seemed to suggest that by listening to the new digital MP3 music format and using the musical device, you, too, could "become black."

1 Richard Powell describes the term "Harlem Renaissance" as an "accurate yet elastic description of the levels and range of black creativity in the 1920s." However, he points out that it hardly allows for the recognition of influential artists beyond the agency of African American creative activity. For the analysis of the visual rhetoric of the Harlem Renaissance, I would like to also draw attention to the work of European and Mexican artists in order to go beyond the familiar narratives of the Harlem Renaissance where we usually find references to the photographer James Van Der Zee, the African American painter Aaron Douglas, and the works of Archibald J. Motley Jr., Palmer Hayden, and Jacob Lawrence (namely, his *The Migration of the Negro* [1940–1941]). These African American artists shaped, in the words of Erika Doss, "a modern visual art that accommodated ethnocentric perspectives." Powell, *Black Art: A Cultural History*, 2nd ed. (London: Thames & Hudson, 2002), 41; Doss, *Twentieth-Century American Art* (Oxford: Oxford UP, 2002), 93. See also Emily Bernard, "The Renaissance and the Vogue," in *The Cambridge Companion to the Harlem Renaissance*, ed. George Hutchinson (New York: Cambridge University Press, 2007), 28–40; Henry Louis Gates Jr., "Harlem on Our Minds," *Critical Inquiry* 24, 1 (1997): 1–12; Patricia Hills, *Painting Harlem Modern: The Art of Jacob Lawrence* (Berkeley: University of California Press, 2009); and Jeffrey O. G. Ogbar, *The Harlem Renaissance Revisited: Politics, Arts, and Letters* (Baltimore, MD: Johns Hopkins University Press, 2010).

2 I follow Winfried Fluck's argument that the specific multiethnic and multicultural composition of US audiences formed the basis for the Americanization of modern culture. See Winfried Fluck, "The Americanization of Modern Culture: A Cultural History of the Popular Media," in *Romance with America? Essays on Culture, Literature, and American Studies*, ed. Laura Bieger and Johannes Voelz (Heidelberg, Ger.: Winter, 2009), 239–69.

3 This essay focuses for the most part on the first half of the twentieth century and is part of a larger research project on silhouettes and visual communication in the transatlantic sphere.

4 Udo Hebel, "'American' Pictures and (Trans) National Iconographies: Mapping Interpictorial Clusters in American Studies," in *American Studies Today: New Research Agendas*, ed. Winfried Fluck, Erik Redling, Sabine Sielke, and Hubert Zapf (Heidelberg, Ger.: Winter, 2014), 401–32.

5 I agree with Stephen Greenblatt that there is "no going back to the fantasy that once upon a time there were settled, coherent, and perfectly integrated national or ethnic communities" that produced a specific cultural narrative. Instead, media circulations are at the heart of silhouette aesthetics, which undermine notions of fixity and stability of cultures. I focus on the contact zones "where cultural goods are exchanged." Greenblatt, *Cultural Mobility: A Manifesto* (Cambridge: Cambridge University Press, 2010), 2, 251.

6 Most research on silhouettes, such as Emma Rutherford's richly illustrated catalog entitled *Silhouette: The Art of the Shadow* (New York: Rizzoli, 2009), either focuses on the eighteenth-century bourgeois tradition of silhouettes or addresses well-known stereotypes in caricatures of African Americans in the nineteenth century.

7 Jay David Bolter and Richard Grusin, *Remediation: Understanding New Media* (Cambridge, MA: MIT Press, 1999), 55.

8 Marshall McLuhan, *Understanding Media: The Extensions of Man* (Cambridge, MA: MIT Press, 1994), 8; Charles R. Acland, *Residual Media* (Minneapolis: University of Minnesota Press, 2007).

9 In the German cultural context, the term is sometimes used interchangeably with "Interbildlichkeit," "Intervisualität," and "Interikonizität." See, for example, Margaret R. Rose, *Pictorial Irony, Parody, and Pastiche: Comic Interpictoriality in the Arts of the 19th and 20th Centuries* (Bielefeld, Ger.: Aisthesis Verlag, 2011).

10 Hebel, "'American' Pictures and (Trans)National Iconographies," 414. As Udo Hebel explains, visual art is always already part of a "network of repertoires and conventions" (ibid., 404). The challenge for American studies is to better understand the cultural matrix that one brings to decoding the frames of reference (in Stuart Hall's sense) informing the decoding processes.

11 As far as silhouettes are concerned, the concept of interpictoriality needs to be enlarged in order to come to terms with the extreme art of omission in silhouettes and the surplus of interpictorial connections activated in the process of viewing. I offer a radicalization of Erwin Panofsky's practice of interpictorial readings by arguing that *Bildtheorie*

needs to combine the three stages from the pre-iconographical description of recognizable empirical givens and experiences in the picture under consideration, to the iconographical tracing of representational conventions, motive clusters, and archival repertoires, and, finally, to the iconological interpretative synthesis exploring the possible meaning, significance, and cultural impact of the picture. The act of seeing silhouettes often transcends the visual dimension since it also stimulates an aesthetic transfer based on sounds and music in popular culture. Panofsky, *Perspective as a Symbolic From* (New York: Zone Books, 1991).

12 E. Nevill Jackson, *The History of Silhouettes* (London: The Connoisseur, 1911), 5.

13 *Oxford English Dictionary Online*, s.v. "silhouette," accessed Nov. 13, 2016, http://www.oed.com.proxy.uchicago.edu/view/Entry/179668?rskey=3b6lxj&result=1.

14 When I talk about silhouettes and silhouette aesthetics, I do not limit my subject to paper cutting with knives and scissors (or the German expression *Scherenschnitte*). Rather I include (1) the practice of thirteenth-century shadow puppets, which were popular in Turkey and the Middle East before they informed Western culture, such as in magic lantern shows; (2) painted silhouettes on different material such as paper, ivory, plaster, or porcelain; and (3) silhouettes in stop-motion photography with moveable cutout figures and hand-drawn or digital animation. Today, we encounter a palimpsest situation in which older techniques of silhouette are layered and reappear in digital formats on the Internet.

15 Müller described the process in detail in *Anweisung zum Silhouettenzeichnen und zur Kunst sie zu verjüngen nebst einer Einleitung von ihren physiognomischen Nutzen* (Leipzig: Römhild, 1779).

16 "The Silhouette, Ghost of the Modern Photograph, Again a Fad," *New York Tribune*, Oct. 26, 1913, 17.

17 Emma Rutherford speculates that Lavater's ideas were "embraced even more passionately in America than in Europe as the country attempted to define a national identity" while facing the specific challenge of integrating a vast number of immigrants from all parts of Europe and other countries around the globe. In addition, the issue of slavery loomed large over the project of establishing a new expression of Americanness. Rutherford, *Silhouette*, 188.

18 This aspect of the portability of silhouettes and their physical movements can be productively linked with Jennifer Roberts's thesis that geographical distance inscribed itself "not only on the outsides but also on the insides of pictures." Roberts, *Transporting Visions: The Movement of Images in Early America* (Berkeley: University of California Press, 2014), 2.

19 Walter Benjamin, "The Work of Art in the Age of Its Technological Reproducibility: Second Version," in *Selected Writings*, vol. 3, *1935–1938*, trans. Edmund Jephcott, Howard Eiland, and others, ed. Howard Eiland and Michael W. Jennings (Cambridge, MA: The Belknap Press of Harvard University Press, 2002), 101–33.

20 "The Silhouette, Ghost of the Modern Photograph, Again a Fad," *New York Tribune*, Oct. 26, 1913, 17.

21 Another set of conventions important to understanding the recodification of silhouettes in "Black Manhattan" is the technology of racial profiling practiced by anthropologists. During the Harlem Renaissance, indeed, various, partly opposing racialized discourses appropriated silhouette aesthetics for different purposes. In the field of anthropology, Lavater's theories were recalled with efforts to use silhouettes for racial type studies. In an article from 1928, the anthropologists Ida McLearn, G. M. Morant, and Karl Pearson explained how, through the use of a new technical device, they could create standardized silhouettes based not only on the shadows of actual sitters but also on the rich reservoir of existing photographs. One example is Rudolf Poech's and Johann Weniger's collection of photographs of one hundred black West Africans published by the Viennese Anthropological Society under the title *Physische Anthropologie* in 1927. The complete title reads *Rudolf Poechs Nachlass, Serie A: Physische Anthropologie, Band 1*, with a special title: *Eine morphologisch-anthropologische Studie, durchgeführt an 100 westafrikanischen Negern, als Beitrag zur Anthropologie von Afrika*. McLearn, Morant, and Pearson optically superimposed one hundred silhouettes as a basis to create a single one with contours reflecting average proportions. The authors arrived at the questionable conclusion that

they had "reached a truly typical West African Negro." In addition, the type silhouettes of the English sitters established the invisible norm from which aberrations were measured, described, and thereby used to stabilize familiar patterns of creating stereotypes through exaggeration: "The prognathism is now still more marked; the whole of the Negro's lips and chin project, but his chin rises with the under surface of the jaw well above the English, the gulion being situated nearly a centimeter farther forward. The Negro nose is much shorter, and with a much smaller base; it is so rounded at the potion that it protrudes beyond the English, giving the Negro his snub-nose appearance." McLearn, Morant, and Pearson, "The Importance of Type Silhouette for Racial Characterization on Anthropology," *Biometrika* 20, 3/4 (1928): 396, 399.

22 Jan Baetens, "Graphic Novels," in *The Cambridge History of the American Novel*, ed. Leonard Cassuto (Cambridge: Cambridge University Press, 2011), 1138.

23 See, in this context, Peter Kuper, introduction to *Wordless Books: The Original Graphic Novels*, ed. David A. Beronä (New York: Harry N. Abrams, 2008), 7–9.

24 In the realm of graphic novels, artists have remediated the techniques of woodcut prints. Consider in particular Frank Miller's film noir–inspired *Sin City* saga (1991–2000). With a focus on the often-conflicting experience of modern urban life after World War I and the Great Depression, the stark social contrasts, violence, social unrest, and loose sexual codes are translated into stylized silhouettes of what might be called hard-boiled silhouettes. For example, in "Just Another Saturday Night" (Aug. 1997), Miller draws on the early style of wordless novels and woodcut techniques, and the fifteen-page narrative "Silent Night" (Nov. 1995) tells its story exclusively through black-and-white silhouette images. Miller, "Silent Night," in *"Sin City": The Frank Miller Library, Set 2* (Milwaukee, WI: Dark Horse, 2006), 6:28–54.

25 "The Silhouette, Ghost of the Modern Photograph, Again a Fad," *New York Tribune*, Oct. 26, 1913, 17.

26 The aesthetic premises of the Harlem Renaissance are usually traced back to the written word. Many scholars have overlooked the visual contributions by the German immigrant Winold Reiss and the Mexican Miguel Covarrubias to seminal publications such as *The New Negro: An Interpretation*, ed. Alain Locke (New York: A. and C. Boni, 1925), or the advertisement campaigns of Alfred Knopf, the leading publisher at the time.

27 For an example of the period's many distorting representations of African Americans as "savage" and "carnal," see Paul Colin's lithographs of the caged, half-naked Josephine Baker (1927) for the revue *Le Tumulte Noir* in Paris. Paul Colin, Karen C. C. Dalton, and Henry Louis Gates Jr., *Josephine Baker and La Revue Nègre: Paul Colin's Lithographs of "Le Tumulte Noir" in Paris, 1927* (New York: Harry N. Abrams, 1998).

28 See Caroline Goeser, *Picturing the New Negro: Harlem Renaissance Print Culture and Modern Black Identity* (Lawrence: University Press of Kansas, 2007)

29 One might argue that it was this kind of white agency combined with international nonblack artists and a patronizing attitude toward African American painters and illustrators that contributed to pushing the visual narrative of the Harlem Renaissance to the margins in favor of the African American literary body of work.

30 Reiss's impressive range of creativity, rich work of ethnic portrait paintings, distinctive interior modernist design, and cutting-edge graphic design have been relegated to the margins of American art history. In Germany, he is hardly known at all. Wanda Corn, in *The Great American Thing: Modern Art and National Identity, 1915–1935* (Berkeley: University of California Press, 1999), has speculated that Reiss's work may indeed embarrass scholars. Caroline Goeser, in *Picturing the New Negro*, has brought attention to Reiss's groundbreaking illustrations for book covers.

31 See Amy Helene Kirschke, "The Black Burden of Black Womanhood: Aaron Douglas and the 'Apogée of Beauty,'" *American Studies* 49, 1/2 (Spring/Summer 2008): 100.

32 Winold Reiss, from an unsent letter dated Jan. 28, 1915, found among Reiss's personal belongings, Reiss Archives. Reiss offers a wealth of visual approaches to express the notion of a naissance or renaissance of African American expression in the arts. The first indication can be gleaned from the design of letters and graphic elements on the cover of *The New Negro*. Some of the shapes, such as the geometrical

triangles and parallel colorful lines, refer to Native American and Mexican folk art. In *The New Negro*, we find what Reiss describes as a type study entitled "Ancestral." In a veristic portrait style, Reiss depicts a dark-skinned young woman in the foreground, and the background shows a blanket or carpet with folk art elements, including the triangular shapes he used—among many other prints and drawings—effectively on the cover of *The New Negro*.

33 Winold Reiss, quoted in Frank Mehring, ed., *The Mexico Diary: Winold Reiss between Vogue Mexico and Harlem Renaissance*, an illustrated trilingual edition with commentary and musical interpretation (Trier, Ger.: WTV, 2016), 123, 124.

34 It is revealing to use the African American professor of philosophy Alain Locke's philosophical concepts and the Mexican philosopher and politician José Vasconcelos's concept of the "Cosmic Race" to contextualize Reiss's fascination with all things Mexican. Vasconcelos's groundbreaking outlook on the future of a postracial civilization was published in 1925, the year that also marks the beginning of what is commonly referred to as the "New Negro" movement. Vasconcelos, *The Cosmic Race / La raza cosmica* (Baltimore, MD: Johns Hopkins University Press, 1997).

35 Alain Locke, "The Legacy of the Ancestral Arts," in Locke, *The New Negro*, 266.

36 Aaron Douglas, quoted in Kirschke, "The Black Burden of Black Womanhood," 99.

37 See, in this context, Lucy Moore's *Anything Goes: A Biography of the Roaring Twenties* (London: Atlantic Books, 2010), 58, where she argues that nightclubs in Harlem delivered exotic, erotic, and "primitivist fantasies" to a largely white audience with racist undertones.

38 J. A. Rogers, "Jazz at Home," in Locke, *The New Negro*, 216.

39 Ibid.

40 Richard J. Powell, *The Blues Aesthetic: Black Culture and Modernism* (Washington, DC: Washington Project of the Arts, 1989). See also Jeffrey Stewart, *To Color America: Portraits by Winold Reiss* (Washington, DC: Smithsonian Institution Press, 1989), 57.

41 The interpretation of dance via silhouettes deviates from the repertoire that German silhouette animation films brought to the United States. The 1920s saw the rise of silhouette films such as Lotte Reiniger's feature-length silhouette animation of *The Adventures of Prince Achmed* (1923–1926). Here, Reiniger translates stories from the *Arabian Nights* as silhouette animations moving gracefully to the musical soundtrack by Wolfgang Zeller. The narrative and aesthetics are in line with German constructions of Orientalism, which found its literary expressions in Karl May's travel accounts of the Middle East and in films such as *Die Todeskarawane* (1920, based on May's 1892 *Von Bagdad nach Stanbul* [From Bagdad to Istanbul]) and *Das Indische Grabmal* (1921) and *Der Tiger von Eschnapur* (1921) (released in the United States as *Mysteries of India, Part I* and *Mysteries of India, II* in 1922). A 1926 article by Hermann G. Scheffauer on the world premiere of *Prince Achmed* in the *New York Times* emphasizes the "innate power of these dark moving figures." Instead of the term "silhouettes," the article refers to the expression "shadow film." Considering the renewed interest in silhouette aesthetics in the Harlem Renaissance and in advertising for African American literature and music, the author implies that the Germanized Orientalism could be easily appropriated for more-contemporary purposes: "At least such technical perfection has been achieved through the simplest mechanical means directed by the trained eye and artistic hand, that the form and medium may be applied not only to fairy themes, but to real and modern subjects." Scheffauer, "New Shadow Film Enriches the Screen," *New York Times*, July 18, 1926, SM6.

42 Alain Locke, "More of the Negro in Art," *Opportunity* 3, 36 (Dec. 1925): 364.

43 Langston Hughes, *The Weary Blues* (New York: Knopf, 1926).

44 For a discussion of Covarrubias's influence on the Harlem Renaissance, see Deborah Cullen, "The Allure of Harlem: Correlations between Mexicanidad and the New Negro Movements," in *Nexus New York: Latin/American Artists in the Modern Metropolis*, ed. Cullen (New York: Museo del Barrio; New Haven, CT: Yale University Press, 2009), 126–51.

45 Ken Gonzales-Day, *Lynching in the West, 1850–1935* (Durham, NC: Duke University Press, 2006), 3.

46 Other Expressionist films such as Friedrich Wilhelm Murnau's *Faust* (1926) and Paul Wegener's *Der Golem; Oder, Wie er in die Welt Kam* (1920), as well as Walther Ruttman's visual experiments, combined shadows and silhouettes in animation sequences.

47 Béla Balázs, review of *Nosferatu* in *Der Tag* (Vienna), Mar. 9, 1923, reprinted in Hans Helmut Prinzler, ed., *Friedrich Wilhelm Murnau: Ein Melancholiker des Films* (Berlin: Bertz, 2003), 130.

48 James Weldon Johnson, *God's Trombones. Seven Negro Sermons in Verse*, with drawings by Aaron Douglas, and lettering by C. B. Falls (New York: Viking Press, 1927).

49 Aaron Douglas, "Aaron Douglas Chats about the Harlem Renaissance," interview with Dr. Leslie M. Collins, in *The Portable Harlem Renaissance Reader*, ed. David Levering Lewis (New York: Penguin Press, 1994), 123.

50 Romare Bearden, "The Negro Artist and Modern Art," *Opportunity* 12, 12 (Dec. 1934), reprinted in Lewis, *The Portable Harlem Renaissance Reader*, 139.

51 Romare Bearden and Harry Henderson, *A History of African-American Artists from 1792 to the Present* (New York: Pantheon, 1993), 128, 133.

52 Aaron Douglas, quoted in Richard J. Powell, *Black Art: A Cultural History* (New York: Thames & Hudson, 1997), 45.

53 Amy Helene Kirschke's analysis of Aaron Douglas's mural artwork in "The Fisk Murals Revealed" emphasizes the "flat style of synthetic Cubism and Matisse" and especially "the work of the European painters Robert Delaunay and Frantisek Kupka and the American Stanton MacDonald Wright." Kirschke, "The Fisk Murals Revealed: Memories of Africa, Hope for the Future," in *Aaron Douglas: African American Modernist*, ed. Susan Earle (New Haven, CT: Yale University Press, 2007), 116.

54 Sieglinde Lemke, *Primitivist Modernism: Black Culture and the Origins of Transatlantic Modernism* (Oxford: Oxford University Press, 1998), 69.

55 Aaron Douglas, quoted in Robert G. O'Meally, "The Flat Plane, the Jagged Edge: Aaron Douglas's Musical Art," *American Studies* 49, 1/2 (Spring/ Summer 2008): 27, 29–30.

56 Bearden, "The Negro Artist and Modern Art," 141. Over the course of the second half of the twentieth century, silhouettes have been continually associated with jazz and other African American musical styles such as soul, rhythm and blues, and rap. Examples include Matisse's explicit juncture of poetry and black cutouts published in the 1948 book *JAZZ*; the pop art revolution in the 1960s, with Andy Warhol at the forefront; and, more recently, the street art of Jean-Michel Basquiat and the reductive explorations of graphic art in Keith Haring's particular interest in hip-hop and dance. In the medium of film, silhouettes continue to function as stylized references to African American coolness and African American self-empowerment (often alluding to the aggressive vigilante self-stylizations in the visual culture of the Black Panthers), and as visual markers of the jazz age in the collective memory of popular culture, as we can see in the artwork of Saul Bass and Maurice Binder and the video clips of Beyoncé and others.

57 Aaron Douglas, quoted in Powell, *Blues Aesthetic*, 24.

58 Kara Walker, quoted in Alexander Alberro, "Kara Walker," *Index* 1, 1 (Feb. 1996): 25. See also Kara Walker, *My Complement, My Enemy, My Oppressor, My Love*, organized by Philippe Vergne, Sander Gilman, Kevin Young, Thomas McEviley, Robert Storr, and Gwendolyn DuBois Shaw (Minneapolis, MN: Hatje Cantz, 2007).

59 See the work of scholars such as Philippe Vergne, Sander Gilman, Kevin Young, Thomas McEviley, Robert Storr, and Gwendolyn DuBois Shaw.

60 Toni Morrison, "On the Backs of Blacks," *Time Magazine*, Dec. 2, 1993, http://content.time.com/time/magazine/article/0,9171,979736,00.html.

61 The image creates an interpictorial reference to the graphic artwork Paul Colin produced in Paris when Josephine Baker became a sensation. The *New Yorker* correspondent Janet Flanner described the stunning appearance of Baker when she appeared in the nude at the opening night of *La Revue Nègre* at the Théâtre des Champs-Élysées in 1925. In a striking contrast, her seemingly absolute blackness in front of a white upper-class audience made her appear like

How Silhouettes Became "Black"

a classical statue: "She was an unforgettable female ebony statue. A scream of salutation spread through the theater. Whatever happened next was unimportant. The two specific elements had been established and were unforgettable—her magnificent dark body, a new model that to the French proved for the first time that black was beautiful, and the acute response of the white masculine public in the capital of hedonism of all Europe-Paris." Janet Flanner, *Paris Was Yesterday, 1925–1939* (New York: Popular Library, 1972), xx. The description of Baker with the reduced visual information makes her appear like a black silhouette. At the same time, the dark silhouette body gives rise to colonial fantasies of otherness and expressive sexuality. With her dance and stage performance, which evoked, as Clifton Crais and Pamela Scully explain, "an animal in heat," Baker referenced the "Hottentot Venus," a popular trope in Europe for primitivism, sexuality, and the common fascinations with hysteria. Clifton Crais and Pamela Scully, *Sara Baartman and the Hottentot Venus: A Ghost Story and a Biography* (Princeton, NJ: Princeton University Press, 2009), 146.

62 See Kara Walker, *Endless Conundrum, An African Anonymous Adventuress*, Walker Art Center, accessed Sept. 12, 2016, http://www.walkerart.org/collections/artworks/endless-conundrum-an-african-anonymous-adventuress.

63 Sabine Schultze and Ina Grätz, eds., *Apple Design* (Hamburg, Ger.: Hatje Cantz Verlag, 2011).

64 Scott McLoud, *Understanding Comics: The Invisible Art* (New York: HarperCollins, 1993), 30.

Contributors

François Brunet

A historian of images and American culture, François Brunet teaches at Université Paris Diderot, where he serves as chair of the Laboratoire de recherches sur les cultures anglophones, and is a fellow of the Institut Universitaire de France. His publications include *La naissance de l'idée de photographie* (new ed., Presses universitaires de France, 2011), *La photographie histoire et contre-histoire* (Presses universitaires de France, 2017), and *Photography and Literature* (Reaktion Books, 2009). He has curated the exhibitions *Images of the West: Survey Photography in French Collections, 1860–1880* (Musée d'Art Américain Giverny, 2007) and *Daguerre's American Legacy: Photographic Portraits from the Wm. B. Becker Collection* (Bry-sur-Marne, Fall 2013; MIT Museum, 2014). He has also published about 150 articles and reviews and is a member of the editorial boards of *American Art* and *History of Photography*. His current projects focus on the international circulation of images and objects in the nineteenth century and on the photographic imagination of history.

Thierry Gervais

is assistant professor at Ryerson University and head of research at the Ryerson Image Centre (RIC), Toronto. He received his PhD from the École des hautes études en sciences sociales (Paris) in 2007. He was the editor in chief of *Études photographiques* from 2007 to 2013 and is the author of numerous articles on photojournalism in peer-reviewed journals and scholarly publications. He was the curator of the exhibition *Dispatch: War Photographs in Print, 1854–2008* (RIC, Fall 2014) and the cocurator of the exhibitions *Views from Above* (Centre Pompidou-Metz, Spring 2013), *Léon Gimpel (1873–1948), The Audacious Work of a Photographer* (Musée d'Orsay, Paris, Spring 2008), and *L'événement: Les images comme acteurs de l'histoire* (Jeu de Paume, Paris, Winter 2007). He organized the symposia "The 'Public Life' of Photographs" (RIC, 2013), "Collecting and Curating Photographs: Between Private and Public Collections" (RIC, 2014), and "Photography Historians: A New Generation?" (RIC, 2015). He edited *The "Public" Life of Photographs* (RIC/MIT Press, 2016), and his book (in collaboration with Gaëlle Morel) titled *La fabrique de l'information visuelle: Photographies et magazines d'actualité* (Textuel, 2015) will be published in English by Bloomsbury in 2017.

Tom Gunning

is the Edwin A. and Betty L. Bergman Distinguished Service Professor in the Department of Cinema and Media Studies at the University of Chicago. He is the author of *D. W. Griffith and the Origins of American Narrative Film* (University of Illinois Press, 1986), *The Films of Fritz Lang: Allegories of Vision and Modernity* (British Film Institute, 2000), and over 150 articles on early cinema, film history and theory, avant-garde film, film genre, and cinema and modernism. With André Gaudreault, he originated the influential theory of the "cinema of attractions." In 2009, he was awarded an Andrew A. Mellon Distinguished Achievement Award, the first film scholar to receive one, and in 2010, he was elected to the American Academy of Arts and Sciences. He is currently working on a book on the invention of the moving image.

J. M. Mancini

is senior lecturer in the Department of History at Maynooth University (Ireland). Her publications include *Architecture and Armed Conflict* (edited with Keith Bresnahan, Routledge, 2015); *Pre-Modernism: Art-World Change and American Culture from the Civil War to the Armory Show* (Princeton University Press, 2005), winner of the Smithsonian American Art Museum's 2008 Charles C. Eldredge Prize for Outstanding Scholarship in American Art; and essays in *American Art*, *American Quarterly*, *Critical Inquiry*, and other journals. She is currently completing a book entitled *Art and War in the Pacific World* (contracted to the University of California Press).

Hélène Valance

is assistant professor at the Université de Franche-Comté. She recently published a book on nocturnes in American art at the turn of the twentieth century entitled *Nuits américaines: L'art du nocturne aux États-Unis, 1890–1917* (Presses de l'université Paris-Sorbonne, 2015). The book received the Terra Foundation–Yale University Press American Art in Translation Book Prize, and will be translated and published by Yale University Press in 2018. Her current projects include a collection of essays on destruction in American art and a book-length study of the reenactments of American myths and historical events in nineteenth- and twentieth-century visual culture.

Frank Mehring

is professor of American studies at Radboud University, Nijmegen. He teaches twentieth- and twenty-first-century visual culture and music,

theories of popular culture, transnational modernism, and processes of cultural translation between European and American contexts. His publications include *Sphere Melodies* (Metzler, 2003) on Charles Ives and John Cage, *Soundtrack van de Bevrijding* (Vantilt 2015), and *The Mexico Diary: Winold Reiss Between Vogue Mexico and the Harlem Renaissance* (wvt: 2016). In 2012, he received from the European Association for American Studies the biennial Rob Kroes Award, which recognizes the best book-length manuscript in Europe in American studies, for his monograph *The Democratic Gap* (Winter, 2014). He has organized the first international symposium on Winold Reiss in Berlin (2011) and co-curated exhibitions on Winold Reiss (2012), the Marshall Plan (2013), and Liberation Songs (2014) in New York, Nijmegen, and The Hague. His current project focuses on the democratic vision of Marshall Plan photography and exhibitions.

About the Foundation

This volume, the third in the series of the Terra Foundation Essays, was conceived to provide an international forum for the thorough and sustained exploration of fundamental ideas and concepts that have shaped American art and culture over time.

For over thirty years, the Terra Foundation for American Art has been committed to supporting innovative programs and initiatives designed to engage audiences around the globe in a lively dialogue on the visual arts of the United States. This series offers a novel platform for international exchange, complementing the foundation's existing programs.

The Terra Foundation for American Art is dedicated to fostering exploration, understanding, and enjoyment of the visual arts of the United States for national and international audiences. Recognizing the importance of experiencing original works of art, the foundation provides opportunities for interaction and study, beginning with the presentation and growth of its own art collection in Chicago. To further cross-cultural dialogue on American art, the foundation supports and collaborates on innovative exhibitions, research, and educational programs. Implicit in such activities is the belief that art has the potential both to distinguish cultures and to unite them.

For information on grants, programs, and publications at the Terra Foundation for American Art, visit terraamericanart.org.

TERRA
FOUNDATION FOR AMERICAN ART